Caterina Caneva, Alessandro Cecchi, Antonio Natali

The Uffizi

Guide to the Collections and Catalogue of all Paintings

Introduction by Luciano Berti

SANDAK
A DIVISION OF G.K. HALL & Co.

Contents

759.94
Caneva

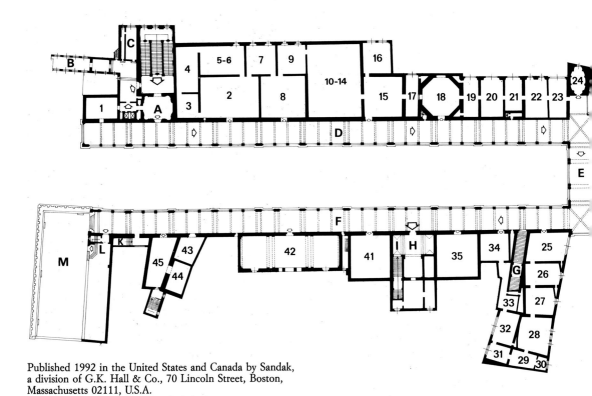

Published 1992 in the United States and Canada by Sandak,
a division of G.K. Hall & Co., 70 Lincoln Street, Boston,
Massachusetts 02111, U.S.A.

© Copyright 1986 Scala,
Istituto Fotografico Editoriale Spa, Florence
and Editrice Giusti di Becocci, Florence
© Copyright of the photographs: Scala
(A. Corsini, M. Falsini, M. Sarri)
Texts by: C. Caneva (Rooms 28-45, The Tapestries, The Ceiling
Frescoes, The Vasari Corridor); A. Cecchi (Rooms 17-27, The
Collection of Prints and Drawings, The Sculpture Collections);
A. Natali (Rooms 1-16, The Church of San Pier Scheraggio).
Design and editorial supervision: Lisa Pelletti Clark
Translation: Thekla Clark
Printed by Lito Terrazzi, Cascine del Riccio (FI) 1992

A – Entrance hall
B – Corridor leading to Palazzo Vecchio
C – Director's offices
D – First Corridor
E – Second Corridor
F – Third Corridor
G – Entrance to Vasari Corridor
H – Room of Buontalenti
I – Buontalenti Stairway
K – W.C.
L – Bar
M – Terrace above Loggia dell'Orcagna

Note: The paintings in each room
are listed clockwise, beginning from the one
to the left of the entrance.

RWB

Introduction

In 1981 the Uffizi celebrated their fourth centenary with an exhibition in Palazzo Vecchio (where, among other things, Botticelli's restored *Primavera* was shown), an International Meeting of scholars dealing with the oldest Gallery in the world, and a show of the more than 200 self-portraits of the world's major artists of the 20th century, donated for the occasion to the Uffizi. On the posters, the city of Florence called itself the "city of the Uffizi." There is no doubt that Francesco I de' Medici founded the Gallery in 1581 with very ambitious ideas. On the top floor of the magnificent building designed by Vasari to house the major offices of the state ('Ufficii' hence the name), between Palazzo Vecchio and the Arno, the Gallery was later to provide an indoor passage all the way to Palazzo Pitti and the Boboli Gardens, via the Vasari Corridor over the Ponte Vecchio, thus leading from the heart of the city to the walls and to the hills of the countryside beyond. The Medici Theatre, which housed the impressive stage performances organized by Buontalenti, was also connected to the Uffizi: it stood where there is now the Gabinetto dei Disegni but also took up the top floor, where the first rooms of the Gallery now are, up to and including the Botticelli Room. Here, the recent restoration has uncovered part of the huge beamed ceiling of the Theatre.

The Gallery housed classical sculptures and historical portraits along its wide corridors (as it still does today), and its highpoint was the elegant octagonal Tribune where all the most precious items were kept. This room was designed following a most complex cosmological symbolism: a weathervane (which still works) represents Air, the dome encrusted with mother-of-pearl represents the Heavens and Water, the walls with their red hangings symbolize Fire, and the floor in semi-precious stones represents Earth. Here Raphael's and Andrea del Sarto's paintings were hung, and later all the Gallery's greatest masterpieces. Below the paintings there were ebony cupboards containing 120 drawers full of medals and other precious objects, topped by exquisite small bronzes by Giambologna. In the centre of the room there was a magnificent chest shaped like a small temple, which was later replaced by the octagonal table with *pietre dure* intarsia (returned there in 1970). The Tribune was famous throughout the world, as a model of what museums should be like; in the 18th century Johann Zoffany painted a view of this room in a painting for the Queen of England.

The Gallery also had another room next to the Tribune where scientific instruments were kept (now the Room of the Hermaphrodite), as well as rooms housing ancient and modern weapons from all countries (the collection was unaccountably dismantled and dispersed by the Lorraine during the 18th century). The Room of the Maps, then an open terrace, had frescoes showing all the possessions of the Tuscan State, as well as more scientific instruments.

On the other side of the Gallery, along the Western (or Third) Corridor, there were laboratories for the minor arts, and the Foundry or Pharmacy where perfumes, medecines, poisons and anti-poisons were distilled. At the end of this wing, on the terrace above the Loggia dell'Orcagna, a garden had been laid out, and the Medici children would go there late in the afternoon to listen to the music being played by the military bands in the square below. Nature and Art (intended, in the general sense, as human activity transforming nature) were the two constant features of the Gallery; and the aesthetic pleasures offered at the Uffizi went from the major figurative arts to the minor decorative ones, from music to the theatre. In fact to this day the Uffizi gives the idea of a museum not conceived as a specialized unit, but rather as a variety of collections (even though the archeological, sculptural, minor arts and scientific sections have now been transferred elsewhere); it is not closed in, but opens onto the city with its huge windows; it communicates with the buildings nearby; it is dynamic not only within the city, but also in the cultural itinerary it offers, for it provides a historical survey (through the statues and portraits in the Corridors) as well as an art historical one. And lastly, from the very beginning the Gallery was conceived as a *res publica* not as a private dynastic collection. As early as 1591 scholars requesting to visit the Gallery were welcomed, two centuries earlier than other European royal collections; the items were organized according to scientific criteria and the collaboration of all scholars, even foreigners, was welcome; the Grand Dukes and their families felt the moral duty to increase the possessions of this state museum and left their private collections to the Uffizi in their wills.

Ferdinando I de' Medici continued at the Uffizi the work begun by his brother Francesco. While in Rome, as a cardinal, he had shown great artistic interest by acquiring famous classical sculptures such as the *Medici Venus*, the *Wrestlers* and the group of the *Niobids*, all of which eventually ended up in the Uffizi. It was thanks to him that the work of contemporary artists was acquired, like Caravaggio. After Cosimo II, who was more interested in the second Gallery, which was indeed a private princely collection in the Palazzo Pitti, another period of

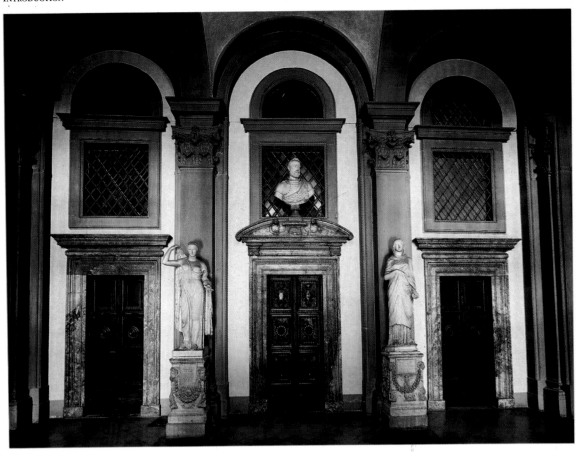

The facade of the Medici Theatre

acquisitions came about during the reign of Ferdinando II, who received in 1631 the Urbino inheritance, thanks to his wife Vittoria della Rovere. Among the paintings from Urbino were such masterpieces as Titian's *Venus*, and other paintings by Titian, Raphael and Barocci. In the meantime his brother, the scholarly Cardinal Leopoldo, began his own remarkable private collection, which entered the Gallery at his death in 1675. In his collection were thousands of drawings by great artists (the nucleus of the Gabinetto dei Disegni connected to the Gallery) and the extraordinary collection of self-portraits of artists from all periods and countries, unique in the world, which is today exhibited in the Vasari Corridor. Other items of Cardinal Leopoldo's collection, which are only partially exhibited, are the historical portraits and the miniatures.

Cosimo III also contributed a great deal to the Uffizi, as well as organizing a modernization of some sections of the museum. As a young man he had travelled and had bought many paintings, in particular of the Flemish schools. His son, Grand Prince Ferdinando, invited the most celebrated painters of the time (Crespi, Magnasco) and also succeeded in obtaining some great masterpieces of the past from churches, such as Andrea del Sarto's *Madonna of the Harpies* or Parmigianino's *Madonna of the Long Neck*.

But since the Medici dynasty was destined to die out through lack of heirs, the last Medici, Anna Maria Ludovica, Electress Palatine, in 1737 drew up a convention which bound all the Medici works of art to the city of Florence. Thus the Medici successors, the Lorraine, were unable to sell or move any part of the inheritance. The Lorraine in turn set about increasing the collections and Peter Leopold in particular devoted great energies to the completion of the reorganization of the Gallery, adding the 18th-century Stairway and Vestibule, as well as the splendid neo-Classical Room of Niobe (1780). In the meantime, in 1759 the first (and not very accurate) guide to the Uffizi had been published by the Keeper Bianchi, who is remembered primarily for the terrible fire that broke out in 1762, during his time. In 1779 the Director Bencivenni Pelli wrote the first truly scholarly history of the Gallery, and in 1782 Abbot Lanzi drew up an accurate guide. Several transformations had in fact taken place over the years; in particular, the acquisition of 15th-century Renaissance painting, the beginning of the rediscovery of the "primitives," and a series of exchanges with the Imperial Galleries in Vienna, which brought paintings by Dürer, Carracci, Rubens and Van Dyck. The Gallery also bought a great number of French masterpieces, including Claude Lorrain's spectacular view of a harbour.

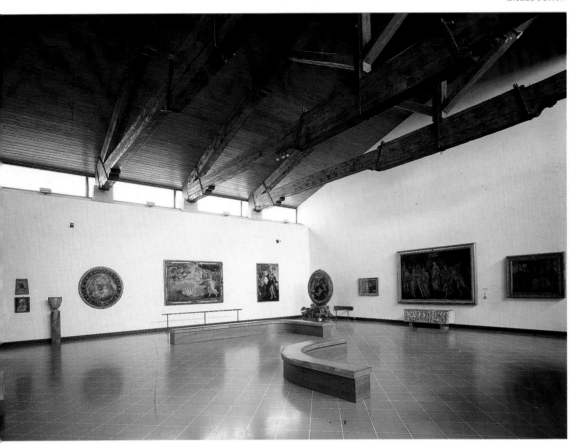

The Botticelli Room

The Second Corridor

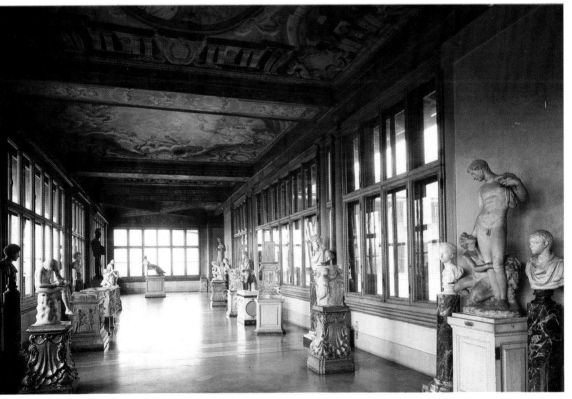

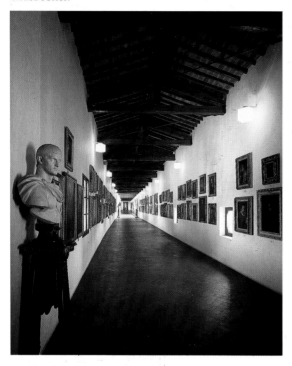

The Vasari Corridor

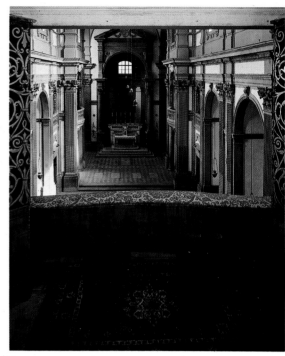

The church of Santa Felicita seen from the Vasari Corridor

In 1795 for the first time the names of the artists were written out next to the paintings. The collection was constantly growing, acquiring paintings from grand ducal villas and collections and from the suppressed religious institutions: Leonardo, Giovanni Bellini, Giorgione, Titian, Tintoretto, Veronese, as well as Simone Martini, Piero della Francesca, Filippo Lippi, Botticelli, Mantegna, Signorelli, Rembrandt.

In 1796 Napoleon visited the Uffizi, but the Director Puccini succeeded in defending the collections; the only piece that the French managed to take away to Paris was the *Medici Venus*, but it was returned to Florence after the fall of Napoleon. In the early part of the 19th century the Gallery acquired a great number of "primitives," and this trend continued even after the unification of Italy in 1860, with the arrival of works by Cimabue and Giotto. The Gallery was enlarged with eleven new rooms at the beginning, created out of the former Medici Theatre, but the lack of space was still strongly felt. Directors such as Enrico Ridolfi and Corrado Ricci modernized the rooms, and acquired new paintings enlarging the collections of Italian schools primarily. Giovanni Poggi, director after the First World War, continued in this trend.

When Italy entered into the Second World War the paintings were transferred to safety in only two weeks; the retreating Nazis in 1944, took many paintings with them to Germany, but they were all returned to Florence in July 1945. Today the Gallery is the result of all the work of renovation and modernization of the rooms that has been carried out since then by architects Michelucci, Bartoli,

Bemporad, among others. As far as new acquisitions are concerned, aside from the contemporary self-portraits mentioned earlier, it will be enough to say that masterpieces by Ambrogio Lorenzetti, Berruguete, Lotto, El Greco, Chardin and Goya have been added to the collection in this last period. The numerous paintings of the Contini-Bonacossi collection, now on show at the Meridiana Gallery in Palazzo Pitti, will also come to the Uffizi. At present, including the Vasari Corridor, there are more than 1,700 paintings on show. The number of yearly visitors, which has risen from 105,000 in 1950 to 1,400,000 in 1980, has brought about new problems concerning the safety of the collections. Studies have been made regarding the best means of preservation, and the Gallery has its own research and restoration laboratories; all newly cleaned and restored paintings now have a red marker on the wall next to them, indicating the year of the cleaning. Since 1978, scholars may request to visit the Deposits, which contain about a thousand paintings and are located on the first floor. In 1979 an overall scientific catalogue of the Uffizi was published. As well as the famous Gabinetto dei Disegni, the Gallery has a Library, a Didactic Section and a Research Office. This Gallery is not only one of the major galleries in the world, but also the most emblematic of Italy. Among all the visitors from all over the world (the present Director calculates that since 1969 he has received about twenty million), there are frequently illustrious guests who share with us all the desire to see and admire the Uffizi, the oldest museum in the world.

The *Hermaphrodite* in Room 17

The Buontalenti Room

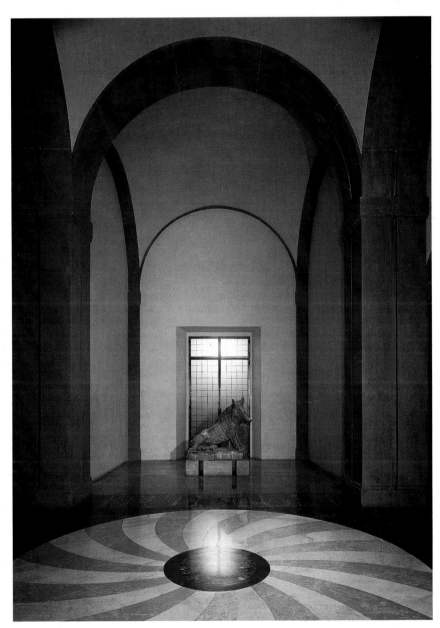

The Church of San Pier Scheraggio

The area which was once the church of San Pier Scheraggio, next to the main entrance to the Uffizi, is the first room the visitor enters. There are still some elements that indicate what the original structure was like. The church was consecrated in 1086 and was restored and modified several times over the course of the centuries, so that its original structure, similar to its contemporary San Miniato al Monte, is scarcely recognizable. The left aisle had disappeared even before Vasari set about incorporating the building into his plans of the Uffizi. Vasari knocked down various parts of the building and, by 1560, the church was left without side aisles altogether. And that is how we see it today, even though it has been transformed into a room of a museum. Until about fifteen years ago this large space was used as a storeroom and the restoration it underwent not only gave it renewed dignity, by making it part of one of the world's most important galleries, but also made it possible to see and study the various stages of its history. Thanks to the excavations that have been carried out in the church we can now clearly distinguish a Roman wall, at the lowest level, which probably belonged to a *taverna*, with decorative frescoes. Above that are the remains of the Longobard church and of the later Romanesque one, with columns, capitals, an apse and traces of frescoes. The restauration work has led to the creation of two rooms. The first one, with a raised passageway that enables the visitor to see the results of the excavations from above, temporarily houses Andrea del Castagno's series of frescoes depicting "Famous Men," removed from Villa Carducci in Legnaia (Florence). These illustrious Florentine men serve as a perfect introduction to the cultural environment that the visitor will find in the rooms of the gallery above. And we must not be surprised by the juxtaposition in this room of ancient frescoes and a monumental work painted almost five centuries later: Corrado Cagli's *Battle of San Martino*, painted for the Milan Triennale exhibition in 1936 and donated to the Uffizi in 1983, after the Gallery's celebration of its fourth centenary in 1981. There are many reasons for placing this modern work here: firstly, the painting is quite obviously inspired by Renaissance ancient masterpieces, but its primary source is undoubtedly Paolo Uccello's *Battle of San Romano* in the Gallery upstairs. The inspiration does not consist solely in the similar subject matter, but rather in the same composition, and in the same idea of portraying an animated clash, using the same perspective foreshortening, the same collection of unrealistic and fantastic colour tones. Cagli's painting is placed at the entrance to the Gallery for another reason as well: it is conceived as the symbol of the Gallery administrators' wish to extend the collections to include even examples of contemporary art. Along the same lines, after the visit to the Gallery, with its exceptional masterpieces, at the exit the visitor will be able to admire another modern work, Marino Marini's *Pomona*. But, returning to Cagli's *Battle of San Martino*, nearby are two other modern pieces: a bronze sculpture by De Chirico and Marini's *Archeologists*.

In the following room, which was the presbytery of the church and where one can still see the apse with its partially frescoed window arches, the detached frescoes originally in this church or in the older constructions below. Above, the *Madonna della Ninna*, against a gold background with two little red angels hovering at her sides.

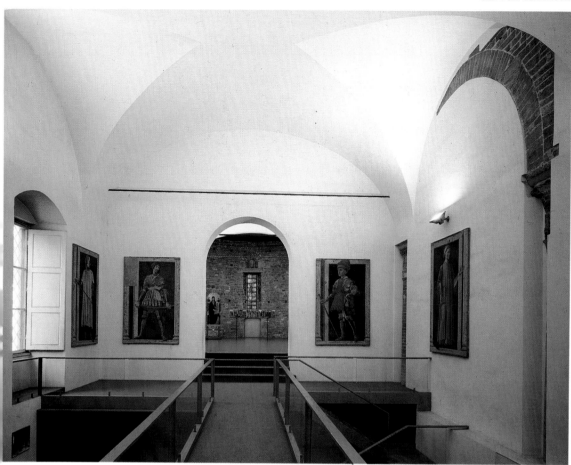

In the first room:

Andrea del Castagno
(Castagno c 1421–Florence
1457)
Queen Esther
Fresco removed and transferred
to canvas, 120x150
Inv. San Marco e Cenacoli, 169
This fresco is part of the series
of famous people that Andrea
painted around 1450 in the
loggia of Villa Carducci at
Legnaia, near Florence; they
were removed around the
middle of the last century and
acquired by the Florentine
Galleries. At the Uffizi since
1969.

Andrea del Castagno
Queen Tomyris
Fresco removed and transferred
to canvas, 245x155
Inv. San Marco e Cenacoli, 168
See previous entry.

Andrea del Castagno
Giovanni Boccaccio
Fresco removed and transferred
to canvas, 250x154
Inv. San Marco e Cenacoli, 165
See above.

Andrea del Castagno
Francesco Petrarca (Petrarch)
Fresco removed and transferred

to canvas, 247x153
Inv. San Marco e Cenacoli, 166
See above.

Andrea del Castagno
Dante Alighieri
Fresco removed and transferred
to canvas, 247x153
Inv. San Marco e Cenacoli, 167
See above.

Andrea del Castagno
Niccolò Acciaioli
Fresco removed and transferred
to canvas, 250x154
Inv. San Marco e Cenacoli, 171
See above.

Andrea del Castagno
Pippo Spano
Fresco removed and transferred
to canvas, 250x154
Inv. San Marco e Cenacoli, 173
See above.

Andrea del Castagno
Farinata degli Uberti
Fresco removed and transferred
to canvas, 250x154
Inv. San Marco e Cenacoli, 172
See above.

Corrado Cagli
(Ancona 1910–Rome 1976)
The Battle of San Martino
Encaustic egg tempera on
board, 545x651

Inv. w.n.
Painted for the 1936 Milan
Triennial Exhibition; presented
to the Uffizi in 1983.

Andrea del Castagno
The Cuman Sibyl
Fresco removed and transferred
to canvas, 250x154
Inv. San Marco e Cenacoli, 170
Part of the series of famous
people. See above.

In the second room:

**13th-century Florentine
School**
Frescoes of San Pier Scheraggio
Five removed frescoes, 189x86,
171x86, 104x60, 60x48, 67x43
Inv. 1890, 9372-6
The church, restored in 1294,
was reconsecrated in 1299;
these frescoes were probably
commissioned at this time and
painted by a Florentine artist
influenced by Bolognese
painting. These were removed
in 1939; others, around the
windows of the apse, are still in
place.

**Master of San Martino alla
Palma**
(active in Florence in the early
14th century)
Coronation of the Virgin, known

as *Madonna della Ninna*
Tempera on wood, 230x117
Inv. 1890, 6165
In the 18th century the painting
was in the chapel of the
Compagnia della Ninna in the
church of San Pier Scheraggio.
It became the property of the
Florentine Galleries in 1781
and was exhibited at the Uffizi
in 1959.

Below:

**14th/15th-century
Florentine School**
Frescoes of San Pier Scheraggio
Two removed frescoes, 86x72,
90x65
Inv. w.n.
These frescoes were originally
in the votive chapel of San Pier
Scheraggio.

**4th/5th-century Roman
painting**
Floral decoration
Tempera on wood, Three
removed frescoes, 105x182,
90x75, 55x88
Inv., w.n.
Fragments of the Roman period
decorations of a room that is
thought to have been a tavern,
discovered under San Pier
Scheraggio.

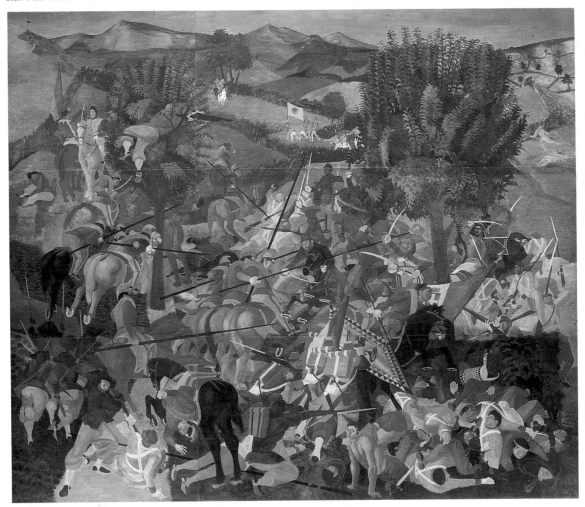

Corrado Cagli: The Battle of San Martino

<div style="text-align: right">

◁
Andrea del Castagno: The Cuman Sibyl

◁◁
Andrea del Castagno: Queen Tomyris

</div>

The Collection of Prints and Drawings

This collection, the most important in Italy and one of the most prestigious in the world, prized for its consistently high quality and its completeness, is on the second floor of the Gallery in rooms fashioned from the huge space once occupied by the Medici Theatre. The Theatre was designed by Buontalenti in 1586 for Grand Duke Francesco I whose bust by Giambologna is placed over the entrance.

The collection is made up of around 110,000 pieces and originated with Cardinal Leopoldo de' Medici, who assiduously collected drawings from all over Italy for more than twenty-five years, adding to the few hundred pieces of the Medici inheritance of the 15th and 16th centuries. The inventory of drawings compiled at his death, in August 1675, numbered 11,810 pieces. The basic collection was enlarged by Cosimo III and his son Prince Ferdinando and passed on to the House of Lorraine in 1737. At that time further prints and drawings were added and a systematic catalogation of all the material was begun. In 1866 the Collection was enriched by the sculptor Emilio Santarelli's bequest to the Uffizi of 12,667 drawings. The Collection today boasts an extensive documentation of various Italian schools, in particular Florentine works from the 14th to the 17th centuries.

Among the most famous drawings from the 14th century are the *Study of Warrior and Horse* by Paolo Uccello, perhaps for the *Battle of San Romano* at the Uffizi or for the paintings of *Saint George and the Dragon* in London or Paris, the drawing by Filippo Lippi for the *Madonna and Child* at the Uffizi as well as several drawings by Andrea del Castagno, Benozzo Gozzoli and Antonio del Pollaiolo. Especially noteworthy is Sandro Botticelli's splendid study for "*Pallas*" with its delicacy of line and shadowy touches, or the drawing of *Judith and her Serving Maid*, signed and dated 1491, by Andrea Mantegna, a work from the period of his fullest maturity and artistic expression.

Although not as vast as some English collections, the documentation on the three great masters of the Renaissance (Leonardo, Michelangelo and Raphael) is of the highest quality and of major importance for the study of their works. There is the landscape study by the young Leonardo, dated 5 August 1473; the drawings of Michelangelo from the years 1504 to 1506 in preparation for the *Battle of Cascina, Saint Matthew* and the *Madonna of Bruges*; as well as some drawings by Raphael that shed valuable light on the artist's development. Beginning with his early preparatory drawings for the frescoes of the Piccolomini Library in Siena (1502/3), the Collection also houses studies for the paintings of *Saint George and the Dragon* in Paris and Washington, as well as drawings for the *Baglioni Deposition* and Vatican Stanze.

More extensive still is the coverage of the 16th-century Florentine artists, beginning with the numerous folios of Andrea del Sarto's drawings, such as the study for the hand holding the book for the *Madonna of the Harpies*, to the many drawings of his pupil, Pontormo, the nudes in unrestrained movement within the turbulent composition, to the bizarre works of Rosso Fiorentino including his first drawing for the *Dei Altarpiece*.

Alongside works by Bronzino and other members of the Florentine Mannerist school, there are drawings of Northern Italians, such as Correggio, Parmigianino, Primaticcio, and Niccolò dell'Abate; the Venetians are represented by Giorgione, Titian, Tintoretto and Veronese. All of these, together with works from the following century, create a vast and unique panorama of Italian art.

Paolo Uccello:
Warrior on Horseback

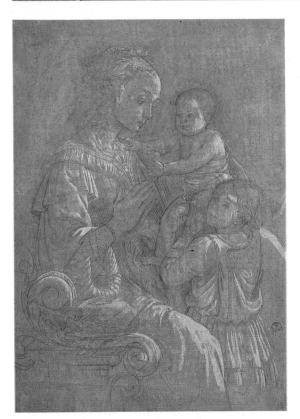

Filippo Lippi: Madonna and Child with an Angel

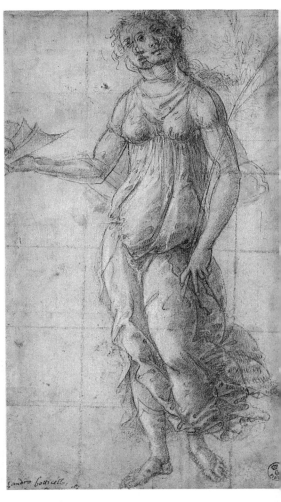

Sandro Botticelli: Pallas

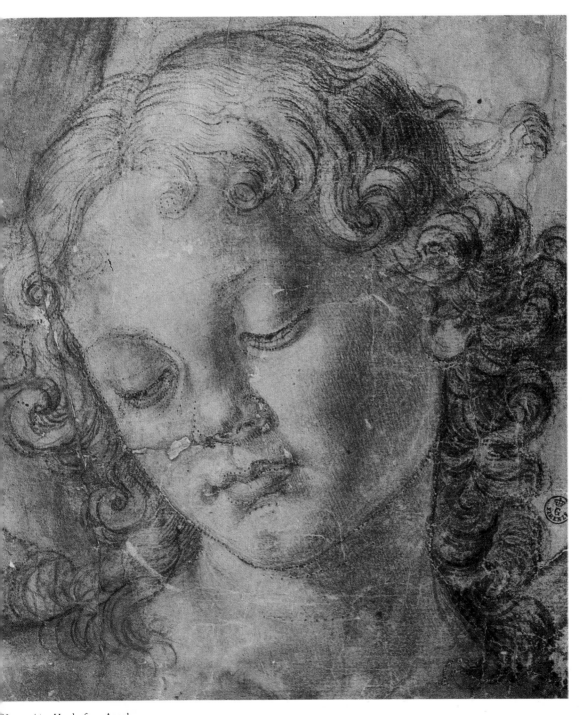

Verrocchio: Head of an Angel

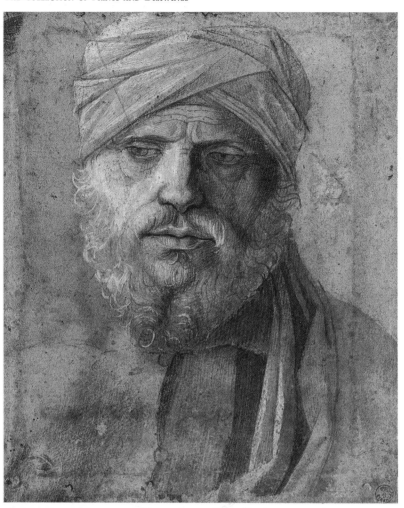

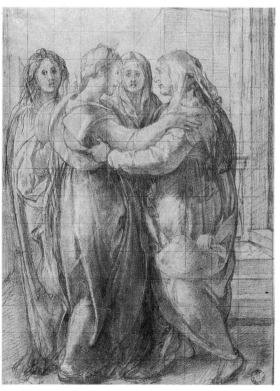

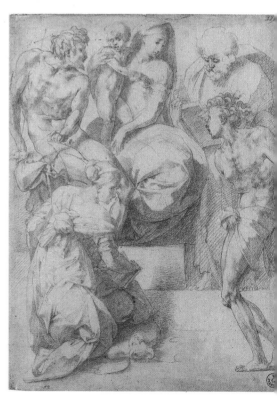

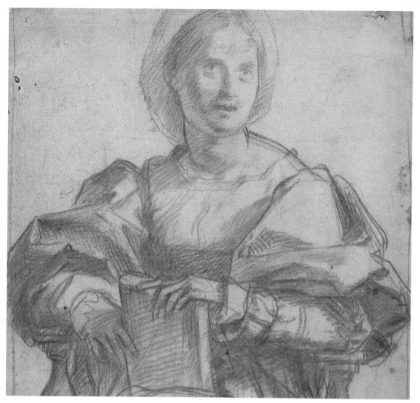

Andrea del Sarto: Portrait of a Lady

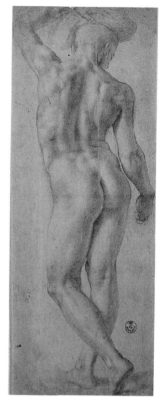

Agnolo Bronzino: Male Nude

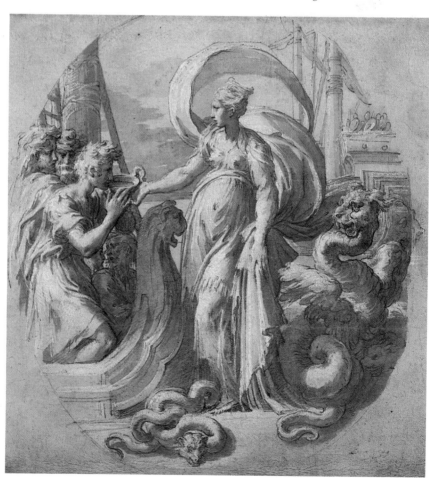

▷
Parmigianino: Circe

◁
Rosso Fiorentino: Madonna
and Child with Saints

◁◁
Pontormo: Visitation

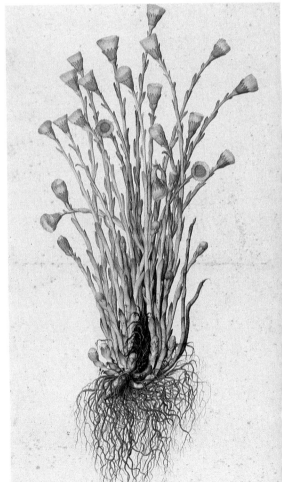

Gian Lorenzo Bernini: Allegory of the River Nile

Jacopo Ligozzi: *Iupsilago farfara*

Guercino: Study for the Saint William

Cristofano Allori: Study of a Youth

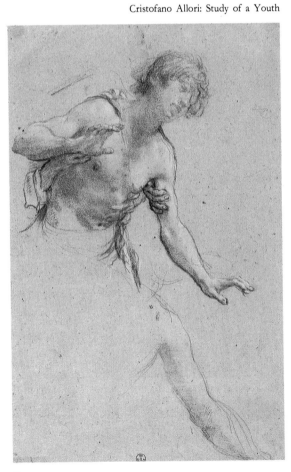

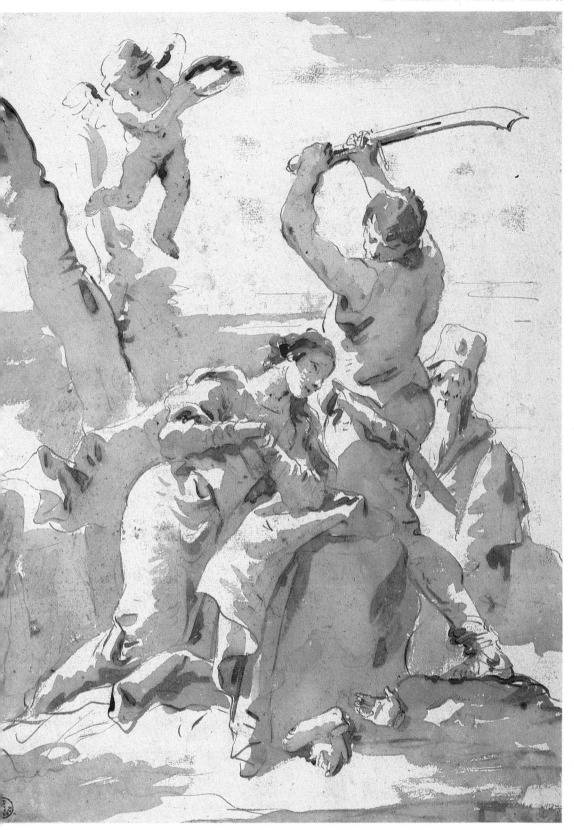

iovan Battista Tiepolo: Martyrdom of a Saint

The Sculpture Collection

Although the Uffizi is today famous throughout the world for its collection of paintings, we must not forget that for a long time it was known as the "Gallery of Statues." Since its foundation, in fact, it housed a remarkable number of sculptures, both classical and "modern," in accordance with the collecting criteria of the Medici in the late 16th century.

After the collections of antiques, accumulated by the Medici in the 15th century, had been dispersed, it was Cosimo I who, together with his sons Francesco and Ferdinando, bought a large number of classical statues in Rome, between 1560 and 1586. Some of these were intended for Florence and some for their Roman villa, on the Pincio hill, which Cosimo had bought in 1576. The Medici collections also contained several outstanding masterpieces of Etruscan art, such as the bronze statues of the *Orator*, the *Chimera* and *Minerva* (all today in the Archeological Museum). It was Cosimo's intention, in fact, to prove the cultural and artistic supremacy of Tuscany, offering evidence of its earliest achievements. The statues and busts were placed along the walls of the corridors, alternating classical and modern works—Roman sculptures next to ones by Donatello, Michelangelo or Bandinelli.

The collection was further enlarged in the second half of the 17th century when several important statues arrived from Rome and were placed in the Tribune in 1677. Among them were the *Hermaphrodite* and the *Venus de' Medici*.

In the early 18th century, in the context of the renewed interest in classical antiquity and the development of a new attitude towards works of art in general, very detailed and scholarly inventories and catalogues were drawn up to illustrate this extraordinary collection.

During the reign of Grand Duke Peter Leopold of Lorraine (1765-90) new acquisitions took place and the whole Gallery was reorganized under the supervision of Luigi Lanzi, "Royal Antiquarian," and architect Zanobi del Rosso.

In 1780 the Gallery was given a new (and truly monumental) entrance: Vasari's staircase was prolonged, creating a vestibule where several important sculptures were placed. In the following year, a solemn celebration inaugurated the Room of Niobe of the Third Corridor, designed by architect Gaspare Maria Paoletti (1727-1813); it was built specifically to house the sculpture group of the Niobids, brought from Rome in seven different stages, between 1778 and 1787.

Many sculptures were transferred to the Etruscan Museum, an independent institution founded in 1870 and inaugurated two years later, and to the new Archeological Museum, founded in 1880 and housed in Palazzo della Crocetta. With the creation of these new museums, the Uffizi lost many important items of its collection, as had already happened in the case of the collections of weapons and armour, scientific instruments and jewellery. Yet, despite these considerable losses, the sculpture collection today is still outstanding enough to give the visitor an idea of the splendour and variety of the collections in the past.

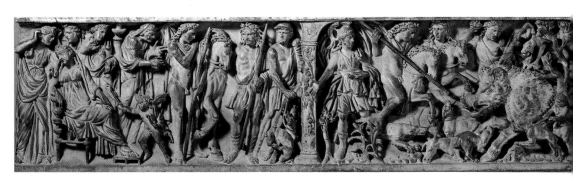

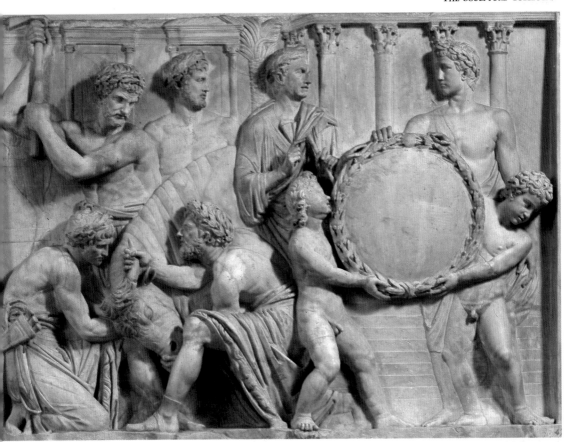

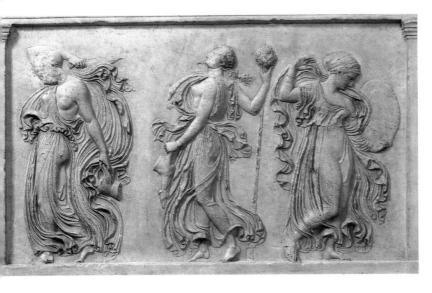

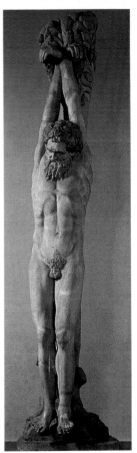

The Maenades (Roman copy of a
5th-century Greek relief)

Marsyas (Roman copy of a 3rd-century B.C.
Hellenistic original)

△
Sacrifice (Roman relief)

▷
Roman sarcophagus with the story of Phaedra
and Hippolytus (3rd century A.D.)

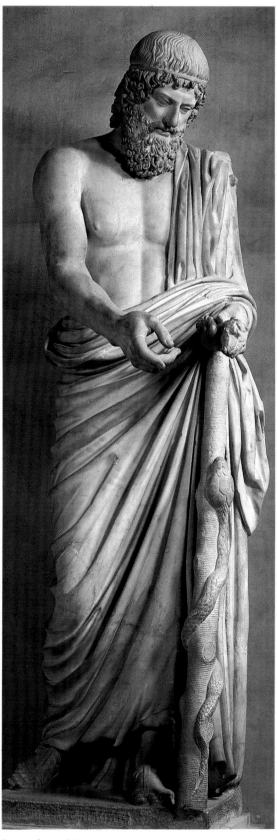

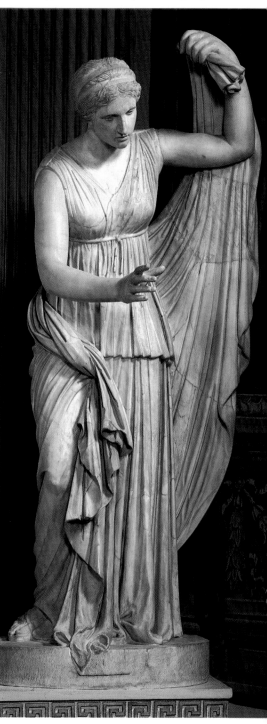

Selene, from the group of the Niobids
(Roman copy a 3rd/2nd-century Greek original)

Statue of a God (Roman copy of a 5th-century
Greek original)

The Sacrifice of Iphigenia
(Neo-Attic, 1st century B.C.)

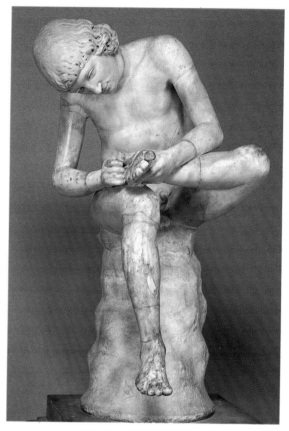

Boy removing a thorn from his foot
(Roman copy of a Hellenistic original)

Bust of a Satyr
(Greek, 2nd century B.C.)

Roman Bust of Hadrian

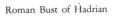

Venus (Roman copy of a 3rd-century B.C. Greek original)

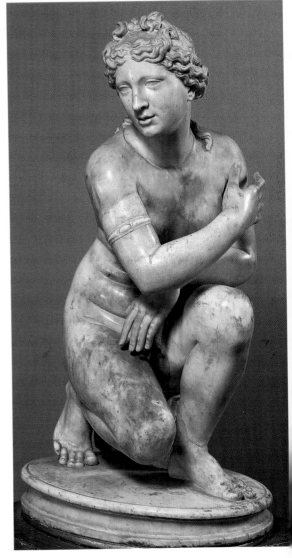

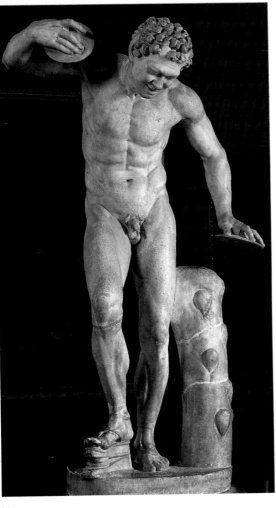

Dancing Faun (Roman copy of a 3rd-century B.C. Greek original)

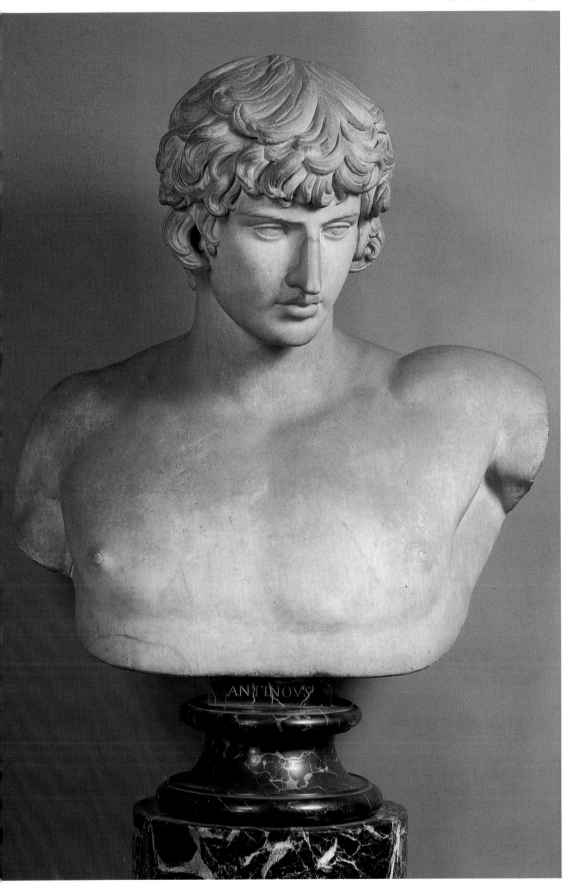

oman bust of Antinous

Domenico Poggini: Francesco I de' Medici

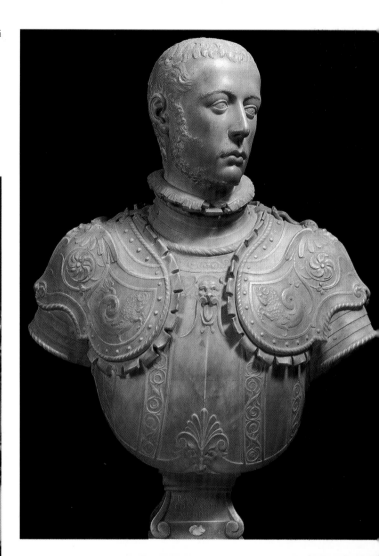

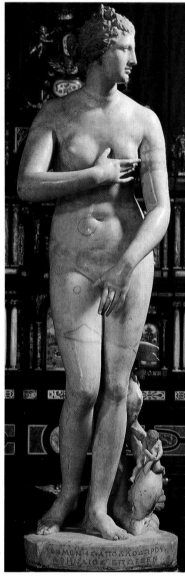

Medici Venus (Hellenistic copy
of a 4th-century B.C. original)

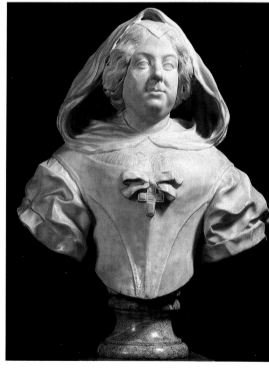

Giovan Battista Foggini: Vittoria della Rovere

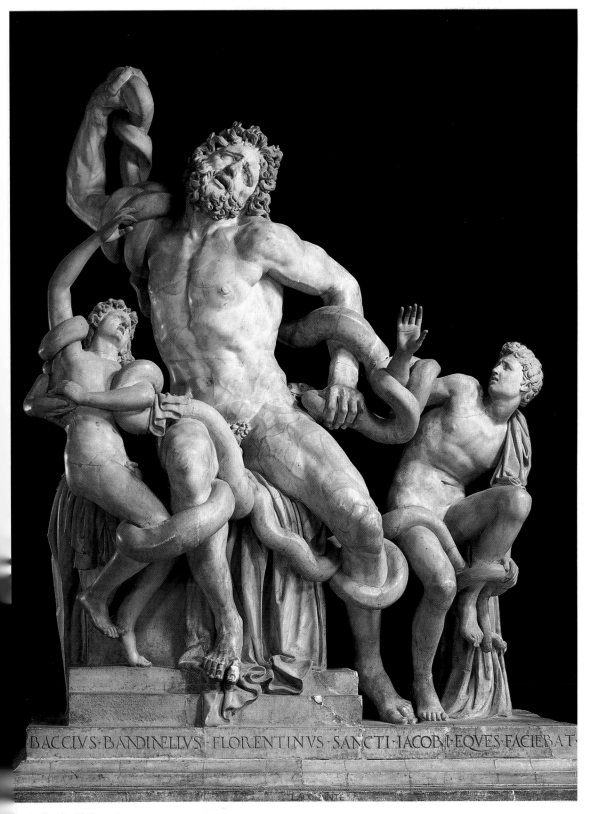

BACCIVS·BANDINELLVS·FLORENTINVS·SANCTI·IACOBI·EQVES·FACIEBAT·

Baccio Bandinelli: Laocoön

The Tapestries

The tapestries at present on display in the Gallery are only a very small part of the splendid Medici collection. This collection was never properly exhibited and several pieces have even been lost or been given away, perhaps because the products of this so-called minor art were never properly taken into consideration in the past. A suitable re-organization and exhibition of the tapestry collection is long overdue.

The richness and variety of the former collection is the result, on the one hand, of the production of the local Florentine workshops, set up by Cosimo I who brought famous Flemish tapestrymakers to Florence; other items of the collection were donated to the Medici by wealthy allies and powerful friends.

The most important and interesting pieces are displayed in the First Corridor: the tapestries woven by Nicholas Karcher from designs by Bachiacca (1549/53), the earliest products of the Florentine workshops.

Next to these are the seven beautiful hangings illustrating "Celebrations at the Valois Court," woven in Brussels around 1582/5 and sent by the Belgians as a gift to Catherine de' Medici, Queen of France. Together with her son Henry III, the Queen appears in all the celebrations depicted in the tapestries: masked balls, court receptions, tournaments and jousts. The members of the court are portrayed in full regalia, with their magnificent garments minutely and accurately described.

In the Third Corridor there are two other important series: one illustrating stories from the life of Jacob, woven in Brussels between 1528 and 1550 from designs by Bernaert van Orley, and the other produced in Florence showing scenes from the Passion, woven by Guasparri Papini around 1592-1605 from cartoons by the Tuscan artists Cigoli and Alessandro Allori.

Scattered about the Gallery are several 17th-century 'Portiere' (door hangings), showing Medici coats-of-arms surrounded by the arms of the grand duchesses. Particularly interesting, in the Room of Niobe, is a 17th-century tapestry showing episodes from the life of Cosimo I. In the small rooms beyond the Tribune there are several scenes of the Passion, made from cartoons by Francesco Salviati.

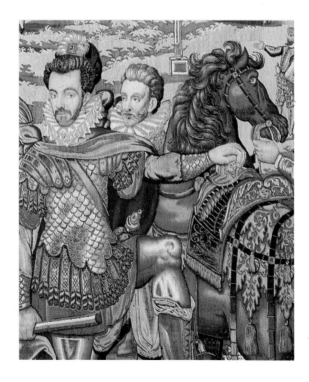

Celebrations at the Valois Court: Entertainments in honour of the Polish ambassadors, detail

Celebrations at the
Valois Court:
Entertainments in honour
of the Polish ambassadors

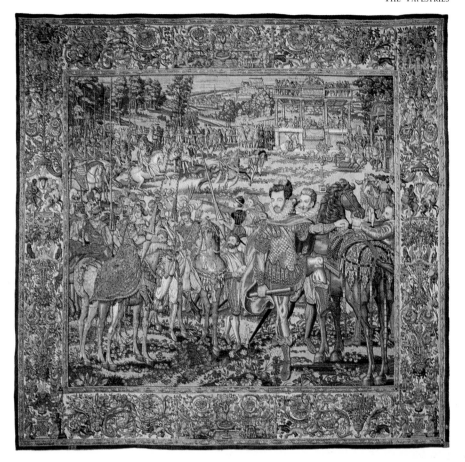

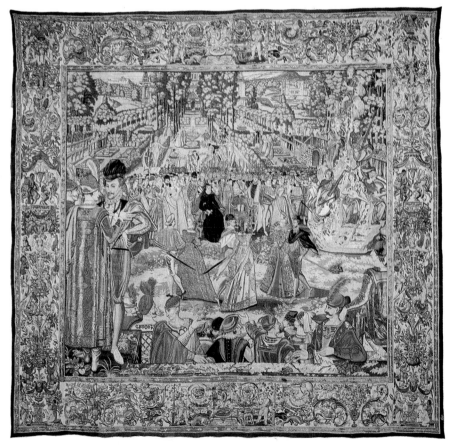

Celebrations at the
Valois Court:
A tournament

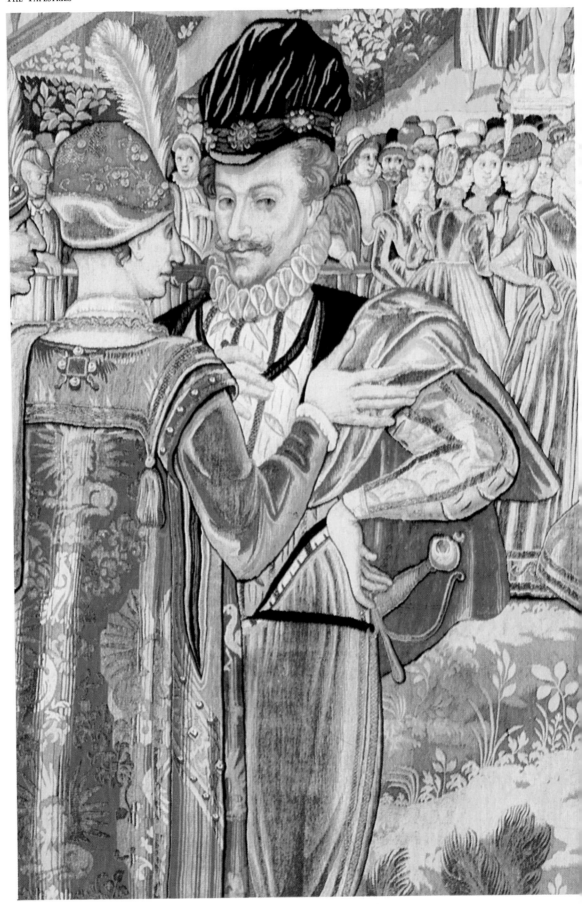

The Ceiling Frescoes

The ceilings of the three corridors and some of the older rooms still have their original frescoes, painted for the most part shortly after the rooms were built. These are decorated with grotesques, a style that became extremely popular in 16th-century Italy after excavations in Rome had uncovered the splendours of imperial dwellings decorated in this highly colourful and imaginative fashion.

The ceiling of the First Corridor (in a small bay the date 1581 is inscribed, the year of the entire work) is decorated with a myriad of animal and floral motifs, painted around medallions with allegories, myths and symbols of Medici glory; pagan divinities, small landscapes, putti, birds and fantastic animals fill every other available space.

This fresco series was painted by a team of artists under the direction of Alessandro Allori, a painter highly appreciated in Medici circles who also worked on the Studiolo in Palazzo Vecchio. A little later the small rooms next to the Tribune were frescoed, rooms designated to house other precious pieces of the Medici Collection, in particular the Armoury. In fact, besides the usual allegories in praise of the Medici and charming scenes of city life, these ceilings are also decorated with battles in exotic countries, trophies and war scenes. They can be dated around 1588. In the following year the walls of the Room of the Maps were decorated with views of Siena, Florence and the Island of Elba. These were done by Ludovico Buti under the supervision of the famous cartographer, Stefano Bonsignori; a little later the grotesques on the ceiling of the "Room of Mathematics" (Room 17) were painted, showing scientific instruments depicted with technical accuracy as well as satyrical intents. After a long break, the fresco work began again in 1658 with the decoration of the Third Corridor starting from the large terrace of the Loggia dell'Orcagna. The subjects in the bays, although placed in frames of grotesques, were designed with the express purposes of praising Tuscany and her most illustrious citizens in all fields of achievement, and above all of glorifying the Medici. The painters who worked here were Cosimo Ulivelli, Agnolo Gori and Jacopo Chiavistelli.

In 1696 the Second Corridor was decorated by Giuseppe Nicola Nasini and Giuseppe Tonelli; the large bays were filled with frescoes exalting the rulers of Tuscany.

With this last phase the decoration was complete, but in 1762 a fire destroyed twelve bays in the Third Corridor. Giuseppe Traballesi, Giuseppe Maria Terreni and Giuseppe del Moro were the painters engaged to replace the damaged frescoes.

Fresco on the ceiling of Room 23: The Manufacture of Cannons

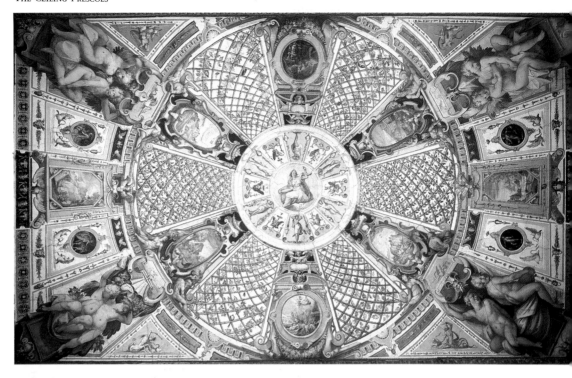

Alessandro Allori: Fresco
on the ceiling of the First Corridor

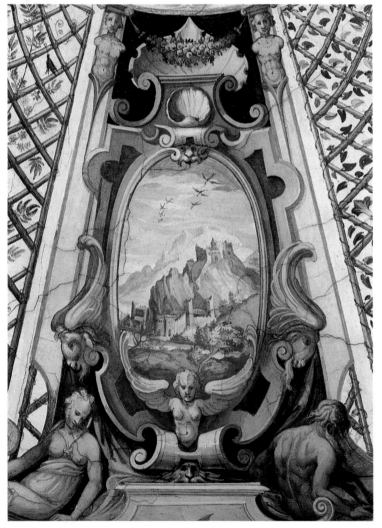

The Gallery

Room I
The Archeological Room

his room, called generically "archeologi-
al," reserved for the exhibition of pieces
om antiquity, was inaugurated in its pre-
nt form in 1981 to coincide with the four
undreth anniversary of the Uffizi itself. The
ew colours of the stands and the walls, the
rmer with a marble-like effect and the lat-
r a sage green, are vaguely reminiscent of
all painting and create in the room a feeling
antiquity at the same time as a feeling of
ace open to the sun.

he room, built around 1920, was originally
lled Room of the Ara Pacis, because at that
me it contained the great reliefs from the
mous Augustan monument acquired by the
edici in 1569. In 1937 a law was passed

decreeing that the pieces be returned to
Rome where the entire Ara Pacis was to be
reconstructed. Afterwards the room was
named for its most famous remaining piece
of sculpture, the *Hermaphrodite*. However, in
1970 this piece, too, was removed and
placed in its original location, a small but ex-
quisite room next to the Tribune. The new
arrangement of the room in 1981 recalls the
lost reliefs by exhibiting plaster copies made
by an able Florentine craftsman at the begin-
ning of the century. The central piece of the
room now is the torso in green basalt, a Ro-
man copy of the *Doryphoros* by Polycleitus,
with its deep glossy patina which resembles
the bronze of the original.

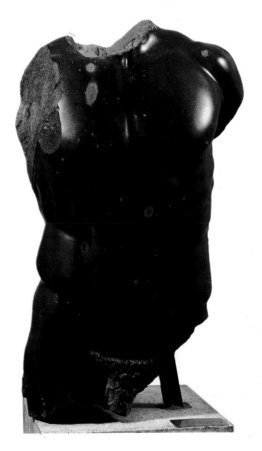

Copy in green basalt
of Polycleitus's *Doryphoros*

ROOM 2
The 13th Century and Giotto

This room, constructed in the last century, was created out of the vast Hall of the Senate – as, indeed, were many of the other rooms which open onto the First Corridor – which in turn had been part of the Medici Theatre. When it was first opened as part of the Museum, it housed tapestries of the Venetian School placed one on top of another to resemble a picture gallery. In a later arrangement, by Giovanni Poggi (1911-1926), Florentine paintings of the 16th century were placed here, with more space in between and thus much easier to view. Then, bowing to the concept that works of art should be arranged chronologically, it seemed right and natural that these first rooms contain works from the very beginning of Italian painting. This brought about the renovation of the room in the 1950s by Michelucci, Scarpa and Gardella, with the results that we see today: vast white walls with a ceiling of huge sloping wooden beams; austere, pure, a space evocative of 13th-century Tuscan churches. Upon entering the room, immediately opposite the entrance, one used be dazzled by Cimabue's extraordinary *Crucifix*. This great

work was returned to its original location the church of Santa Croce, where, shor later, it was irreparably damaged in the disa trous flood of 1966. Its place was taken Giotto's *Madonna of Ognissanti* (*c* 1310), whi was already on display in the room. Movi the Giotto to this position enhanced t painting and made it the centre arou which the entire room revolved. This is t position that it occupies today, flanked the side walls by two other famous Mado nas: Cimabue's (*c* 1280) and Duccio's (128 These, too, were on display already, b placed as they now are they form a sort ideal triptych, illustrating different concep and cultures, but all created at a time of e traordinary developments in Italian paintin Cimabue's *Madonna*, austere and solemn, presents the height of the Byzantine tra tion, while at the same time announcing end. Duccio's painting, delicate yet rigorou expresses in its figures the individuality Sienese culture. And, finally, Giotto's gre work that hails not only new aesthetic sions, but innovative philosophic concepts well.

Florentine artist of the mid-13th century
Madonna and Child
Tempera on wood, 98x60
Inv. 1890, 9213
This painting has been dated at the second half of the 13th century. At the Uffizi since 1948.

Master of the Bardi Saint Francis
(active between 1240 and 1270)
Crucifix with eight stories from the Passion
Tempera on wood, 250x200
Inv. 1890, 434
Origin unknown; in 1888 it was mentioned in the inventory of the Uffizi; later is was exhibited at the Accademia and returned to the Uffizi in 1948.

Maddalena Master
(active in Florence at the end of the 13th century)
Saint Luke
Tempera on wood, 132x50
Inv. 1890, 3493
From Santissima Annunziata.

At the Uffizi since 1948.

Duccio di Boninsegna
(Siena *c* 1255–1319)
Rucellai Madonna
Tempera on wood, 450x290
Inv. w.n.
Painted in 1285 for the Compagnia dei Laudesi of Santa Maria Novella. At the Uffizi since 1948.

Giotto
(Vespignano, Vicchio di Mugello 1267–Florence 1337)
The Badia Polyptych
Tempera on wood, 91x334
Dep. Santa Croce, 7
Originally on the high altar of the Badia in Florence; painted in the very first years of the 14th century. At the Uffizi since 1957.

Giotto
Ognissanti Madonna
Tempera on wood, 325x204
Inv. 1890, 8344
Painted around 1310 for the high altar of the church of

Ognissanti in Florence. At the Uffizi since 1919.

Cimabue
(Florence, active 1272–1302)
Santa Trinita Madonna
Tempera on wood, 385x223
Inv. 1890, 8343
Painted around 1280 for the high altar of the church of Santa Trinita. At the Uffizi since 1919.

Pisan artist of the late 12th century
Crucifix with stories from the Passion
Tempera on wood, 377x231
Inv. 1890, 432
Painted at the end of the 12th or in the first years of the 13th century. Acquired by the Uffizi in the last century; lent to the Accademia in 1919 and returned to the Uffizi in 1948.

Meliore di Jacopo
(documented in Florence in 1260)
Christ the Redeemer and four Saints

Tempera on wood, 85x210
Inv. 1890, 9153
The inscription gives the nam of the artist and the date, 127
At the Uffizi since 1948.

School of Bonaventura Berlinghieri
(13th century)
Crucifixion
Madonna and Child with Saints
Tempera on wood, 103x122
Inv. 1890, 8575-6
The two panels are from a convent in Lucca. At the Uff since 1948.

Master of the Bardi Saint Francis
(active between 1240 and 12
Saint Francis Receives the Stigma
Tempera on wood, 81x51
Inv. 1890, 8574
Painted around the mid-13th century. Presented to the Florentine Galleries. At the Uffizi since 1948.

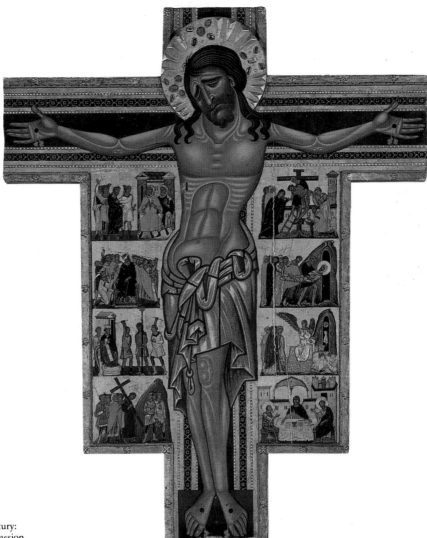

Pisan artist of the late 12th century:
Crucifix with stories from the Passion

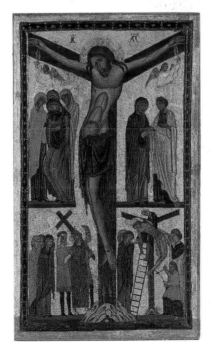

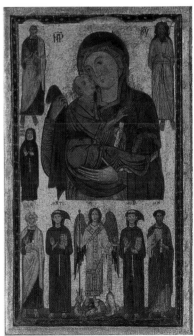

School of Bonaventura
Berlinghieri: Crucifixion
and Madonna and Child

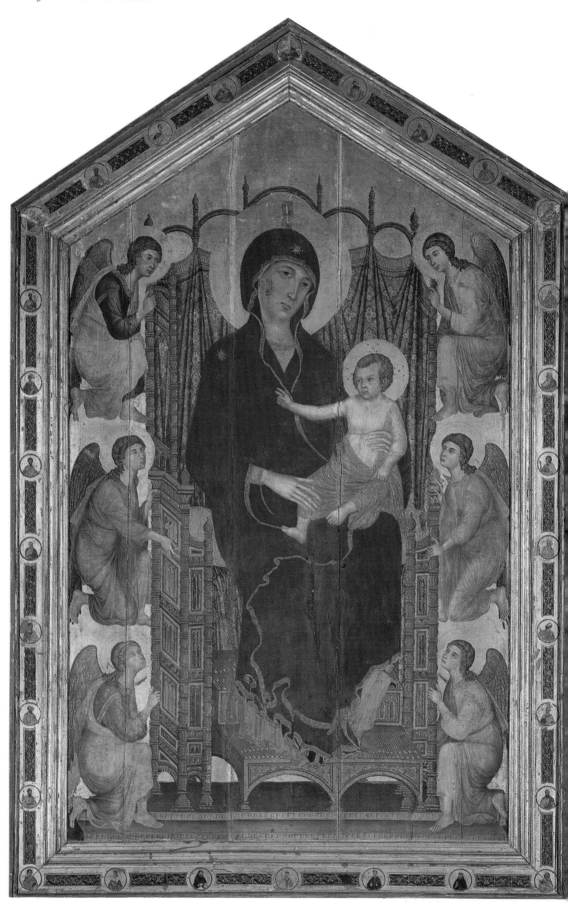

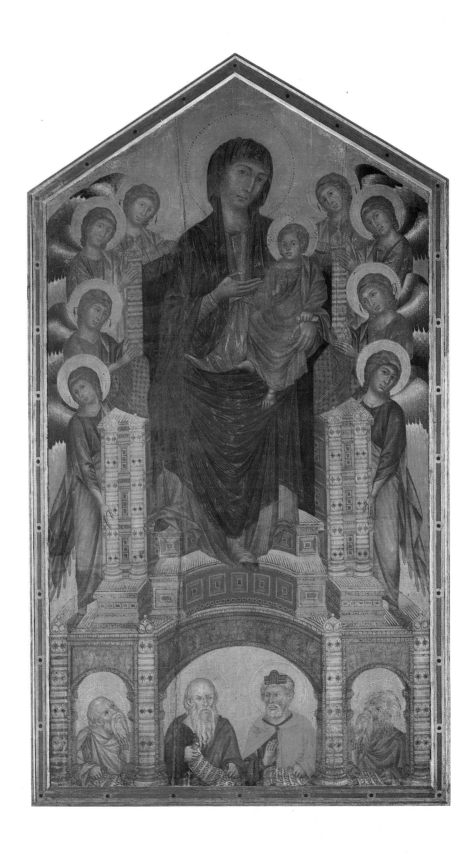

imabue: Santa Trinita
Madonna

Duccio: Rucellai Madonna

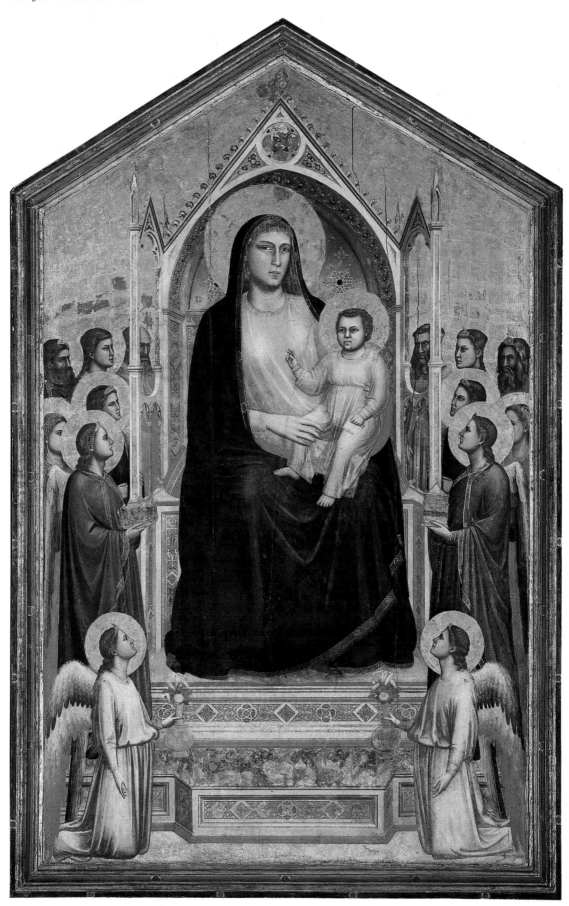

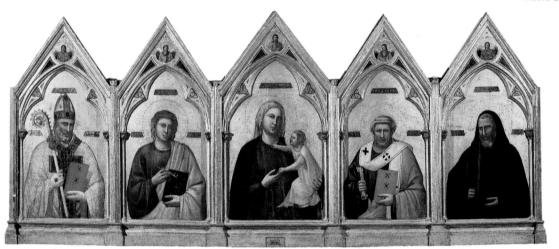

Giotto: The Badia Polyptych

Giotto: Ognissanti Madonna

Giotto: The Badia Polyptych, detail

Giotto: Ognissanti Madonna, detail

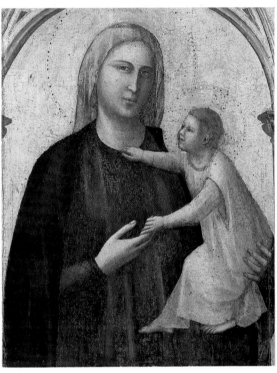

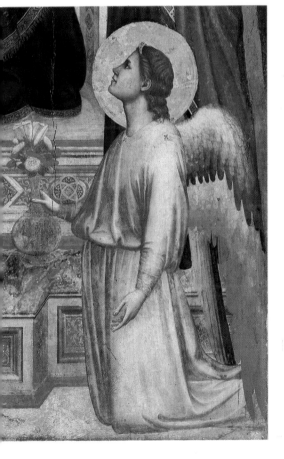

Many of the innovative features introduced by Giotto into Italian art are present in the *Ognissanti Madonna*. Here, as in the frescoes in Padua painted shortly before, the artist put into practice his conception of space, which is already very close to the early Renaissance mathematical representations of spatial depth. The *Badia Polyptych* was painted a few years earlier, between the frescoes in the upper church in Assisi and those in the Scrovegni chapel.

ROOM 3
Sienese Painting of the 14th Century

The restructuring and re-arranging which took place during the 1940s affected the first six rooms of the Uffizi, including the Pollaiolo Room (excluding the Lippi Room which has an analogous arrangement but was done later). This small but magnificent room was originally part of the following one and housed Florentine paintings of the 15th century. Formerly, late Gothic paintings, still tied in some measure to the artistic traditions of the past, were placed here together with paintings that were already fully within the "Humanist" tradition. When the room was divided in two and the 15th-century works were, according to chronological requirements, placed further ahead on the museum's itinerary, this small room was given over to a precious group of masterpieces of 14th-century Sienese painting. The difference in style is immediately apparent as one leave[s] the presence of the three Madonnas in th[e] preceding room and enters this room. Th[e] initial impact is provided by Simone Mart[i]ni's graceful and elegant *Annunciation* (1331) which, of all the works exhibited, is the mo[st] typically Sienese, with its magnificent use [of] colour and its delicate figures. Next to S[i]mone's *Annunciation* with its elegant, po[li]shed style, the other paintings, the Mador[n]nas and the Stories of Saints painted by th[e] brothers Pietro and Ambrogio Lorenzetti fo[r] churches in Florence, seem, perhaps becaus[e] they show touches of Giotto's new styl[e] more solid, sturdier, with a greater attentio[n] to naturalism; but still permeated with th[e] pictorial sensitivity, full of the fantastic an[d] dreamlike elements that characterize Siene[se] painting.

Pietro Lorenzetti
(Siena *c* 1280–1348?)
Madonna and Child with Angels
Tempera on wood, 145x122
Inv. 1890, 445
Painted around 1340 according to the inscription. At the Uffizi since 1815.

Ambrogio Lorenzetti
(Siena 1285–*c* 1348)
Madonna and Child with Saints Nicholas and Proculus
Tempera on wood, 171x57 (main panel), 141x43 (wings)
Inv. 1890, 8731, 9411, 8732
The triptych was painted in 1332 for the church of San Procolo. The wings were already in the Uffizi in the last century, while the central panel was presented as a gift in 1959 by Bernard Berenson.

Niccolò di Ser Sozzo Tegliacci
(first mentioned in Siena in 1334–Siena 1363)
Madonna and Child
Tempera on wood, 85x55
Inv. 1890, 8439

In 1919 the painting was stolen from the church of Sant'Antonio in Bosco near Poggibonsi; when it was recovered it was given to the Uffizi where it was first exhibited in 1933.

Simone Martini
(Siena *c* 1284–Avignon 1344)
and **Lippo Memmi**
(Siena, doc. 1317-1347)
Annunciation and Two Saints
Tempera on wood, 184x210
Inv. 1890, 451-3
Signed and dated 1333, the painting was painted on the altar of Sant'Ansano in Siena Cathedral. It was transferred to the Uffizi in 1799 by Grand Duke Pietro Leopoldo.

Above the door:

Pietro Lorenzetti
Cusps of the Beata Umiltà Altarpiece
Tempera on wood, 51x21 each one
Inv. 1890, 6129-31
Three of the four cusps

portraying the Evangelists, from the Beata Umiltà Altarpiece (see below).

Pietro Lorenzetti
Beata Umiltà Altarpiece
Tempera on wood, 128x57 (central panel), 45x32 (each scene), diam. 18 (each roundel)
Inv. 1890, 8347, 6120-6, 6129-31
The altarpiece, dating from around 1340, was reconstructed according to an 18th-century drawing. Originally in the women's convent of San Giovanni Evangelista in Faenza. At the Uffizi since 1919.

Simone dei Crocifissi
(Bologna, doc. 1355–1399)
Nativity
Tempera on wood, 25x47
Inv. 1890, 3475
The painting dates from around 1380; the inscription at the bottom reads: "Symon pinxit." At the Uffizi since 1906.

Niccolò di Bonaccorso
(Siena, doc. 1372–1388)
Presentation of the Virgin in the Temple
Tempera on wood, 50x34
Inv. 1890, 3157
Part of a larger composition, now dispersed except for two other panels. At the Uffizi sinc[e] 1900.

Ambrogio Lorenzetti
Four Stories from the Life of Saint Nicholas
Tempera on wood, 96x35 (eac[h] panel)
Inv. 1890, 8348-9
Originally in the church of San[n] Procolo in Florence, the panel[s] date from around 1330. At the Uffizi since 1919.

Ambrogio Lorenzetti
Presentation in the Temple
Tempera on wood, 257x168
Inv. 1890, 8346
Signed and dated 1342; commissioned for the altar of San Crescenzo in Siena Cathedral. At the Uffizi since 1913.

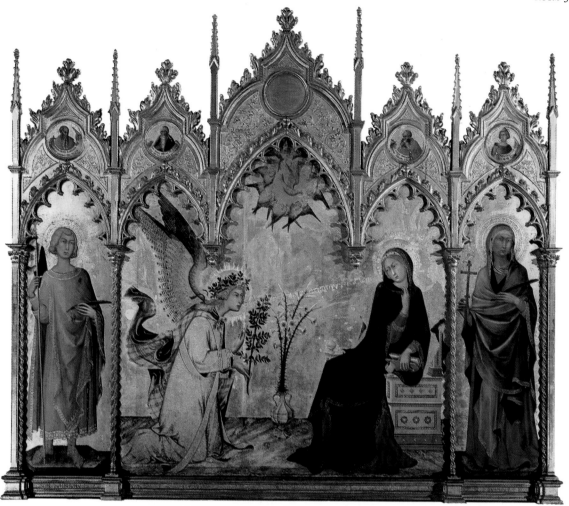

Simone Martini: Annunciation

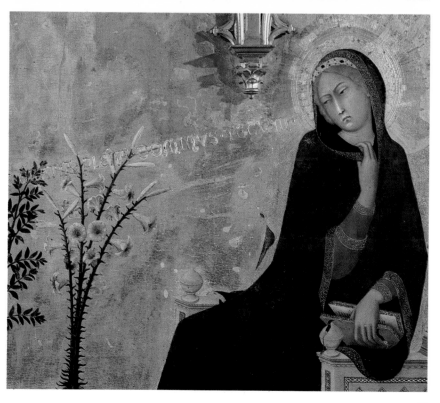

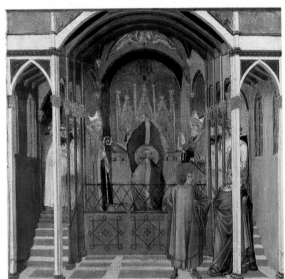

Ambrogio Lorenzetti: Four Stories from the Life of Saint Nicholas

Ambrogio Lorenzetti was undoubtedly the Sienese painter who most benefited from Giotto's lesson. His works at the Uffizi are emblematic of his activity in Florence, which began in the 1320s. They are the four *Stories of Saint Nicholas*, small but exquisite exercises in perspective, the *Madonna and Child with Saints Nicholas and Proculus*, very Florentine in its depiction of spatial depth but Sienese in its use of colour, and the extraordinary *Presentation in the Temple*.

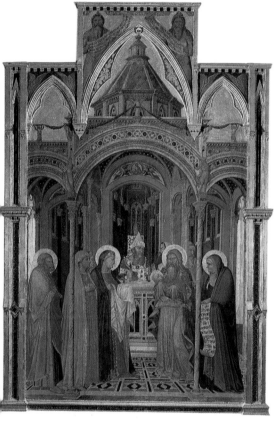

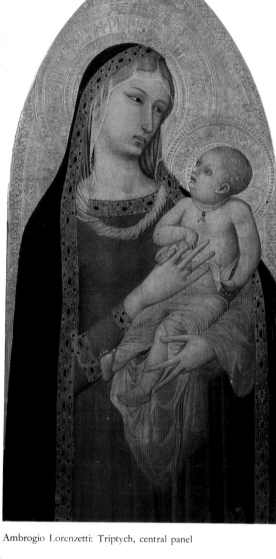

Ambrogio Lorenzetti: Presentation in the Temple

Ambrogio Lorenzetti: Triptych, central panel

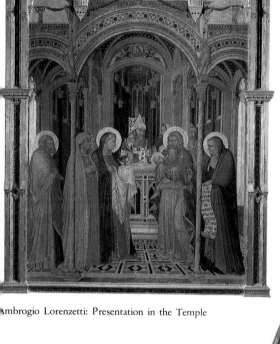

Ambrogio Lorenzetti: Triptych,
Madonna and Child with Saints
Nicholas and Proculus

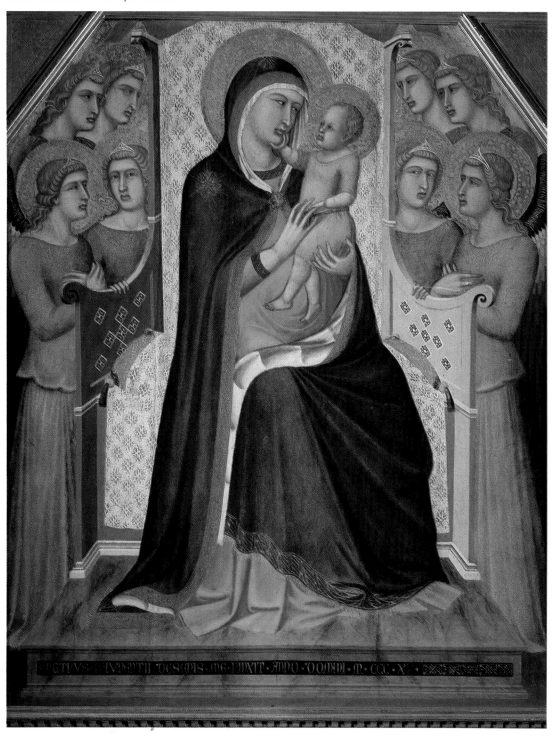

Pietro Lorenzetti: Madonna and Child with Angels

Pietro, Ambrogio's older brother, is documented as a painter from 1306. The Gallery possesses two important works dating from the early 1340s: the *Madonna and Child with Angels*, from Pistoia, and the *Altarpiece of the Blessed Umiltà*, painted for the Vallombrosian nuns in Florence and which shows, next to the solemn figure of the saint, a series of narrative and anecdotal scenes, similar in mood to Ambrogio's contemporary *Stories of Saint Nicholas*.

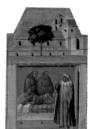

Pietro Lorenzetti: Beata Umiltà Altarpiece

ROOM 4
Florentine Painting of the 14th Century

Here, although the architecture is stylistically similar to that of the preceding room, and although the period is still the 14th century, one returns to a Florentine style and culture, strikingly marked by the influence of Giotto. Among the earliest works that show the innovations brought about by Giotto's ideas is the missal-cover of *Saint Cecilia*, by an artist called, for lack of information as to his full identity, merely the Saint Cecilia Master. This artist was probably one of Giotto's assistants from his Assisi period. The Saint is enthroned in the centre of the painting with eight scenes from her life portrayed at the sides. The scenes are all placed in rather spare settings where the study of perspective is evident, a study that although still empirical, nevertheless is quite advanced in its way and bears witness to one of the most revolutionary lessons taught by Giotto. There is also evidence of the lasting effect of this tradition — although half a century has passed — in the graceful architecture that surrounds the monumental *Saint Matthew*, against a gold

background, in the triptych of the sam name; it was painted by the brothers Andr and Jacopo di Cione (*c* 1367/70) for t church of Orsanmichele. A recent resoratic allows us to examine the work as it was o ginally, conceived to be placed around t perimeter of a column in the church. Near and attesting to the importance and extrac dinary spread of Giotto's influence, is t nearly contemporary, now dismembered, *I lyptych of Ognissanti* by Giovanni da Milano Lombard artist who worked in Floren creating a style consisting of Florentine ai Sienese elements blended with his nati Northern style. His influence is most mark in the lyrical *Pietà* of San Remigio, attribut to Giottino. This painting whose naturalis touches — the contemporary robe of t donor, so accurately detailed, or the flow blood still visible on the cross — blend ma vellously with the abstract gold backgrour creates a uniform and solemn stage in whi the characters play out the mournful dran of the lamentation over the body of Christ.

Giovanni da Milano
(Como *c* 1325–after 1369)
Ognissanti Polyptych
Tempera on wood, 132x39 (each panel), 49x39 (each scene)
Inv. 1890, 459
Painted for the high altar of the church of Ognissanti around 1360 or immediately afterwards. At the Uffizi since 1861.

Andrea di Cione called Orcagna
(Florence *c* 1320–1368)
and **Jacopo di Cione**
(Florence *c* 1330–1398)
Saint Matthew and Stories from his Life
Tempera on wood, 291x265
Inv. 1890, 3163
Begun by Andrea in 1367 for the church of Orsanmichele and finished by his brother Jacopo. At the Uffizi since 1899.

Bernardo Daddi
(Florence *c* 1290–1348)
San Pancrazio Polyptych

Tempera on wood, 165x85 (central panel), 127x42 (each side panel), 31x17 (each cusp panel), 50x38 (each predella panel), diam. 20 (each roundel)
Inv. 1890, 8345
Painted between 1335 and 1340 for the church of San Pancrazio and later dismembered. At the Uffizi since 1919.

Giottino
(Florence 1320s–after 1369)
Pietà
Tempera on wood, 195x134
Inv. 1890, 454
Painted between 1360 and 1365 for the church of San Remigio. At the Uffizi since 1851.

Taddeo Gaddi
(Florence *c* 1300–1366)
Madona and Child Enthroned
Tempera on wood, 154x80
Inv. Dep. 3
Signed and dated 1355, it was painted for Giovanni Segni whose family coat-of-arms

appears on the base of the throne. At the Uffizi since 1914.

Nardo di Cione
(Florence *c* 1320–1365/6)
Crucifixion
Tempera on wood, 145x71
Inv. 1890, 3515
Of unknown provenance, the painting was in the Accademia in 1842. At the Uffizi since 1948.

Bernardo Daddi
Madonna and Child with Saints Matthew and Nicholas
Tempera on wood, 144x194
Inv. 1890, 3073
Signed and dated 1328, the triptych was painted for the monastery of Ognissanti. At the Uffizi since 1871.

Bernardo Daddi
Madonna and Child Enthroned
Tempera on wood, 56x26
Inv. 1890, 8564
The painting is signed and originally was also dated

(1334). At the Uffizi since 1948.

Jacopo del Casentino
(*c* 1290–Florence after 1358)
Small Triptych
Tempera on wood, 39x42
Inv. 1890, 9528
It is the only painting signed Jacopo del Casentino and is therefore very important in terms of the reconstruction o the artist's work. At the Uffiz since 1948.

Saint Cecilia Master
(active in Florence *c* 1300–1320)
Saint Cecilia and Eight Stories fr her Life
Tempera on wood, 85x181
Inv. 1890, 449
This altar frontal, from the church of Santa Cecilia, is to generally dated shortly after 1304; it is the work of an anonymous master who may have worked with Giotto at Assisi. At the Uffizi since 18

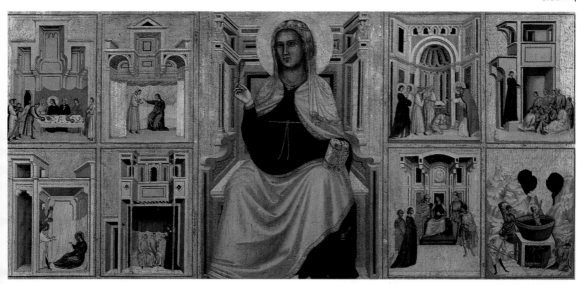

Saint Cecilia Master: Altar frontal

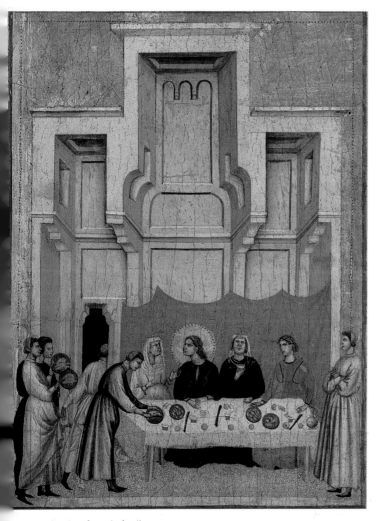

Saint Cecilia altar frontal, detail

Bernardo Daddi: San Pancrazio Polyptych, detail

Giovanni da Milano:
Ognissanti Polyptych

◁
Orcagna: Saint Matthew
and Stories from his Life

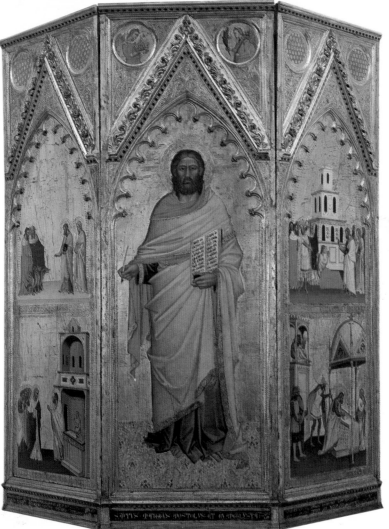

▷
Giottino: Pietà

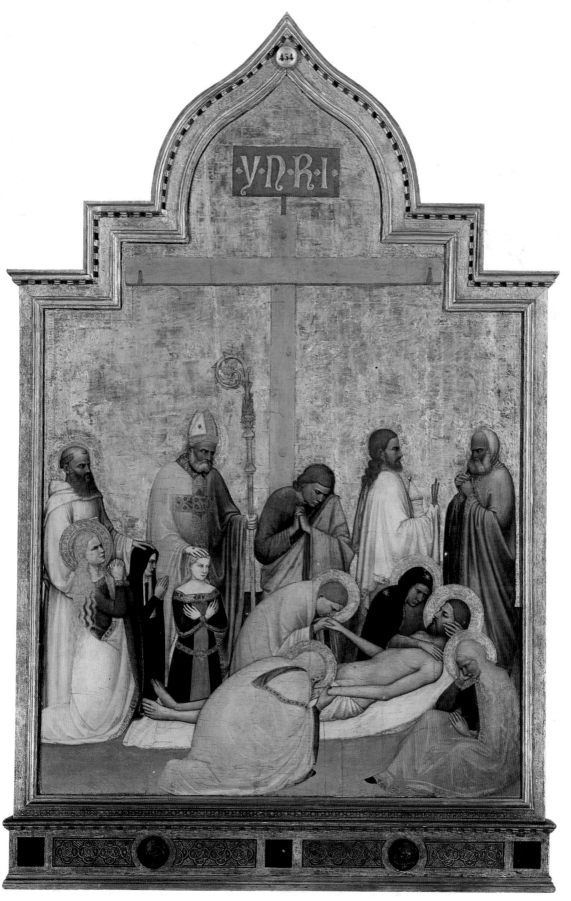

International Gothic

In this room, where the light is spread uniformly from a huge hooded skylight, are gathered works reaching the highest level of the style known to art historians as International Gothic. This style, in reality, is no more than an extension of a period whose ideas and styles are still Gothic, albeit a Gothic more animated and embellished than usual, but where the awareness of Humanist values is already apparent. An excellent example of this is the glittering *Adoration of the Magi* by Gentile da Fabriano (1423), commissioned for the family chapel in Santa Trinita by Palla Strozzi, who although a Humanist, and a well informed, up-to-date one, at the same time was loath to loose the beauties of a style that had by then reached its peak. In this, as in other works of the period, the painters consciously avoided the new ideas brought forth by the Florentines in their revolutionary re-appraisal of the classical world, a re-evaluation that offered a model for new life styles as well. This fact is well illustrated by the paintings in this room. It hardly seems possible that the *Adoration* was painted in the same city where Brun-

elleschi was elaborating his new theories an where Masaccio was putting them into prac tice. Here, Gentile ignores dimensions an proportions, and seems not to care about th laws of perspective; he places his figures i layers, without any concern for spatial dept These characteristics appear to be even mo strongly emphasized in the imposing *Coron tion of the Virgin* by Lorenzo Monaco, painte ten years earlier for the church of Santa M ria degli Angioli, with its striking curvin lines in the clothing of the tall, bending f gures and the use of gold, which makes splendid backdrop for the delicate colours the clothing of the saints. A similar styl although highlighted by several innovativ touches, can be found in the *Tebaide*, genera ly attributed to Starnina, which has had othe prestigious attributions in the past (F Angelico and Paolo Uccello, for example This animated story — lively, excited at time — of hermits scattered over rough, hars landscapes, among improbable buildings an impervious caverns, recounts a fable that traditional only in appearance, showing as does a new sense of space and of colour.

Lorenzo Monaco
(Siena ? c 1370–Florence c 1425)
and **Cosimo Rosselli**
(Florence 1439–1507)
Tempera on wood, 115x70
Inv. 1890, 466
Painted around 1421/2 for the church of Sant'Egidio; Cosimo Rosselli added the Prophets and the Annunciation in the second half of the century. At the Uffizi since 1844.

Giovanni di Paolo
(Siena 1403–1482)
Madonna and Child with Saints
Tempera on wood, 247x212
Inv. 1890, 3255
Signed and dated 1445.
Originally (since 1904) at the Uffizi, it was transferred to the Pitti in 1954. In 1955 it returned to the Uffizi.

Agnolo Gaddi
(Florence c 1350–1396)
Crucifixion
Tempera on wood, 59x77
Inv. 1890, 464
The panel was part of a

dismembered polyptych, perhaps the one that Agnolo painted for San Miniato al Monte or a similar one. At the Uffizi since 1860.

Unknown Artist from Northern Italy
(first half of the 15th century)
Saint Benedict Repairs the Nurse's Tray
Tempera on wood, 108x62
Inv. 1890, 9405
Two other panels of the same series are exhibited in this room. The unknown artist has been variously identified with Gentile da Fabriano, Pisanello and Wenceslas of Bohemia. At the Uffizi since 1937.

Gentile da Fabriano
(Fabriano c 1370–Rome 1427)
Adoration of the Magi
Tempera on wood, 300x283 (overall, including frame), 173x228 (central panel only)
Inv. 1890, 8364
Signed and dated 1423, it was painted for Palla Strozzi's chapel in Santa Trinita. The

scene showing the Presentation in the Temple in the predella is a copy, since the original is in the Louvre. At the Uffizi since 1919.

Gentile da Fabriano
Four Saints from the Quaratesi Polyptych
Tempera on wood, 200x60 (each panel)
Inv. 1890, 887
Gentile painted the polyptych, now dismembered, during his Florentine period (1422/5) for the Quaratesi chapel in San Niccolò Oltrarno. The other parts are now in London, Rome and Washington. At the Uffizi since 1863.

Lorenzo Monaco
Coronation of the Virgin
Tempera on wood, 450x350
Inv. 1890, 885
Signed and dated 1413 (1414 in the modern calendar), it was painted for the church of the Convento degli Angioli. At the Uffizi since 1866.

Unknown Artist from Northern Italy
Saint Benedict Exorcizes a Monk
Tempera on wood, 111x66
Inv. 1890, 9403
See above, same artist.

Florentine Master
(first quarter of the 15th century)
Thebaid
Tempera on wood, 80x216
Inv. 1890, 447
This extraordinary painting ha been attributed to various artists; the traditional attribution is to Starnina. It arrived at the Uffizi the first time in 1780, but it only became a permanent exhibit in 1948.

Unknown Artist from Northern Italy
Saint Benedict Blesses the Poisoned Wine
Tempera on wood, 109x62
Inv. 1890, 9404
See above, same artist.

Florentine Master: Thebaid

Lorenzo Monaco: Adoration of the Magi

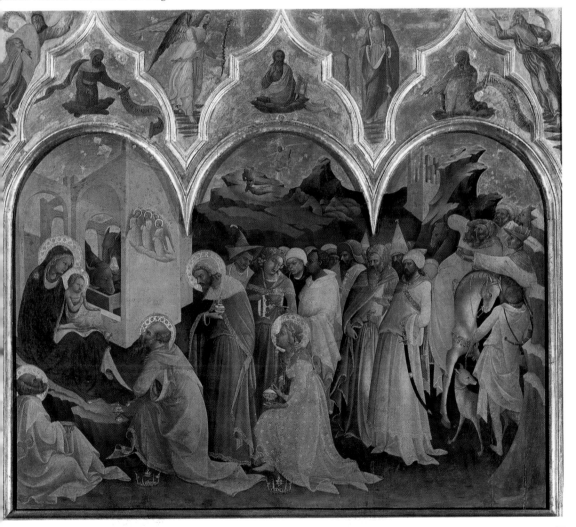

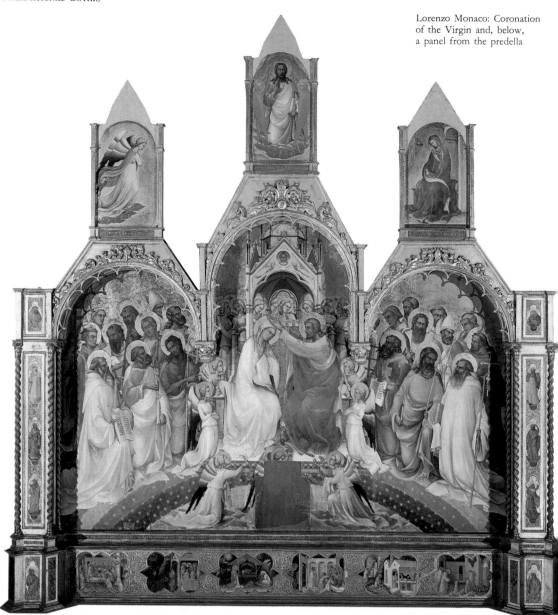

Lorenzo Monaco: Coronation of the Virgin and, below, a panel from the predella

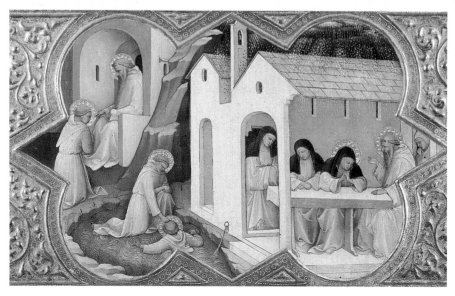

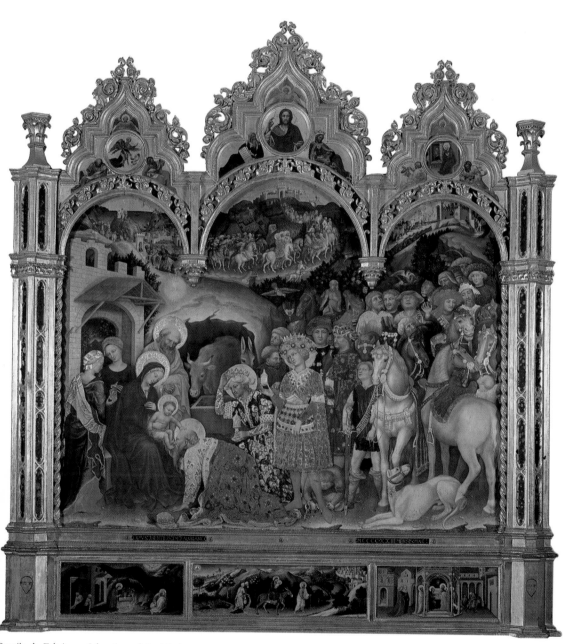

Gentile da Fabriano: Adoration of the Magi

Room 7
The Early Renaissance

The brief description of the paintings in the preceding room provides an introduction to what is to be seen here: the works most representative of the new cultural movement, to be distinguished from other early 15th-century works that are still bound, however tenuously, to the Gothic style. The new Humanist values, the passionate admiration and emulation of classical antiquity, the search for spatial perspective using the laws of mathematics, the practice of placing figures in correct proportion to their surroundings – all these new theories are clearly shown in the paintings in this room. The paintings here, all of them very famous, cover the period from the mid-1420s to the 1460s, that is to say from the *Madonna and Child with Saint Anne*, painted by both Masolino and the younger, more innovative Masaccio, to the celebrated diptych of the *Duke and Duchess of Urbino* by Piero della Francesca. In the former it is interesting to distinguish between the painters: Masolino, whose graceful style is filled with echoes of past traditions, is responsible for the figure of Saint Anne and all the angels except the upper righthand one; Masaccio, on the other hand, with his enthusiasm for the new ideas regarding the importance of the third dimension and the proper

use of perspective, is responsible for the Madonna and Child, as well as the angel in the glittering green robe.

Again and again, one returns to the study and use of perspective when discussing the values and ideals of the new movement. Here in this room are two works which especially reflect the fervour with which contemporary painters sought to solve the problems of spatial organization: the *Santa Lucia dei Magnoli Altarpiece* by Domenico Veneziano so delicate in the colours of the elegant architecture, so rigorous in the imposition of geometrical rules – and the *Battle of San Romano*, painted by Paolo Uccello who was almost obsessed by the study of perspective foreshortening. He somehow managed to capture these horses and their riders in the most daring and difficult poses, within the limited space of this painting, which was commissioned for the bedroom of Lorenzo de' Medici. No less filled with innovations are the two works by Fra Angelico, the mystic painter of transcendental visions, who nevertheless accepted and championed the new ideas, although in a personal way, incorporating the new developments in his work without, however, making a complete break with the past.

Paolo Uccello
(Florence 1397–1475)
The Battle of San Romano
Tempera on wood, 182x220
Inv. 1890, 479
Dating from around 1456, the painting is one of three on the same subject (the others are in the National Gallery, London and at the Louvre) that hung in Lorenzo the Magnificent's bedroom in the Medici's town palace. At the Uffizi since the second half of the 18th century.

Piero della Francesca
(Borgo San Sepolcro 1410/20–1492)
The Duke and Duchess of Urbino
Tempera on wood, 47x33 (each panel)

Inv. 1890, 1615
On the front the two panels show profile portraits of Federico da Montefeltro, Duke of Urbino, and his wife, Battista Sforza. The reverse shows allegorical representations of their virtues. To be dated around 1465/70. At the Uffizi since 1773.

Masolino
(San Giovanni Valdarno 1383?–1440)
and **Masaccio**
(San Giovanni Valdarno 1401–Rome 1428)
Madonna and Child with Saint Anne
Tempera on wood, 175x103
Inv. 1890, 8386

Painted probably around 1424 for the church of Sant'Ambrogio. Masolino painted Saint Anne and all the angels except for the top righthand one, painted by Masaccio who is also responsible for the Madonna and Child. At the Uffizi since 1919.

Domenico Veneziano
(Venice *c* 1400–Florence 1461)
Santa Lucia dei Magnoli Altarpiece
Tempera on wood, 209x216
Inv. 1890, 884
Painted around 1445 for the church of Santa Lucia dei Magnoli; the predella panels are in several museums outside Italy. At the Uffizi since 1862.

Fra Angelico
(Vicchio di Mugello
c 1400–Rome 1455)
Madonna and Child
Tempera on wood, 134x59
Inv. Dep. 143
It is probably the central part of a polyptych; at the bottom, part of the inscription recording the names of the patrons. At the Uffizi since 1949.

Fra Angelico
Coronation of the Virgin
Tempera on wood, 112x114
Inv. 1890, 1612
Painted around 1435, it was mentioned by Vasari in his description of Sant'Egidio. At the Uffizi since 1948.

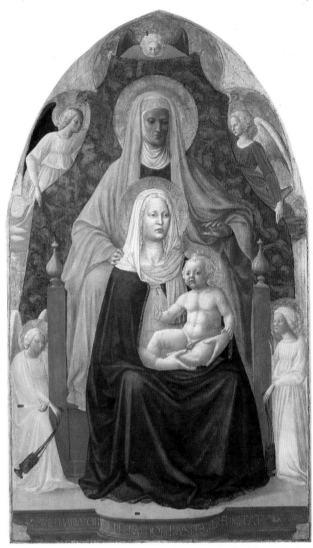

Masolino and Masaccio: Madonna and Child
with Saint Anne

Paolo Uccello: The Battle
of San Romano

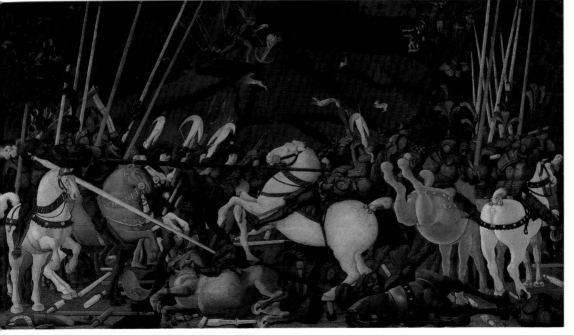

◁
Fra Angelico:
Coronation of the Virgin

▽
Fra Angelico:
Madonna and Child

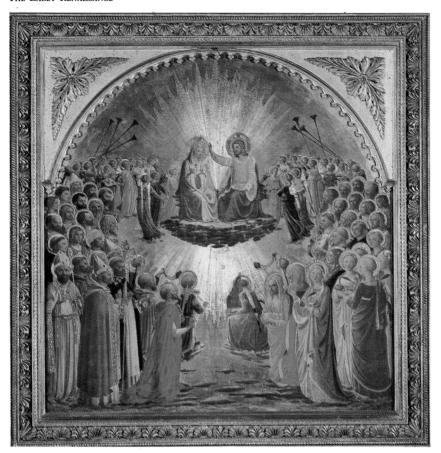

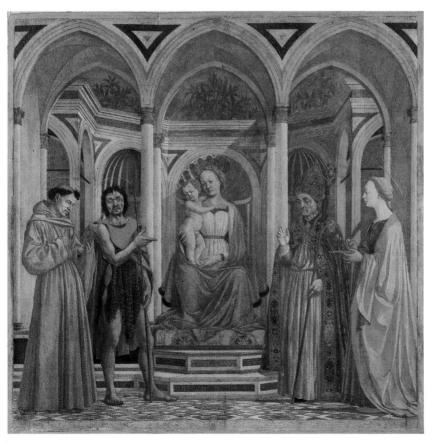

Domenico Veneziano:
Santa Lucia dei Magnoli
Altarpiece

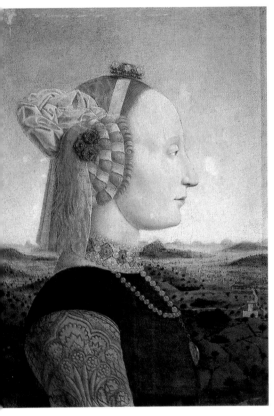
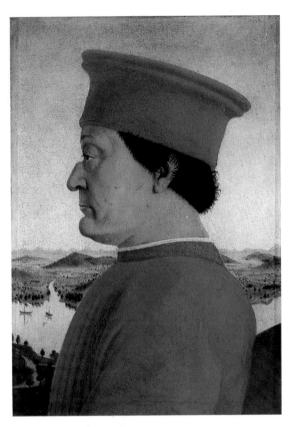

Piero della Francesca: The Duke and Duchess of Urbino, recto

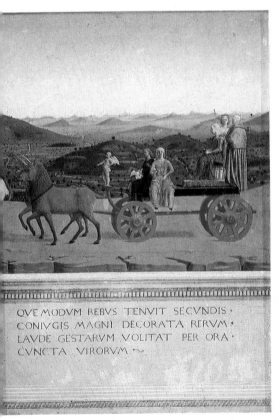
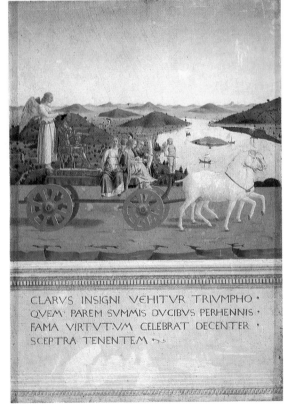

QVE MODVM REBVS TENVIT SECVNDIS ·
CONIVGIS MAGNI DECORATA RERVM ·
LAVDE GESTARVM VOLITAT PER ORA ·
CVNCTA VIRORVM

CLARVS INSIGNI VEHITVR TRIVMPHO ·
QVEM PAREM SVMMIS DVCIBVS PERHENNIS ·
FAMA VIRTVTVM CELEBRAT DECENTER ·
SCEPTRA TENENTEM

Piero della Francesca: The Duke and Duchess of Urbino, verso

This room was added to the Gallery when it was modernized around the turn of the century. The room, as it is today, inaugurated in 1973, has been conceived to harmonize with the surrounding rooms designed by Michelucci, Scarpa and Gardella. Here, following the pattern of the adjacent room of 13th-century painting, white walls and the simple beamed ceiling with its three massive centre beams create a solemn austerity. The resemblance to a church nave suits the paintings shown here, as they were, for the most part, conceived as altarpieces; one is actually placed in a recess of the upper wall on a pietra serena base which simulates an altar.

The paintings in this room date from the middle decades of the 15th century (except for the slightly later *Coronation of the Virgin* by Botticelli), and are all Florentine, except for two done by Sienese artists who were in close touch with Florentine artistic events: a *Madonna and Child with Saints* by Vecchietta, who probably studied in Florence as his first known work was with Masolino on the frescoes at Castiglione Olona, and a *Madonna and Child* by Matteo di Giovanni, a painter strongly influenced by the stylistic elements found in the work of the Pollaiolo brothers. The most conspicuous paintings in the room, both in number and in quality, are those by Filippo Lippi. A Carmelite monk, Lippi grew to maturity both as an artist and a man in the monastery adjacent to the church of the Carmine, which he entered as a child because of family misfortunes. It was here that he saw Masaccio at work in the Brancacci Chapel and began, during his daily visits, to learn to draw and paint from that extraordinary master. His were not the routine, perfunctory visits made by all the young painters, but as Vasari says, "Filippo was by far the most advanced of all the others in ability and knowledge." A famous letter of Domenico Veneziano's, written to Piero de Medici requesting an important commission mentions as examples of "bon maestr (great masters) Filippo Lippi and Fra Angelico. Lippi, he says, is at work on a painting for the church of Santo Spirito which wi keep him occupied for five years as it is suc an important commission; it was the altar piece for the Barbadori chapel, today in th Louvre. The predella, however, is in the U fizi. Domenico was pessimistic as to the tim needed to finish the painting for Lippi soo afterwards signed several other contracts, in cluding the one for the magnificent *Corona tion of the Virgin*. This painting, recentl cleaned and restored to its pure and exquisit colours, must be considered one of the pain er's masterpieces. Here one can see what h learned from Masaccio, as well as the lesson learned from his contact with Luca dell Robbia, whose influence is shown in th classical purity, the sculptural lines and th use of the third dimension that so character ize Luca's art. Nor did Filippo's admiratio for the great sculptor diminish with time: i the justly celebrated *Madonna and Child wit Two Angels*, a late work, he harks back t Luca in the delicate profile of the Madonna with that fragile, slightly curved outline an in the round face of the Child which seems t be taken directly from an ancient coin. It wa under this influence that the young Botticel li, Lippi's pupil, began his career as can b seen in the charming and delicate *Madonna the Rosegarden*.

Botticelli's extraordinary *Coronation of th Virgin* is also in this room. Painted for th church of San Marco, some twenty year later than the *Madonna of the Rosegarden*, it ha been placed here to take advantage of th vast wall space which allows the visitor to admire the power and monumentality of th work.

[F]ippo Lippi
([F]lorence *c* 1406–Spoleto 1469)
[Ad]oration of the Child with Saints
[Te]mpera on wood, 140x130
[Inv]. 1890, 8353
[Co]mmissioned by Lucrezia
[Tor]nabuoni for a cell in the
[her]mitage of Camaldoli, built
[by] her husband Piero de'
[Me]dici in 1463. At the Uffizi
[sin]ce 1919.

[F]ippo Lippi
*[Ad]oration of the Child with Saints
[Jos]eph, Jerome, Mary Magdalen and
[H]arion*
[Te]mpera on wood, 137x134
[In]v. 1890, 8350
[Pa]inted around 1455 for the
[Co]nvent of Annalena. At the
[Uf]fizi since 1919.

[Ba]rtolomeo di Giovanni
([ac]tive in Florence late
[15]th–early 16th century)
[Sa]int Benedict Performs a Miracle
[Te]mpera on wood, 32x30
[In]v. 1890, 3154
[Th]is panel, together with the
[fol]lowing one, was part of a
[pr]edella in the hospital of Santa
[M]aria Nuova. At the Uffizi
[sin]ce 1900.

[Ba]rtolomeo di Giovanni
[Sai]nt Benedict Performs a Miracle
[Te]mpera on wood, 32x31,5
[In]v. 1890, 1502
[se]e previous entry. At the
[Uf]fizi since 1825.

[Pa]olo Uccello
([F]lorence 1397–1475)
*[N]ativity and Annunciation to the
[Sh]epherds*
[Sin]opia, 140x215
[In]v. w.n.
[Th]is is the sinopia of a fresco
[pa]inted around 1446 in a
[lu]nette of the cloister of the
[ho]spital of San Martino alla
[Sc]ala. At the Uffizi since 1982.

Sandro Filipepi called Botticelli
(Florence 1445–1510)
Coronation of the Virgin
Tempera on wood, 378x258
Inv. 1890, 8362
The altarpiece was originally in
the chapel of Sant'Alò in the
church of San Marco; it was
commissioned by the Guild of
Goldsmiths and was painted
between 1488 and 1490. At the
Uffizi since 1919.

Filippo Lippi
Madonna and Child with two Angels
Tempera on wood, 95x62
Inv. 1890, 1598
Painted sometime between
1455 and 1466; from the Villa
of Poggio Imperiale. At the
Uffizi since 1796.

Sandro Botticelli
Madonna of the Rosegarden
Tempera on wood, 124x64
Inv. 1890, 1601
Probably commissioned by the
Guild of 'Mercatanzia' or by the
Wool Merchants; painted
around 1470. At the Uffizi
since 1782.

Paolo Uccello
Nativity and Annunciation to the Shepherds
Fresco, 140x215
Inv. Dep. 314
See above, entry for sinopia of
this fresco. At the Uffizi since
1973.

Lorenzo di Pietro called Vecchietta
(Siena 1410–1480)
Madonna and Saints
Tempera on wood, 156x230
Inv. 1890, 474
Signed and dated 1457; it was
commissioned by Giacomo
d'Andreuccio, a silk merchant,
and comes from the chapel of
the Monselvoli Villa, belonging

to the Petrucci family who gave
it to the Grand Duke of
Tuscany in 1798. The Grand
Duke donated it to the Uffizi.

Matteo di Giovanni
(Sansepolcro *c* 1430–Siena
1495)
*Madonna and Child with two Saints
and two Angels*
Tempera on wood, 64x48
Inv. 1890, 3949
From the Oratory of the Selva
contrada in Siena. At the Uffizi
since 1915.

Above the door leading to the
corridor:

Nicolas Froment
(Uzes *c* 1435–Avignon *c* 1483)
Resurrection of Lazarus
Tempera on wood, 175x200
Inv. 1890, 1065
Signed and dated 1461;
presented to the monastery of
Bosco ai Frati in the Mugello by
Cosimo the Elder who had
received it as a gift from
Francesco Coppini, the Papal
Legate in Flanders. At the
Uffizi since 1841.

Filippo Lippi
*Annunciation, Saint Anthony
Abbot and Saint John the Baptist*
Tempera on wood, 57x24 (each
panel)
Inv. 1890, 8356-7
Part of a polyptych of unknown
origin; exhibited at the
Accademia and transferred to
the Uffizi in 1919.

Filippo Lippi
Coronation of the Virgin
Tempera on wood, 220x287
Inv. 1890, 8352
Commissioned for
Sant'Ambrogio in 1441 and
paid for in 1447; contains both
a self-portrait and a portrait of
the patron. At the Uffizi since
1919.

Alessio Baldovinetti
(Florence 1425–1499)
Madonna and Child with Saints
Tempera on wood, 176x166
Inv. 1890, 487
Painted for the Medici Villa of
Cafaggiolo around 1455. At the
Uffizi since 1796.

Filippo Lippi
*Madonna and Child with Four
Saints*
Tempera on wood, 196x196
Inv. 1890, 8354
Painted in the early 1440s for
the chapel of the Novitiate in
Santa Croce. At the Uffizi since
1919.

Below:
**Francesco di Stefano called
Pesellino**
(Florence 1422–1457)
Predella with Stories of Saints
Tempera on wood, 32x144
Inv. 1890, 8355
It is the predella of the
altarpiece above. Two of the
five panels are copies, since the
originals (*Saint Francis receives the
Stigmata* and *Saints Cosma and
Damian heal an invalid*) are now
in Paris. At the Uffizi since
1919.

Alessio Baldovinetti
Annunciation
Tempera on wood, 167x137
Inv. 1890, 483
Probably painted in 1457 for
the Salvestrine friars of San
Giorgio alla Costa. At the Uffizi
since 1868.

Filippo Lippi
*Predella of the Barbadori
Altarpiece*
Tempera on wood, 40x235
Inv. 1890, 8351
The Barbadori Altarpiece,
commissioned in 1437, was
originally in Santo Spirito and is
today in the Louvre. At the
Uffizi since 1819.

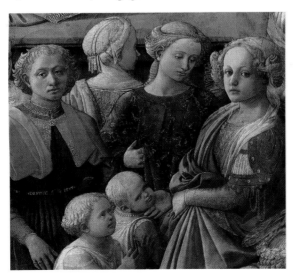

[F]ilippo Lippi: Coronation
[o]f the Virgin, detail

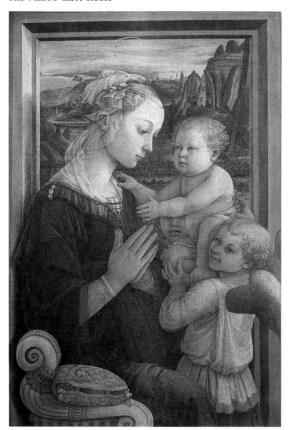

Filippo Lippi: Madonna and Child with Angels

▽
Filippo Lippi: Madonna and
Child with Four Saints

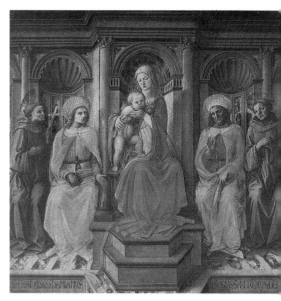

Filippo Lippi: Coronation of the Virgin

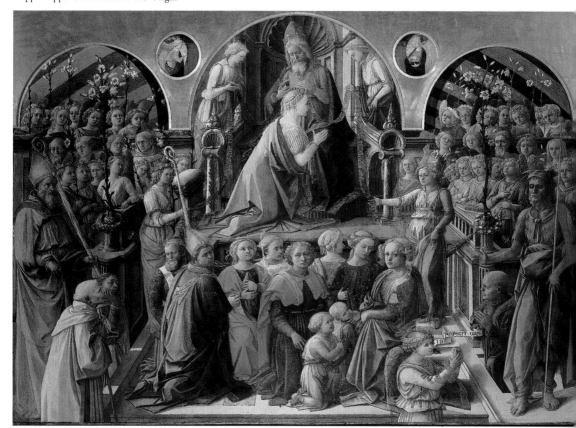

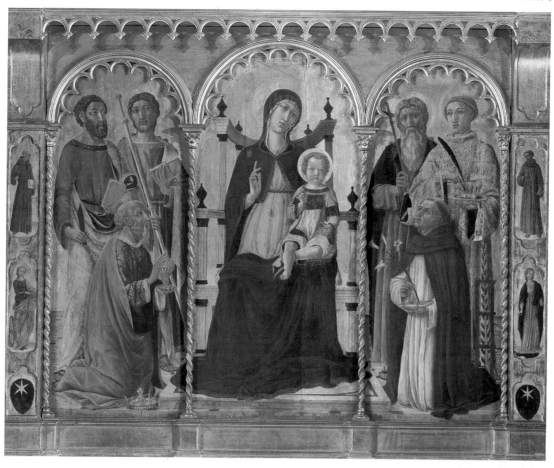

Vecchietta: Madonna and Saints

▷

Alessio Baldovinetti: Annunciation

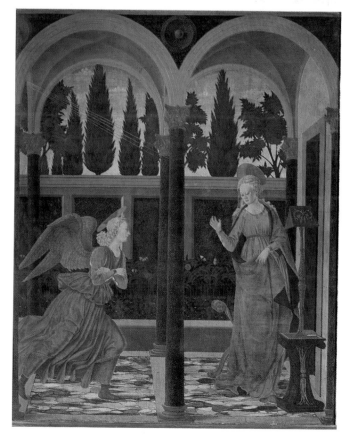

ROOM 9
The Antonio Pollaiolo Room

This room – the last in the group designed by Michelucci – houses primarily paintings by the brothers Antonio and Piero Pollaiolo that clearly document the liveliness of the artistic world of the 1460s in Florence. It is not by chance that the room is named for Antonio, although there are twice as many paintings of Piero's here, for it was Antonio, the versatile artist – painter, sculptor, goldsmith, designer, engraver – who best expressed the growing interest in the realism of motion shown in accentuated linearity. The figures are drawn with strong, rapid strokes, the muscles and sinews are tense and taut, the outlines of the profiles are sharp. These are the qualities that distinguish him from his brother Piero, who preferred to create his paintings by the modelling of light and colour, although he, too, concentrated on the drawing of figures and compositions.

Antonio's new artistic vision, a vision that influenced a great many Florentine painters of the second half of the 15th century, is shown here in two dramatic paintings of the *Labours of Hercules* and an elegant *Portrait of a Lady.* The works show the influence of Antonio's skills as sculptor and goldsmith on his work as a painter: the former in the sculptural quality of the taut bodies, the latter in the meticulous attention to the sitter's clothing and jewels.

Piero's style is documented here by, among others, the paintings of the six Cardinal Virtues for the Sala del Consiglio of the Mercatanzia (the seventh, *Fortitude*, is by Botticelli) and the altarpiece for the Cardinal of Portugal's Chapel in the church of San Miniato al Monte. Antonio must have had some part in this painting, at least in the design. It is also of interest in this painting to notice the concern for magnificence and outward signs of wealth that was prevalent in Florence at the time. Finally, as a prelude to the next room, the visitor can see here three early works by Botticelli. Beside the already mentioned *Fortitude*, there are two paintings of the story of Judith and Holophernes that still show the influence of Filippo Lippi's workshop, although it is already clear that Botticelli has developed a style of his own.

Piero Benci called Pollaiolo
(Florence *c* 1443–Rome 1496)
Portrait of Galeazzo Maria Sforza
Tempera on wood, 65x42
Inv. 1890, 1492
Painted in 1471, it hung in one of Lorenzo the Magnificent's ground floor rooms in Palazzo Medici. In 1880 it was discovered in the warehouses of the Royal Galleries and transferred to the Uffizi.

Antonio Benci
(Florence *c* 1431–Rome 1498)
and **Piero Benci called the Pollaiolo brothers**
Saints James, Vincent and Eustace
Tempera on wood, 172x179
Inv. 1890, 1617
Painted in 1466/7 for the chapel of the Cardinal of Portugal in San Miniato al Monte. At the Uffizi since 1800.

Lorenzo di Credi, attr. to
(Florence *c* 1459–1537)
Portrait of a Young Man
Attributed to various artists among whom Filippino Lippi.

From the collection of Cardinal Leopoldo de' Medici. At the Uffizi since 1861.

Antonio Pollaiolo
Portrait of a Lady
Tempera on wood, 55x34
Inv. 1890, 1491
Painted around 1475, this portrait has also had many attributions. At the Uffizi since 1861.

Sandro Filipepi called Botticelli
(Florence 1445–1510)
The Discovery of the Body of Holophernes
Tempera on wood, 31x25
Inv. 1890, 1487
Painted, together with the following small panel, around 1470. They were presented to Bianca Cappello by Rodolfo Sirigatti. At the Uffizi since 1632.

Sandro Botticelli
The Return of Judith
Tempera on wood, 31x24
Inv. 1890, 1484

See previous entry.

Antonio Pollaiolo
Hercules and the Hydra
Tempera on wood, 17x12
Inv. 1890, 8268
This small painting and the following one are autograph copies, in reduced scale, of the large canvases that Antonio painted for Palazzo Medici around 1460. Only recently rediscovered, they have been at the Uffizi since 1975.

Antonio Pollaiolo
Hercules and Antaeus
Tempera on wood, 16x9
Inv. 1890, 1478
See previous entry.

Above:

Tuscan 15th-century Master
Marsyas
Bronze, height 30
Inv. Bargello Bronzes 89
At the Uffizi since 1977.

Jacopo del Sellaio
(Florence 1442–1493)

Ahasuerus's Banquet
Tempera on wood, 45x63
Inv. 1890, 491
Together with two other panels it was part of the decoration of a "cassone" or wedding chest. At the Uffizi since 1781.

Sandro Botticelli
Fortitude
Tempera on wood, 167x87
Inv. 1890, 1606
Commissioned by the Guild of "Mercatanzia" in 1470 for the Council Hall; the other six Virtues were painted by Piero Pollaiolo. At the Uffizi since 1861.

Piero Pollaiolo
Temperance
Tempera on wood, 167x88
Inv. 1890, 497
One of the six Virtues that Piero painted for the Guild of "Mercatanzia." Except for *Charity*, which was painted in 1469, the others were all painted around 1470. All six at the Uffizi since 1717.

onio Pollaiolo:
trait of a Lady

ro and Antonio Pollaiolo: Saints
es, Vincent and Eustace

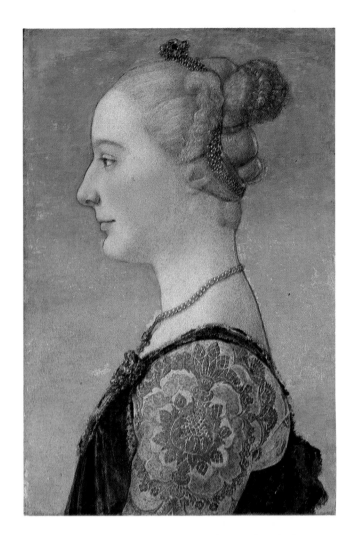

ero **Pollaiolo**
idence
mpera on wood, 167x88
. 1890, 1610
e previous entry.

ero **Pollaiolo**
tice
mpera on wood, 167x88
v. 1890, 496
e above.

ero **Pollaiolo**
ith
mpera on wood, 167x88
v. 1890, 498
e above.

ero **Pollaiolo**
pe
mpera on wood, 167x88
v. 1890, 495
e above.

ero **Pollaiolo**
harity
mpera on wood, 167x88
v. 1890, 499
e above.

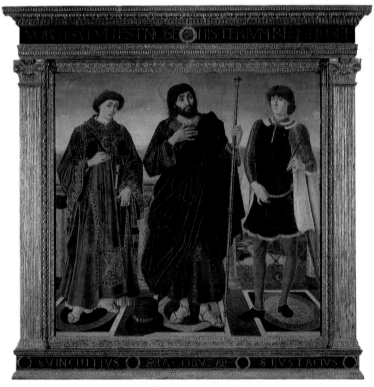

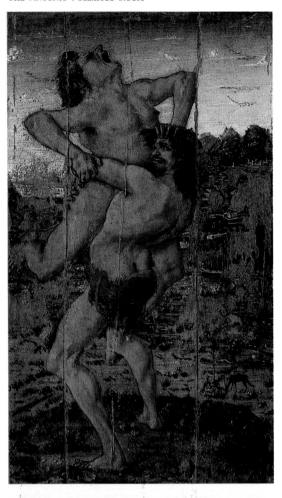

◁
Antonio Pollaiolo: Hercules and Antaeus

▽
Antonio Pollaiolo: Hercules and the Hydra

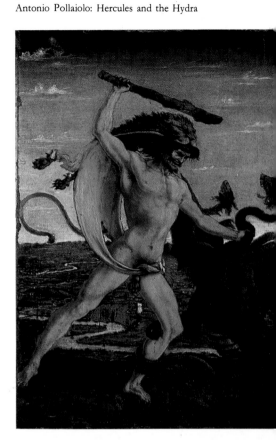

Sandro Botticelli: The Discovery of the Body of Holophernes

Sandro Botticelli: The Return of Judith

Piero Pollaiolo: Temperance

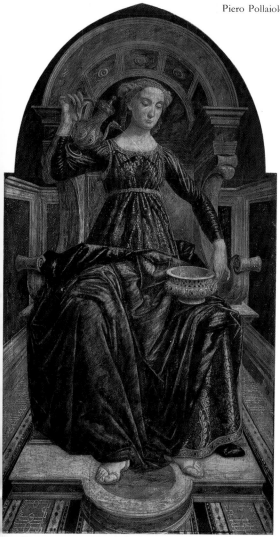

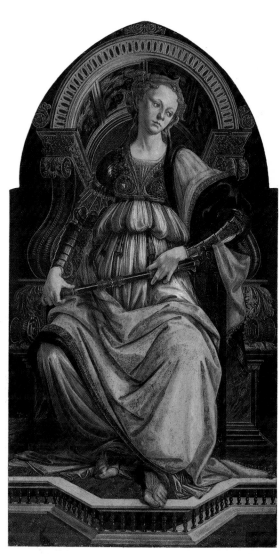

Sandro Botticelli: Fortitude

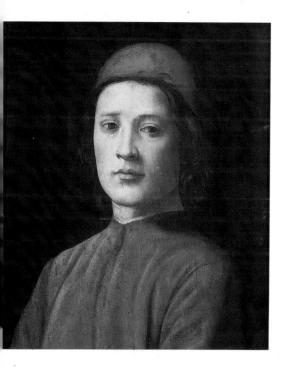

Lorenzo di Credi: Portrait of a Young Man

The Botticelli Room, inaugurated in its present form in 1978, was created in 1943 by dividing a section of the Medici Theatre horizontally. In the years immediately following the Second World War, this space was set aside to house large altarpieces by Perugino, Filippo Lippi and Signorelli. Then, during the re-organization of the Uffizi in the 1950s, based as mentioned above on chronological criteria, Botticelli's paintings were placed here for the first time.

The room is named for the most important collection in the world of Botticelli's masterpieces: paintings on religious subjects, such as the *Magnificat Madonna* and the *Madonna of the Pomegranate* or the *Adoration of the Magi*, as well as works dealing with mythological themes, subject to a variety of allegorical interpretations, such as the *Birth of Venus*, *Spring (Primavera)* or *Pallas and the Centaur*. All of these works are strongly tied to the cultivated Medici court of the end of the 15th century, whose ideas found in Botticelli a faithful and subtle interpreter. In the same room, almost as an example of two painters beginning their investigations from an analogous position and finding different solutions, there are also several paintings by Filippino

Lippi, whose early work is so similar to Botticelli's that at one time it was considered the work of an unknown painter, simply called "Sandro's friend." However, two large paintings – the *Signoria Altarpiece* and the *Adoration of the Magi*, painted for the church of San Donato at Scopeto to replace the unfinished *Adoration* by Leonardo – show the gifted master that Filippino became.

A work that demonstrates a greater interest in the observation of nature is the impressive *Portinari Altarpiece* which came to Florence in 1483 from Bruges where Hugo van der Goes painted it. This painting, like many other works by Northern European masters, was responsible for introducing Florentine artists to the characteristics of Flemish culture. In this same room are examples of a painter who felt the Flemish influence very strongly, Ghirlandaio. It is interesting to note, on the other hand, that many Flemish artists were influenced by Italian painters, as can be seen in the *Entombment* by Rogier van der Weyden, which may well have been painted in Florence around 1450. The same subect had been treated in a similar manner in a famous painting by Fra Angelico a few years earlier.

Filippino Lippi
(Prato 1457–Florence 1504)
Allegory
Tempera on wood, 20x22
Inv. 1890, 8378
The interpretation of this small panel, painted sometime between 1485 and 1500, is very difficult: we know only that it refers to family quarrels. At the Uffizi since 1919.

Filippino Lippi
Self-portrait (?)
Fresco on a tile, 50x31
Inv. 1890, 1711
Not all scholars agree that this is Filippino's self-portrait; some even think that it may be much later. At the Uffizi since 1771.

Filippino Lippi
Portrait of an Old Man
Fresco on a tile, 47x38
Inv. 1890, 1485
Like in the case of the previous fresco, there are experts who

doubt the authenticity of this one. At the Uffizi since 1773.

Sandro Filipepi called Botticelli
(Florence 1445-1510)
Magnificat Madonna
Tempera on wood, diam. 118
Inv. 1890, 1609
Painted sometime between 1481 and 1485, the painting gets its title from the book open at the page of the "Magnificat." At the Uffizi since 1785.

Sandro Botticelli
Birth of Venus
Tempera on canvas, 172.5x278.5
Inv. 1890, 878
From the Medici Villa at Castello; painted around 1485 for Giovanni and Lorenzo di Pierfrancesco de' Medici. At the Uffizi since 1815.

Sandro Botticelli

Pallas and the Centaur
Tempera on canvas, 207x148
Inv. Dep. 29
Also painted for Giovanni and Lorenzo di Pierfrancesco de' Medici in the early 1480s. At the Uffizi since 1922.

Sandro Botticelli
Madonna of the Pomegranate
Tempera on wood, diam. 143.5
Inv. 1890, 1607
Painted probably in 1487 for the Audience Hall of the Massai di Camera in Palazzo Vecchio, as is confirmed also by the fleurs-de-lys on the frame. At the Uffizi since 1780.

Sandro Botticelli
Calumny
Tempera on wood, 62x91
Inv. 1890, 1496
Painted around 1495 for Antonio Segni. At the Uffizi since 1773.

Sandro Botticelli
Spring (Primavera)
Tempera on wood, 203x314
Inv. 1890, 8360
Like Botticelli's other allegories, this one was also painted for Giovanni and Lorenzo di Pierfrancesco de' Medici. At the Uffizi in 1815, then at the Accademia; it returned definitively in 1919.

Sandro Botticelli
Adoration of the Magi
Tempera on wood, 111x134
Inv. 1890, 882
Painted for the church of Santa Maria Novella around 1475, it contains the portraits of several members of the Medici family. At the Uffizi since 1796.

Filippino Lippi
Adoration of the Child
Tempera on wood, 96x71
Inv. 1890, 3246
Painted in the early 1480s, in

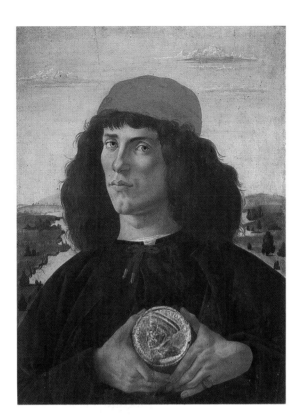

Sandro Botticelli:
Portrait of a Young
Man with a Medal

e past it was attributed to an
tist called simply "Sandro's
end," whose work is now
nerally accepted as Filippino's
rly work. At the Uffizi since
)02.

lippino Lippi
int Jerome
empera on wood, 136x71
v. 1890, 8652
ainted around 1485 for the
adia Fiorentina. At the Uffizi
nce 1935.

orenzo di Credi
lorence 1459?–1537)
doration of the Shepherds
empera on wood, 224x196
v. 1890, 8399
ainted before 1510 for the
urch of Santa Chiara, where it
mained until 1908 when it
as transferred to the
ccademia. At the Uffizi since
)19.

orenzo di Credi
enus
empera on wood, 151x69
v. 1890, 3094
ainted around 1490, it was
scovered in 1869 in a
oreroom in the Medici villa of
ifaggiolo. At the Uffizi since
393.

**omenico Bigordi called
hirlandaio**
lorence 1449–1494)
doration of the Magi
empera on wood, diam. 172
v. 1890, 1619

Dated 1487; from the house of
Giovanni Tornabuoni. At the
Uffizi since 1790.

Domenico Ghirlandaio
*Stories from the Lives of Saints and
Man of Sorrows*
Tempera on wood, 10.5x220
Inv. 1890, 8387
Predella for the altarpiece
painted in the early 1480s for
the church of Santa Maria a
Monticelli. At the Uffizi since
1919.

Sandro Botticelli
*Stories from the Lives of Saints and
Man of Sorrows*
Tempera on wood, 21x41,
21x40.5, 20x38, 21x38
Inv. 1890, 8390-3
Panels from the predella of the
San Barnaba Altarpiece. At the
Uffizi since 1919.

Sandro Botticelli
San Barnaba Altarpiece
Tempera on wood, 268x280
Inv. 1890, 8361
Painted for the church of San
Barnaba around 1488; in 1808
transferred to the Accademia.
At the Uffizi since 1919.

Sandro Botticelli
Saint Augustine in his Study
Tempera on wood, 41x27
Inv. 1890, 1473
Recorded in 16th-century
sources in the house of
Bernardo Vecchietti; painted in
the 1490s. At the Uffizi since
1779.

Domenico Ghirlandaio
Madonna Enthroned with Saints
Tempera on wood, 190x200
Inv. 1890, 881
Painted around 1484 for the
church of San Giusto degli
Ingesuati, destroyed during the
siege of Florence in 1529/30.
At the Uffizi since 1853.

Sandro Botticelli
Annunciation
Tempera on wood, 150x156
Inv. 1890, 1608
Commissioned in 1489 by
Benedetto di Ser Giovanni
Guardi for the church of
Cestello (today Santa Maria
Maddalena dei Pazzi). At the
Uffizi since 1872.

Filippino Lippi
"Pala degli Otto"
Tempera on wood, 355x255
Inv. 1890, 1568
Painted in 1486 for the
Magistratura degli Otto di
Pratica (a body of eight
magistrates) and hung probably
in the Sala dei Dugento in
Palazzo Vecchio. At the Uffizi
since 1782.

Filippino Lippi
Adoration of the Magi
Tempera on wood, 258x243
Inv. 1890, 1566
Painted in 1496 for the church
of San Donato at Scopeto, in
order to replace the *Adoration*
commissioned from Leonardo
but never finished. At the Uffizi
since 1666.

Sandro Botticelli
*Portrait of a Young Man with a
Medal*
Tempera on wood, 57.5x44
Inv. 1890, 1488
The sitter, who has been
variously identified as the
artist's brother or as the artist
himself, holds a medal
portraying Cosimo the Elder,
which was coined after 1464.
The portrait dates from
1474/5. At the Uffizi since
1704.

At the centre of the room:

Hugo van der Goes
(Ghent *c* 1440–Roode Kloster
near Brussels 1482)
Portinari Triptych
Oil on wood, 253x586
(overall), 253x304 (central
panel), 253x141 (each wing)
Inv. 1890, 3191-3
Painted in Bruges around 1475
for the Medici agent Tommaso
Portinari, the triptych was
transferred to Florence in 1483
and placed in the church of
Sant'Egidio. At the Uffizi since
1900.

Rogier van der Weyden
(Tournai *c* 1400–Brussels 1464)
Entombment
Oil on wood, 110x96
Inv. 1890, 1114
Probably painted in Florence
when the artist came to Italy for
the Jubilee in 1450. At the
Uffizi since 1666.

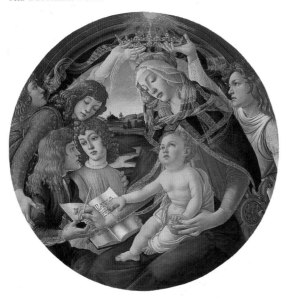

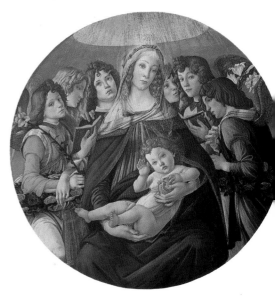

Sandro Botticelli: Magnificat Madonna Sandro Botticelli: Madonna of the Pomegranate

Sandro Botticelli: Adoration of the Magi ▷

Sandro Botticelli: Primavera, det

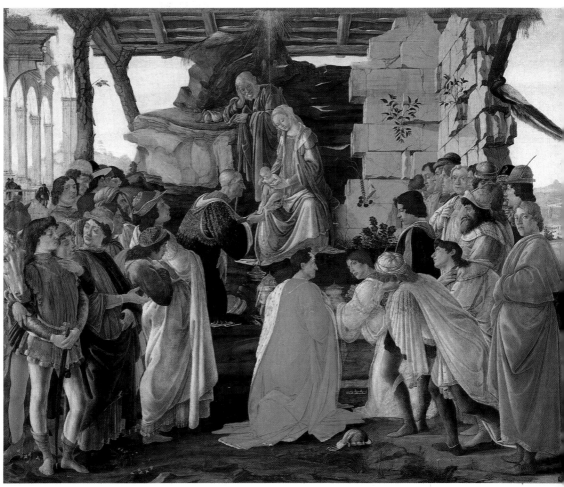

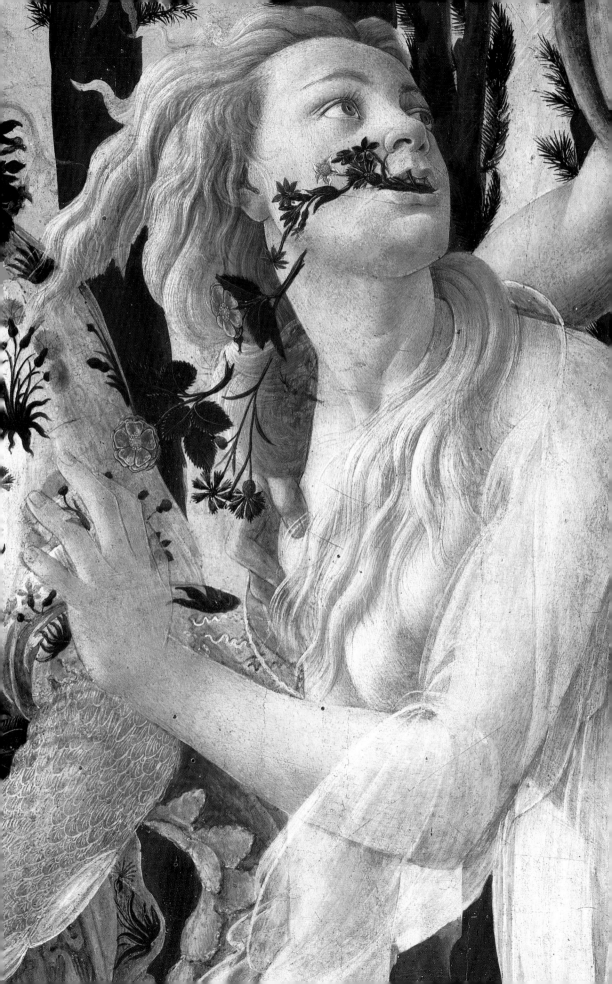

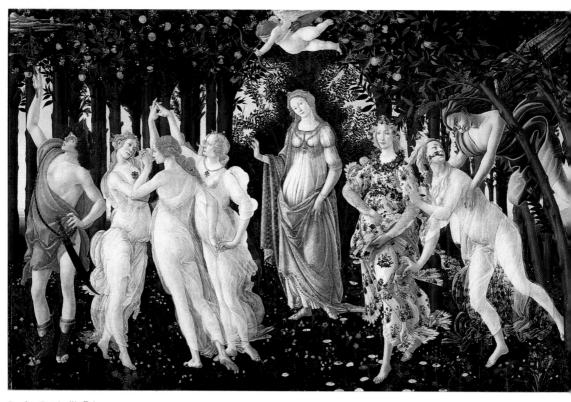

Sandro Botticelli: Primavera

The two most famous works by Botticelli in the Uffizi are the *Primavera* (Spring) and the *Birth of Venus*, painted for the Medici villa at Castello. These two mythological compositions, inspired by neo-Platonist ideals, are emblematic of the complex cultural life in Florence in the late 15th century, t which Botticelli adds the exquisite elegance of hi draughtsmanship. The group of the dancing Grace and the beautiful figure of Venus are among the bes known images of the world's artistic heritage.

Sandro Botticelli: The Birth of Venu

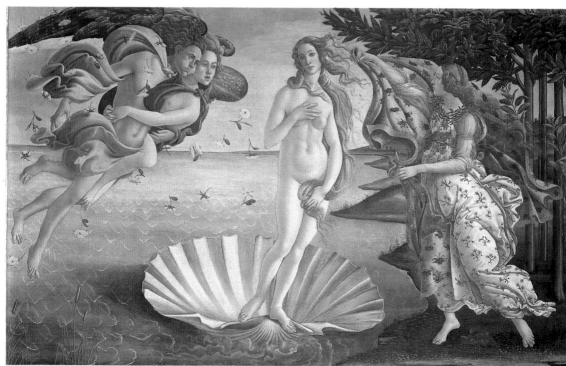

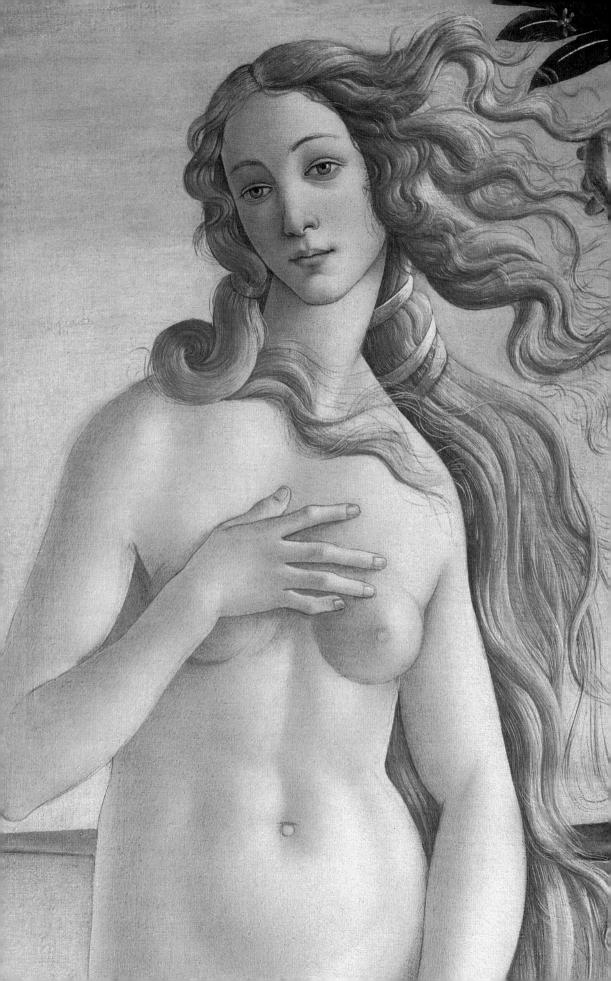

Sandro Botticelli: Pallas and the Centaur

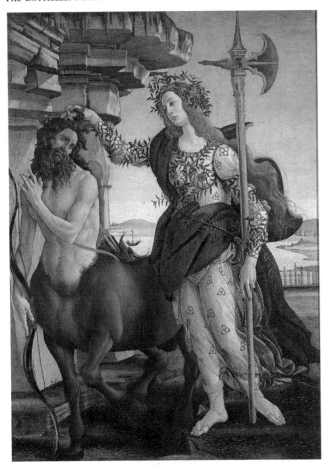

Sandro Botticelli: Calumny

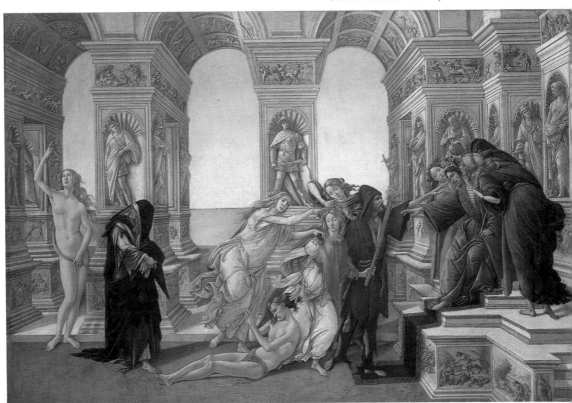

▷
Filippino Lippi: "Pala degli Otto"

Filippino Lippi: Portrait of an Old Man

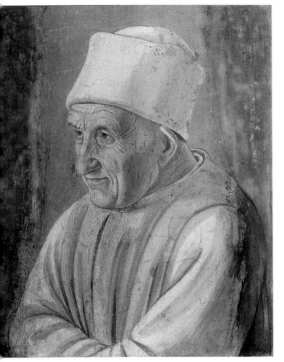

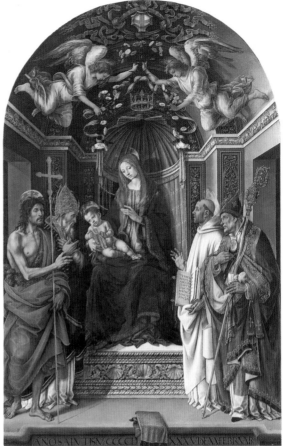

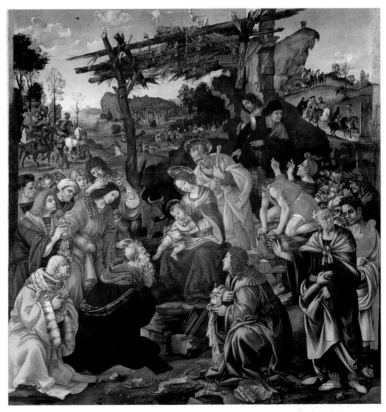

Filippino Lippi: Adoration of the Magi

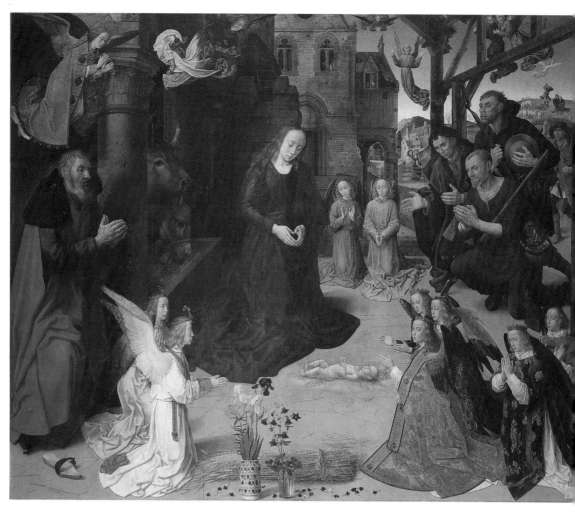

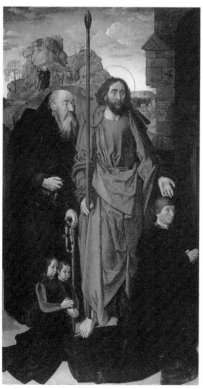

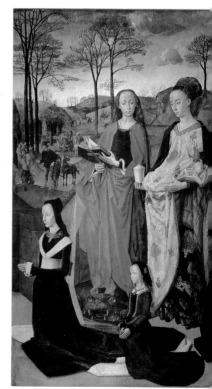

Hugo van der Goes:
Portinari Triptych

Rogier van der Weyden:
Entombment

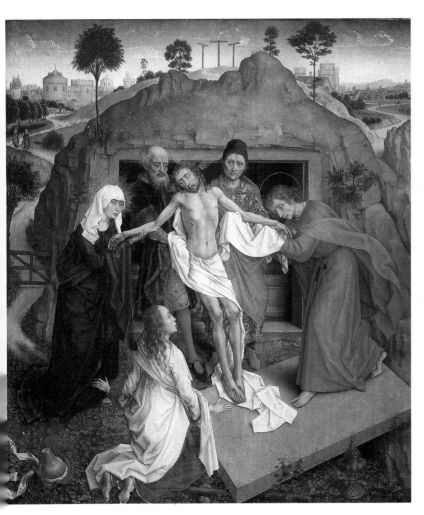

Domenico Ghirlandaio: Madonna Enthroned with Saints

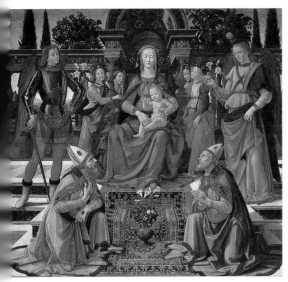

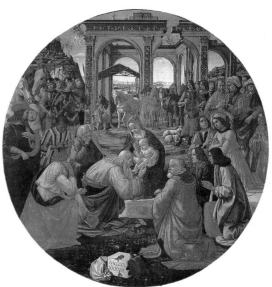

Domenico Ghirlandaio: Adoration of the Magi

The Leonardo Room

Inaugurated in its present form in 1980, this room had previously undergone numerous modernizations. In the second half of the 19th century it housed a vast number of paintings from the 16th and 17th centuries, all the work of Tuscan artists; it was called the Room of the Tuscan School. In the first decades of this century, the room housed Umbrian and Sienese paintings of the 16th century, with works by Perugino and Signorelli. Then, with the postwar re-organization (1946-1948), the room became a repository for the most important and fundamental works of early 16th-century Florentine painting, laid out according to modern criteria, beautifully and uniformly lit by the sunlight pouring in from a well-designed and functional skylight. In the 1950s the room was called the Room of Leonardo and the Umbrian School and the extraordinary unfinished *Adoration of the Magi* stood against a large piece of drapery, in the same place where it stands today – then, as now, the focal point of the room. Today the room boasts two other works by Leonardo. One, the *Baptism of Christ* in which he was an assistant to Verrocchio, and the other, the *Annunciation*, by his hand alone. In the former, Leonardo's work is confined to the angel at the left and the misty landscape that seems to dissolve in the distance (some critics have also seen Leonardo's touch in the gentle depiction of Christ). The second painting, despite differing attributions and controversies, is now generally accepted as being by Leonardo – a youthful Leonardo to be sure, but one already capable of producing this delicate, light but solid composition.

Together with Leonardo in this room are other masters who were trained in that expert workshop run by Verrocchio. Recently some critics have assigned to Verrocchio himself the painting of the three archangels, hanging alongside Leonardo's *Adoration*, a painting that is usually attributed to Francesco Botticini who could have painted it at a time when he felt the influence of Verrocchio and Botticelli particularly strongly. Among the other painters represented here, for all of whom Verrocchio's art was a point of departure, are Perugino whose beautifully restored *Pietà*, painted for the church of San Giusto degli Ingesuati, clearly shows Northern European influence, and Lorenzo di Credi with his exquisite *Annunciation*, which is certainly one of his masterpieces.

On the walls near the entrance are two impressive altarpieces by Luca Signorelli, a painter associated with the Umbrian artistic tradition as well as the Florentine. The small room that the visitor sees after the Tribune is dedicated to him. A most distinctive artistic personality is represented here by two very different paintings: the artist is Piero di Cosimo and the paintings are the *Liberation of Andromeda* and the *Incarnation*. The former has a secular mythological subject and has recently been interpreted as an allegory of the return to power of the Medici in 1512, after a brief period of Republican government; the second deals with a religious theme, with the Virgin as protagonist both in the centre of the painting and the scenes on the sides, around the group of saints.

Luca Signorelli
(Cortona 1445/50–1523)
Allegory of Fertility and Abundance
Tempera on wood, 58x105.5
Inv. 1890, 3107
Painted shortly after 1500, it was bought in 1894 and exhibited in the same year at the Uffizi.

Luca Signorelli
Last Supper, Agony in the Garden, Flagellation

Tempera on wood, 32.5x204.5
Inv. 1890, 8371
Predella for the altarpiece with the *Trinity, the Virgin and Saints* also in this room (see below). At the Uffizi since 1919.

Pietro Vannucci called Perugino
(Città della Pieve *c* 1448–Fontignano 1523)
Pietà
Tempera on wood, 168x176
Inv. 1890, 8365

Painted in 1493/4 for the church of San Giusto degli Ingesuati. At the Uffizi since 1919.

Luca Signorelli
The Trinity, the Virgin and Saints
Tempera on wood, 272x180
Inv. 1890, 8369
Painted between 1500 and 1510 for the Confraternita della Trinità dei Pellegrini in Cortona. At the Uffizi since 1919.

Lorenzo di Credi
(Florence 1459?–1537)
Annunciation
Tempera on wood, 88x71
Inv. 1890, 1597
Painted in the early 1480s, it is one of the most representative works by this artist. At the Uffizi since 1798.

Below:

Piero di Cosimo
(Florence 1461/2–1521)

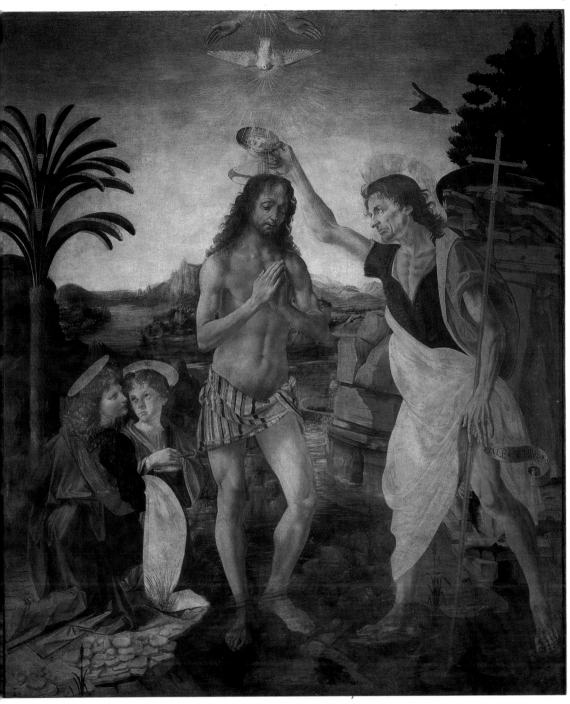

Verrocchio and Leonardo: Baptism of Christ

Perseus Frees Andromeda
Oil on wood, 70x123
Inv. 1890, 1536
Painted around 1513, since it probably refers to the Medici's return to Florence in 1512 after the Republican period. At the Uffizi since 1589 when it was exhibited in the Tribune.

Francesco Botticini
(Florence 1446–1498)
The Three Archangels
Tempera on wood, 153x154

Inv. 1890, 8359
In the past attributed to Verrocchio; painted around 1470. At the Uffizi since 1919.

Leonardo da Vinci
(Vinci 1452–Amboise 1519)
Adoration of the Magi
Tempera mixed with oil with parts in red or greenish lacquer, and white lead, 243x246
Inv. 1890, 1594
Commissioned by the monks of San Donato at Scopeto in 1481,

it was left unfinished when Leonardo set off for Milan. At the Uffizi since 1670.

Andrea di Cione called Verrocchio
(Florence 1435–Venice 1488)
and **Leonardo da Vinci**
Baptism of Christ
Tempera on wood, 180x152
Inv. 1890, 8358
From the church of San Michele at San Salvi; painted by Verrocchio with the assistance

of Leonardo, who seems to be responsible for an angel, the landscape in the background and part of the figure of Jesus. At the Uffizi since 1914.

Piero di Cosimo
Incarnation
Oil on wood, 206x172
Inv. 1890, 506
Painted around 1505 for the Tedaldi chapel in Santissima Annunziata. At the Uffizi since 1804.

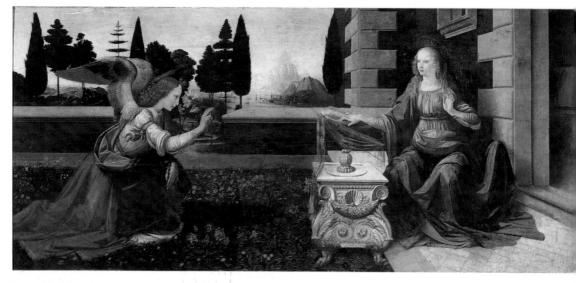

Leonardo: Annunciation

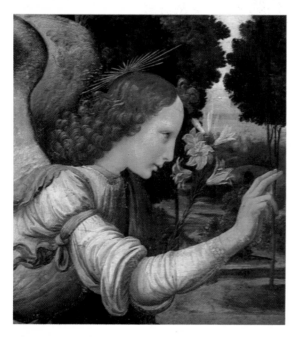

Leonardo da Vinci
Annunciation
Tempera on wood, 98x217
Inv. 1890, 1618
From the church of San
Bartolomeo at Monteoliveto;
painted around 1472/5 when
Leonardo was still in
Verrocchio's workshop. At the
Uffizi since 1867.

Luca Signorelli
Crucifix with Mary Magdalen
Tempera on canvas, 247x165
Inv. 1890, 8368

Painted shortly after 1500;
from the Annalena convent. At
the Uffizi in 1814, then at the
Accademia, then again at the
Uffizi after 1919.

Luca Signorelli
*Annunciation, Nativity, Adoration
of the Magi*
Tempera on wood, 21x210
Inv. 1890, 1613
From the church of Santa Lucia
at Montepulciano. At the Uffizi
since 1831.

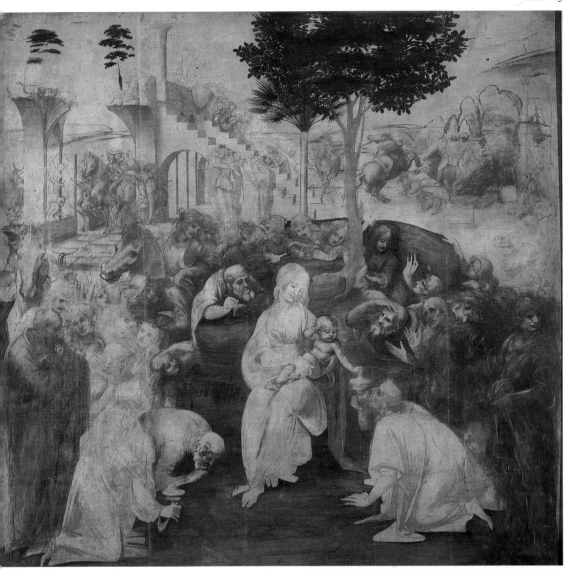

eonardo: Adoration of the Magi

Leonardo's early work, dating from the period when
he was still tied to Verrocchio's workshop where he
had been an apprentice together with several other
important artists, is illustrated in the Uffizi by two
paintings. The *Baptism of Christ* was painted by both
Leonardo and Verrocchio, whereas the *Annunciation*
is entirely by Leonardo, although still very much
under Verrocchio's influence. The unfinished
Adoration of the Magi, on the other hand, is a totally
autonomous work. The foreground is crowded with
figures converging towards the spot where the event
is taking place; the background shows ruined
buildings and receding landscapes, dotted with
figures involved in different kinds of action,
including duels between knights.

Piero di Cosimo: Incarnation

Lorenzo di Credi: Annunciation

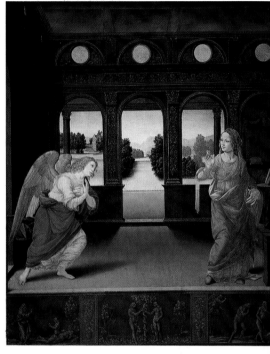

Piero di Cosimo: Perseus Frees Andromeda

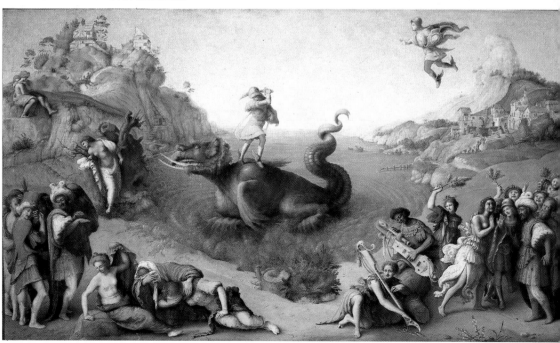

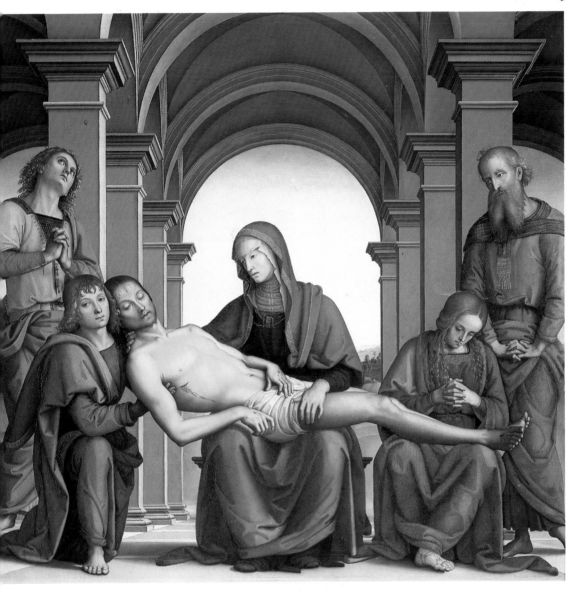

Perugino: Pietà

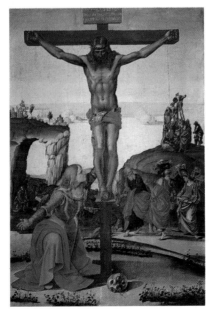

Luca Signorelli: Crucifix
with Mary Magdalen

ROOM 16
Room of the Maps

This room, originally a loggia, was frescoed in 1589 with maps showing the "lands belonging to the old Florentine Dominion," the "State of Siena" and the Island of Elba. The painter was Ludovico Buti, working from designs by Stefano Bonsignori, who painted the names of the cities in gold, red and black. The terrace opened to the East, while the two windows, which were later walled in, were on either side of the frescoed pilaster showing Elba. The ceiling was decorated with paintings of mythological subjects by Jacopo Zucchi, done in Rome around 1572 for Cardinal Ferdinando de' Medici. After Ferdinando became Grand Duke of Tuscany on the death of his brother Francesco, in 1588 he had the paintings brought to Florence and had them placed where they are now, set into the ceiling between the wooden beams decorated by Buti with garlands of fruits and flowers. The loggia was closed in with the construction of huge windows between the columns and Ferdinando placed here a collection of scientific instruments that remained until the middle of the 18th century. At the end of the last century the frescoes were covered and works by 15th-century Tuscan painters (Fra Angelico, Botticelli, Lorenzo di Credi and Signorelli) were shown here. At the turn of the century the two large frescoes of Tuscany were uncovered, but two large tapestries showing stories from the life of Julius Caesar covered the fresco of Elba. In the centre of the room was the famous diptych by Piero della Francesca, with the *Annunciation* by Melozzo da Forlì and a small triptych.

Around 1930 the room still contained the important paintings by Piero and Melozzo, while two marble full-size copies of Polycletus's *Doryphoros* were placed in front of the tapestries as well as the splendid green basalt torso, also a copy of the *Doryphoros*. At the beginning of the 1950s the fresco of Elba was covered with a curtain serving as a backdrop for Leonardo's *Annunciation*. Piero's diptych remained here, together with a roundel of the *Adoration* attributed to Lorenzo di Credi.

With the new organization of the room (1980), important paintings by Memling have been placed on either side of the now uncovered fresco of Elba, as well as copies of the telescope and the astrolabe belonging to Galileo, in memory of the room's 16th-century collection of scientific instruments.

Hans Memling
(Seligenstadt *c* 1435–Bruges 1494)
Madonna and Child with two Angels
Oil on wood, 57x42
Inv. 1890, 1024
Painted around 1480; from the collection of Ignazio Hugford. At the Uffizi since 1779.

Hans Memling
Saint Benedict
Oil on wood, 45.5x34.5
Inv. 1890, 1100
It is the left wing of the Small Portinari Triptych, from the hospital of Santa Maria Nuova. The central panel, a Madonna and Child, is now in Berlin. At the Uffizi since 1825.

Hans Memling
Portrait of Benedetto Portinari
Oil on wood, 45x34
Inv. 1890, 1090
Dated 1487; if it is, as seems likely, the right wing of the Small Portinari Triptych, it helps us date the whole work. At the Uffizi since 1825.

Hans Memling
Portrait of a Man
Oil on wood, 35x25
Inv. 1890, 1101
Painted around 1490; of unknown origin. Mentioned in the Uffizi collection as early as 1863.

Hans Memling
Portrait of a Man
Oil on wood, 38x27
Inv. 1890, 1102
Attributed to Antonello, it was bought in 1836 by Abbot Luigi Celotti. At the Uffizi in the same year.

Master of the Baroncelli Portraits
(Flanders, 15th century)
Portraits of Pierantonio Baroncelli and Maria Bonciani
Oil on wood, 56x31 (each)
Inv. 1890, 1036, 8405
The two panels arrived at the Uffizi at different times (1845 and 1843). Now recomposed as a diptych, they show an Annunciation on the reverse side.

Hans Memling: Saint Benedict

Hans Memling: Portrait of Benedetto Portinari

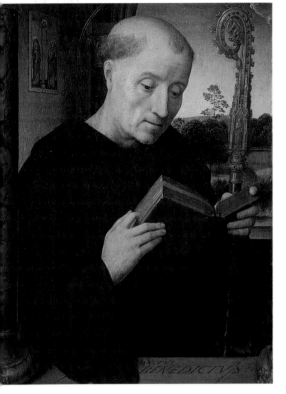

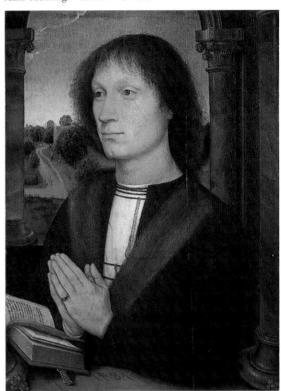

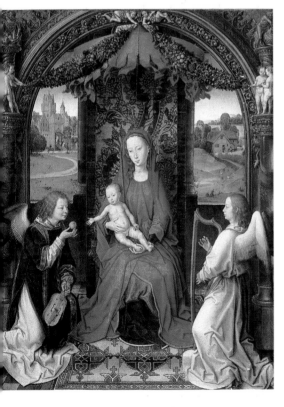

Hans Memling: Madonna and Child with two Angels

Hans Memling: Portrait of a Man

ROOM 17
The Room of the Hermaphrodite

This small room, next to the Tribune, was created shortly after 1589, year of the Medici-Lorraine wedding, when Ferdinando I was Grand Duke; it was listed in the inventory as the "small room wherein are to be found mathematical instruments, maps of the universe and much more." The original function of the room is reflected in the decoration of part of the ceiling (the part toward the window was done much later, in the 18th century) with grotesques and figures holding astrolabes, compasses and other scientific instruments, attributed to Giulio Parigi (Florence 1540-1635).

During the restoration of the room in 1970, carried out under the direct supervision of the Gallery, the architect Nello Bemporad uncovered some small niches in the wall,

painted so as appear to be carved out of porphyry. A group of small bronzes and statuettes from the Bargello Museum has now been placed in these niches.

After the restoration of the room, the statue of the *Hermaphrodite* was returned here, to the place it occupied in 1669; the *Cupid and Psyche*, discovered in Rome in 1666 and housed in the Tribune in the 18th century has also now been placed here.

On the wall opposite the window, to the left of the entrance to the Tribune, is the *Crossing of the Red Sea*, painted by Pietro Bonaccorsi known as Perin del Vaga.

Mantegna's triptych, his *Madonna and Child* and the *Portrait of Cardinal Carlo de' Medici* that were placed here in 1970, were moved in 1984 to Room 23, the Correggio Room.

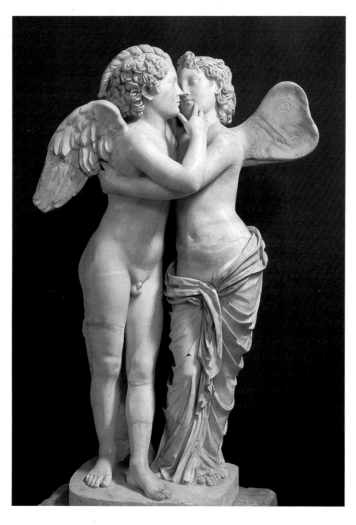

Cupid and Psyche

Room 18
The Tribune

The Tribune, perhaps even more than the Studiolo in Palazzo Vecchio (finished in 1571), consciously reflects the cultivated taste of Francesco I de' Medici (1541-1587). Francesco commissioned Bernardo Buontalenti to design this octagonal room as a place to house the most precious pieces from the Medici Collection.

The work on the room, begun in 1584, was virtually completed three years later when Francesco died. Dionigi di Matteo Nigetti and Bartolo da Venezia were the artists responsible for the wood intarsia, Bernardino Poccetti and Agostino Ciampelli for the decoration of the dome and Jacopo Ligozzi for the decorative frieze.

The decoration of the Tribune is based on the same cosmological themes used in the Studiolo, with symbols depicting the four elements. Air is shown in the wind rose and pennant on the lanterna, while the allusion to Water is in the mother-of-pearl applied to the dome and the variety of fish painted on the frieze. The red, blue and gold colours are intended to honour the Medici as an obvious allusion to the colours that appear on their coat-of-arms.

The octagonal little temple, covered with gold and precious stones, has disappeared, as has the large "Studiolo," also designed by Buontalenti, and the room has changed in the course of the passing centuries according to the prevailing fashion and taste. In the refurnishing of this exquisite room, which once contained small bronzes and precious objects, it was attempted, in 1970, to reconstruct as closely as possible its original appearance. For example, the splendid table with inlay of pietre dure, commissioned by Ferdinando II and created between 1633 and 1649 in the Grandducal workshop from a design by Jacopo Ligozzi, Bernardino Poccetti and Baccio del Bianco, was placed in the centre of the room. The group of six statues, which includes the famous *Medici Venus*, were placed here in the years between 1677 and 1680 by Cosimo III de' Medici, who had them transferred to Florence from the Villa Medici in Rome.

The walls are covered in red damask cloth, similar to the original, against which the paintings are hung. The paintings belong either to the original group placed here in 1589 or have been chosen because they were exhibited in the Tribune at different periods. There are a number of paintings by Agnolo Bronzino, the sophisticated portraitist and painter at the court of Cosimo I; particularly notable are the portraits of Eleonora di Toledo and her children and the portraits of Bartolomeo and Lucrezia Panciatichi, aristocratic products of an elegant, learned Mannerism, far removed from both the solid classical style of Andrea del Sarto, represented here by a *Portrait of a Lady*, and the restless, tormented style of Pontormo, whose stupendous painting *Madonna and Child with Saint John* is exhibited here together with his *Portrait of Cosimo the Elder*. Andrea's other famous pupil, Rosso Fiorentino, a follower of the first phase of Mannerism in Florence, is represented by a bewitching, tiny *Musician Angel*, alongside works from Raphael's Roman period and works of members of his school. There is the *Slaughter of the Innocents* by Daniele da Volterra and several paintings by that versatile artist from nearby Arezzo, Giorgio Vasari, painter, architect and the first art historian, who played a dominant role at the Medici court. There are also paintings by Vasari's friend and contemporary, Cecchino Salviati, an unconventional and talented follower of Roman Mannerism, whose sparkling paintings show great virtuosity as well as an obvious debt to Michelangelo and Raphael.

Above:

Carlo Caliari
(Venice 1570–1596)
The Expulsion from Earthly Paradise
Oil on canvas, 99x110
Inv. 1890, 944
Painted around 1586. At the Uffizi since 1769.

Tapestry with Medici-Lorraine coat-of-arms (after 1589)

Carlo Caliari
Adam's Family
Oil on canvas, 99x111
Inv. 1890, 951
See previous entry.

Carlo Caliari
Creation of Eve
Oil on canvas, 96x115
Inv. 1890, 954
See previous entry.

Tapestry with Medici-Lorraine coat-of-arms (after 1589)

Carlo Caliari
Original Sin
Oil on canvas, 98x113
Inv. 1890, 960
See previous entry.

Below:

Agnolo Bronzino, attr. to
(Florence 1503–1572)
Annunciation
Tempera on wood, 57x43.5
Inv. 1890, 1547
Painted around 1550. At the Uffizi since 1773.

Alessandro Allori
(Florence 1535–1607)
Portrait of Bianca Cappello
Fresco, 75x52
Inv. 1890, 1500
Painted around 1580. At the Uffizi since 1948.

Giorgio Vasari
(Arezzo 1511–Florence 1574)
Portrait of Lorenzo the Magnificent
Tempera on wood, 90x72
Inv. 1890, 1578
Painted in 1533/4 for Duke Alessandro de' Medici. At the Uffizi since 1784.

Daniele Ricciarelli da Volterra
(Volterra 1509–Rome 1566)
Slaughter of the Innocents
Tempera on wood, 51x42
Inv. 1890, 1429
Painted in 1557 for the church of San Pietro in Volterra. At the Uffizi since 1782.

Jacopo Carrucci called Pontormo
(Pontorme near Empoli 1494–Florence 1556)
Portrait of Cosimo the Elder
Tempera on wood, 86x65
Inv. 1890, 3574
Painted around 1518/20 for Goro Gheri, the secretary of Lorenzo the Magnificent. At the Uffizi since 1914.

Jacopo Pontormo
Madonna and Child with the Young Saint John
Tempera on wood, 89x74
Inv. 1890, 4347
Painted around 1527/8. At the Uffizi, in the Tribune, in 1589.

Ridolfo Bigordi called Ghirlandaio
(Florence 1483–1561)
Portrait of a Man
Tempera on wood, 43x33.5
Inv. 1890, 2155
Painted around 1517/20. At the Uffizi since 1853.

Agnolo Bronzino
Portrait of a Woman with a Book
Tempera on wood, 58x46.5
Inv. 1890, 770
Painted around 1545. At the Uffizi since 1773.

Agnolo Bronzino
Portrait of Lucrezia Panciatichi
Tempera on wood, 102x85
Inv. 1890, 736
Painted around 1540 for the famous Florentine family, together with the portrait of Lucrezia's husband Bartolomeo. At the Uffizi since 1704.

Francesco de' Rossi called Cecchino Salviati
(Florence 1510–Rome 1563)
Charity
Tempera on wood, 156x122
Inv. 1890, 2157
Painted around 1543/5 while the artist was in Florence. At the Uffizi since 1778.

Agnolo Bronzino
Portrait of Bartolomeo Panciatichi
Tempera on wood, 104x84
Inv. 1890, 741
See above, portrait of Lucrezia Panciatichi. At the Uffizi since 1704.

Cecchino Salviati
Christ Carrying the Cross
Tempera on wood, 66x45
Inv. 1890, 801
Painted around 1540/5, probably while the artist was in Florence. At the Uffizi since 1862.

In the niche in the end wall: Ebony cabinet decorated with semi-precious stones, dating from the last years of Cosimo III's rule (1639-1723); on either side, majolica vases from Guidubaldo II della Rovere's collection, made by Orazio Fontana's workshop in Urbino in the late 16th century.

Jacopo Pontormo (?)
Leda and the Swan
Tempera on wood, 55x40
Inv. 1890, 1556
Painted around 1512/3. At the Uffizi, in the Tribune, in 1638.

Agnolo Bronzino
Portrait of Francesco I de' Medici
Tempera on wood, 58.5x41.5
Inv. 1890, 1571
Painted in 1551 for the ducal family when the prince was ten years old. At the Uffizi since 1863.

Francesco di Cristofano called Franciabigio
(Florence 1484–1525)
Madonna of the Well
Tempera on wood, 106x81
Inv. 1890, 1445
Painted in 1517/8. At the Uffizi since 1666.

Raffaello Sanzio called Raphael
(Urbino 1483–Rome 1520) and assistants
Saint John the Baptist in the Desert
Oil on canvas, 165x147
Inv. 1890, 1446
Painted around 1518/20, perhaps for Cardinal Colonna. At the Uffizi, in the Tribune, in 1589.

Giulio Pippi called Giulio Romano
(Rome c 1499–Mantua 1546)
Madonna and Child
Tempera on wood, 105x77
Inv. 1890, 2147
Painted in the 1520s. At the Uffizi since 1793.

Giovan Battista di Jacopo called Rosso Fiorentino
(Florence 1495–Fontainebleau 1540)
Musician Angel
Tempera on wood, 47x39
Inv. 1890, 1505
Painted around 1522; probably in origin part of a larger painting. At the Uffizi, in the Tribune, in 1605.

Agnolo Bronzino
Giovanni de' Medici as a Child
Tempera on wood, 58x45.6

Inv. 1890, 1475
Painted in 1545 for the ducal family when Giovanni was only two years old. At the Uffizi since 1704.

Giorgio Vasari
The Prophet Elisha
Tempera on wood, 40x29
Inv. 1890, 1470
Painted around 1566, at the same time as the other painting of the same subject for the monks of San Pietro at Perugia. At the Uffizi since 1773.

Agnolo Bronzino
Bia, illegitimate daughter of Cosimo I de' Medici
Tempera on wood, 63x48
Inv. 1890, 1472
Painted shortly before 1542, when the child died at the age of five. At the Uffizi since 1796.

Agnolo Bronzino
Portrait of a Man with a Lute
Tempera on wood, 98x82.5
Inv. 1890, 1575
Painted between 1532 and 1540. At the Uffizi since 1704.

Agnolo Bronzino
Eleonora of Toledo with her Son Giovanni
Tempera on wood, 115x96
Inv. 1890, 748
Painted around 1545/6 for the ducal family. At the Uffizi since 1798.

Andrea d'Agnolo called Andrea del Sarto
(Florence 1486–1530)
Portrait of a Lady
Tempera on wood, 87x69
Inv. 1890, 783
A late work, painted around 1528/9. At the Uffizi, in the Tribune, in 1589.

Giorgio Vasari
Allegory of the Immaculate Conception
Tempera on wood, 58x39
Inv. 1890, 1524
Painted in 1541; connected to the painting of the same subject for the Altoviti chapel in Santi Apostoli. At the Uffizi since 1771.

Agnolo Bronzino
Cosimo I in Armour
Tempera on wood, 71x57
Inv. Dep. 28
Painted around 1545 when the Duke of Florence was twenty-six years old and had been ruling the duchy since 1537. At the Uffizi since 1771.

View of the interior of the dome of the Tribune

The Tribune

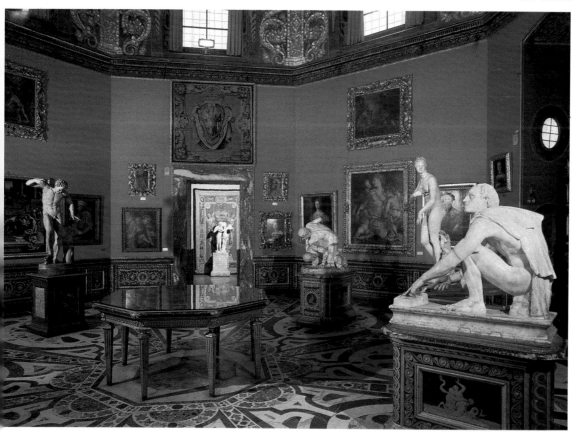

Bronzino: Portrait of Eleonora of Toledo
with her son Giovanni

Bronzino: Portrait of Bia, illegitimate
daughter of Cosimo I de' Medici

Bronzino: Portrait of Bartolomeo Panciatichi

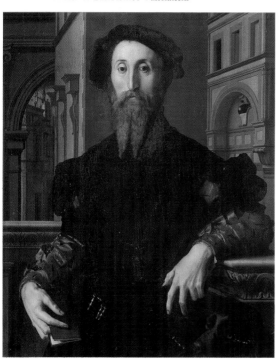

Bronzino: Portrait of Cosimo I in armour

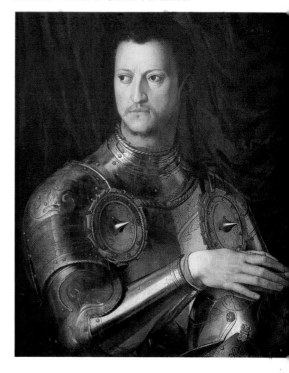

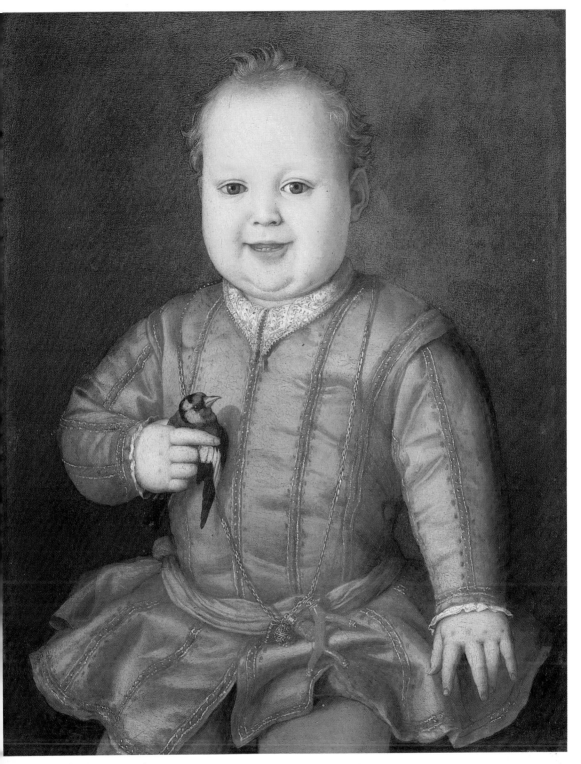

Bronzino: Portrait of Giovanni de' Medici as a Child

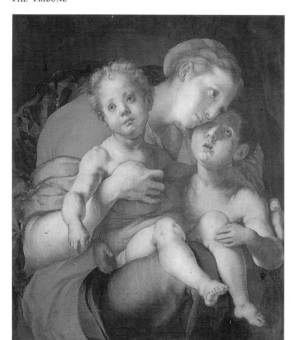

Pontormo: Madonna and Child with the Young Saint John

Pontormo: Portrait of Cosimo the Elder

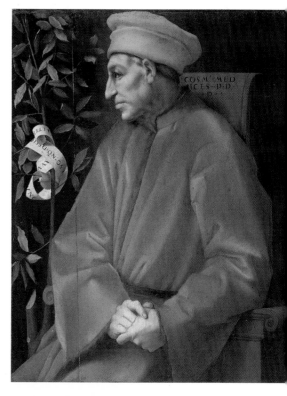

Rosso Fiorentino: Musician Angel

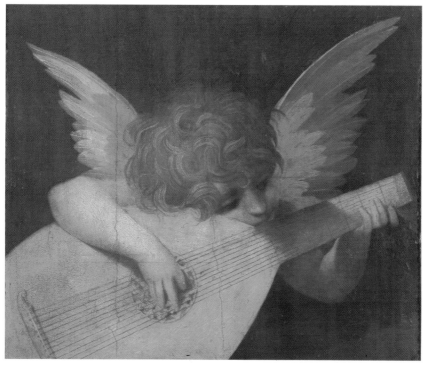

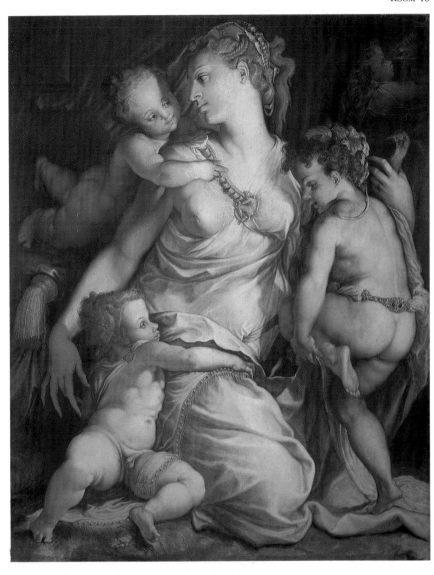

Cecchino Salviati: Charity

Raphael: Saint John
the Baptist in the Desert

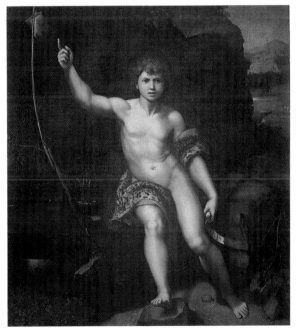

ROOM 19
The Signorelli and Perugino Room

This room, like the following ones, was once part of the Armoury, with ceilings frescoed in 1588 by Ludovico Buti, when Ferdinando I was Grand Duke of Tuscany. The ceiling of the room, in the re-organization that began in 1656, was painted by Agnolo Gori in 1665 at the same time that he was working on the decoration of part of the ceiling of the Third Corridor of the Gallery. There are allegories of Florence and Tuscany, triumphs and battles as well as the chariots of Jove, Mars, Saturn, Venus and a number of Medici emblems and coats-of-arms, including those of Cosimo I, Francesco I, Ferdinando I, Cosimo II and Vittoria della Rovere, wife of Ferdinando III.

Today the room contains paintings by Perugino and Signorelli (whose works can also be seen in Room 15) and various other masters from Emilia, Romagna and Central Italy.

Perugino, a prolific painter and Raphael's teacher, is represented here by paintings from the last decade of the 15th century such as the altarpiece for the Martini Chapel at Fiesole, dating from 1493, a painting filled with melancholy grace, characterized by the elegant composition of the figures, or the expressive *Portrait of Francesco delle Opere* (1494) or those haunting portraits of Vallombrosian monks that were once part of a large altarpiece commissioned by the Vallombrosian Order at the beginning of the 16th century. Luca Signorelli, born in Cortona, is represented here by a large tondo showing the *Holy Family* and by a *Madonna and Child with Allegorical Figures*, both commissioned by Florentines and both showing, in the solid and three-dimensional construction of the figures, the lessons learned from Piero della Francesca as well as his contact with exponents of Florentine art, such as the Pollaiolo brothers and Verrocchio.

Luca Signorelli
(Cortona *c* 1445–1523)
Holy Family
Tempera on wood, diam. 124
Inv. 1890, 1605
Painted between 1484 and 1490, perhaps for the Audience Hall of the Capitani di Parte Guelfa. At the Uffizi since 1802.

Pietro Vannucci called Perugino
(Città della Pieve *c* 1448–Fontignano 1523)
Portraits of Don Biagio Milanesi and Baldassarre Vallombrosano
Tempera on wood, 28.5x26.5, 26x27
Inv. 1890, 8375-6
Both panels were part of the predella of the altarpiece showing the Annunciation and Saints, previously in Vallombrosa and now at the Accademia, signed and dated 1500. At the Uffizi since 1810.

Luca Signorelli
Madonna and Child with Allegorical Figures
Tempera on wood, 170x117.5

Inv. 1890, 502
Painted while the artist was in Florence, in 1490/5, for Lorenzo di Pierfrancesco de' Medici for his villa in Castello. At the Uffizi since 1779.

Perugino
Portrait of Francesco delle Opere
Tempera on wood, 52x44
Inv. 1890, 1700
Painted in 1494, as is recorded in the inscription on the reverse. At the Uffizi since 1833.

Above the door leading to Room 20:

Lorenzo di Alessandro da Sanseverino
(Sanseverino Marche, doc. 1468–1503)
Pietà
Tempera on wood, 62x158
Inv. 1890, 3142
It was the top part of the altarpiece showing the Mystical Marriage of Saint Catherine, painted around 1491 for the church of Santa Lucia in Fabriano, and today at the

National Gallery, London. At the Uffizi since 1902.

Francesco Raibolini called Francia
(Bologna *c* 1450–1517)
Portrait of Evangelista Scappi
Tempera on wood, 55x44
Inv. 1890, 1444
Painted in 1500/5. At the Uffizi since 1773.

Marco Palmezzano
(Forlì *c* 1460–1539)
Crucifixion
Tempera on wood, 112x90
Inv. 1890, 1418
Painted around 1500/10; previously in the church of San Bartolomeo at Monteoliveto near Florence. At the Uffizi since 1844.

Perugino
Portrait of a Man
Tempera on wood, 37x26
Inv. 1890, 1474
Painted around 1494. At the Uffizi since 1890.

Melozzo degli Ambrosi called Melozzo da Forlì

(Forlì 1438–1494)
Annunciation
Tempera on wood, 116x60
Inv. 1890, 3341 and 3343
Painted around 1466/70. At the Uffizi since 1906.

Girolamo Genga
(Urbino 1476–1551)
Martyrdom of Saint Sebastian
Tempera on wood, 100x83
Inv. 1890, 1535
Painted in the early 16th century. At the Uffizi since 1798.

Lorenzo Costa
(Ferrara *c* 1460–1535)
Saint Sebastian
Tempera on wood, 55x49
Inv. 1890, 3282
Painted in 1490/1. At the Uffizi since 1906.

Perugino
Madonna and Child with Saints
Tempera on wood, 178x164
Inv. 1890, 1436
Signed and dated 1493; painted for the Martini chapel in San Domenico near Fiesole. At the Uffizi since 1784.

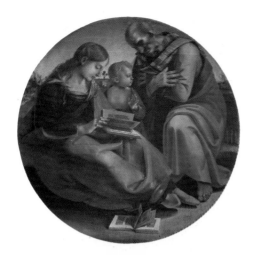

Luca Signorelli: Holy Family

Luca Signorelli: Madonna and
Child with Allegorical Figures

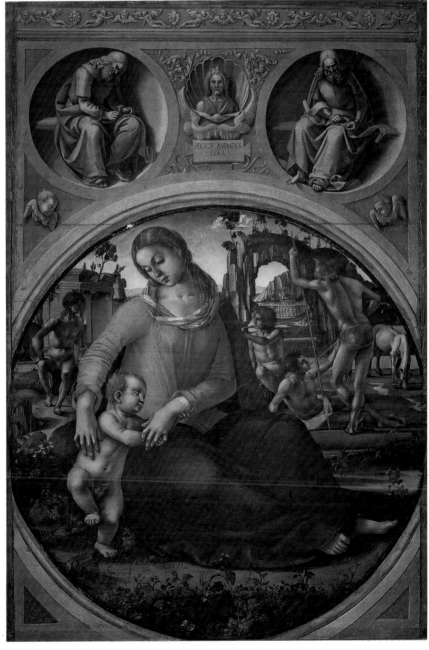

Perugino: Portrait of Don Biagio Milanesi

▷
Melozzo da Forlì: Annunciation

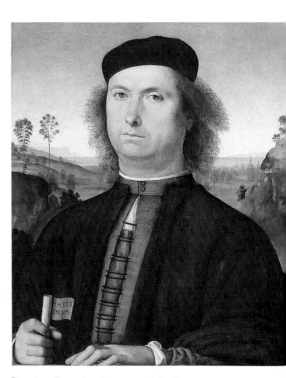

Perugino: Portrait of Francesco delle Opere

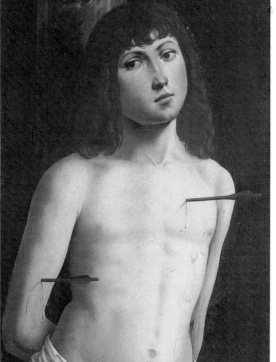

Lorenzo Costa: Saint Sebastian

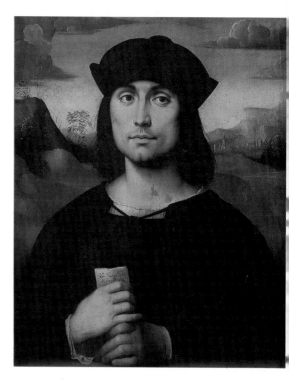

Francia: Portrait of Evangelista Scappi

▷
Girolamo Genga: Martyrdom of Saint Sebastian

▷▷
Marco Palmezzano: Crucifixion

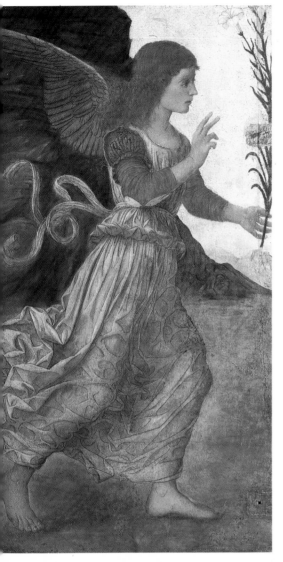

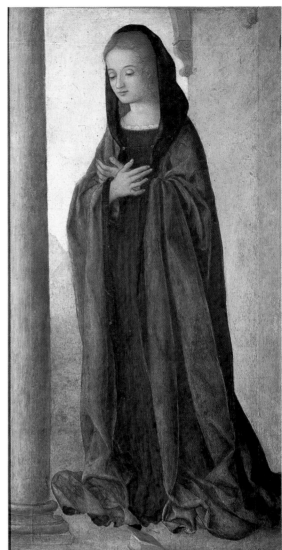

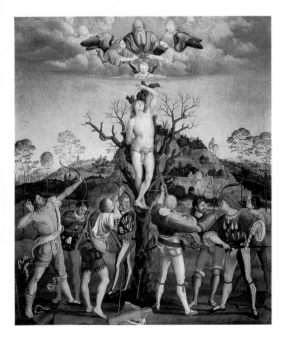

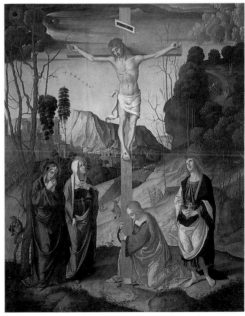

Originally decorated, together with the neighbouring rooms of the Armoury, by Ludovico Buti in 1588, the room now has a decoration of grotesques with four scenes of festivals and celebrations in Florence. These scenes, mentioned by Pelli-Bencivenni in 1779, show a nighttime festa in the courtyard of the Pitti Palace, the "Festa degli Omaggi" (a religious festival) in Piazza Signoria, a game of Calcio (a form of football) in Piazza Santa Croce and a unidentified celebration in Piazza Santa Maria Novella.

The decoration for the most part dates from the middle of the 19th century and it is logical to assume, according to stylistic analysis, that the ceiling was rebuilt and repainted around the already existing paintings.

This room now contains works by Düre Cranach and other German masters of th 15th and 16th centuries. There are some st pendous paintings by Albrecht Dürer, th great painter and engraver from Nuremberg who was strongly influenced by the class cism and intensity he found in the works o Mantegna and Bellini. Among the works b Dürer are the splendid *Portrait of the Artist Father*; the *Adoration of the Magi*, in whic Northern naturalism and attention to deta are blended with a solemn monumentalit and Italian sense of perspective; the *Calvar* an evocative pen and brush work similar t the engravings in which Dürer excelled. It shown here next to a copy made in 1604 b Jan Brueghel the Elder.

Lukas Cranach the Elder, workshop of
(Kronach 1472–Weimar 1553)
Martin Luther and his Wife
Oil on wood, 36.5x23, 37x23
Inv. 1890, 1160, 1139
Monogrammed and dated 1529. At the Uffizi since 1753.

Hans Süss von Kulmbach
(Kulmbach *c* 1480–Nuremberg 1522)
Crucifixion with Mary Magdalen and Donors
Oil on wood, 167x92
Inv. 1890, 1025
Monogrammed; painted around 1511/4. At the Uffizi since 1777.

Lukas Cranach the Younger
(Wittemberg 1515–Weimar 1586)
Lukas Cranach the Elder
Oil on wood, 64x49
Inv. 1890, 1631
Painted in 1550, as is recorded in the inscription, three years before his father's death. At the Uffizi since 1753.

Lukas Cranach the Elder, workshop of
Portrait of a Man
Oil on wood, 42x29
Inv. 1890, w.n.
Painted around 1530. Date of entry unknown.

Georg Lemberger
(Landshut 1490/5–Magdeburg

c 1540)
Saint George Frees the Princess
Oil on wood, 19x18
Inv. 1890, 1056
Painted in 1520, according to the date on the horse's tail. At the Uffizi since 1796.

Hans Burgkmair
(Augsburg 1473–1531)
Portrait of a Man
Parchment on wood, 27.2x22.5
Inv. Dep. 432
Signed and dated 1506. At the Uffizi since 1952.

Lukas Cranach the Elder, workshop of
Martin Luther and Philipp Melanchthon
Oil on wood, 21x16
Inv. 1890, 512, 472
Painted in 1543, according to the date on the portrait of Luther. At the Uffizi since 1773.

Lukas Cranach the Elder, workshop of
Friedrich III the Wise and Johann I, Electors of Saxony
Oil on wood, 20x15
Inv. 1890, 1150, 1149
Painted in 1533, according to the signature and date on the portrait of Friedrich the Wise. Date of entry unknown.

Hans Maler zu Schwaz
(Schwaz, doc. 1500–1510)
Ferdinand of Castille

Oil on wood, 33x23
Inv. 1890, 1215
Painted in 1524. At the Uffizi since 1796.

Joos van Clève
(Antwerp *c* 1485–1540/1)
Portrait of a Man
Oil on wood, 31x20
Inv. 1890, 1645
Painted around 1512. At the Uffizi since 1952.

Albrecht Dürer
(Nuremberg 1471–1528)
Madonna and Child with a Pear
Oil on wood, 43x31
Inv. 1890, 1171
Monogrammed and dated 1526. At the Uffizi since 1773.

Albrecht Dürer
The Artist's Father
Oil on wood, 47.5x39.5
Inv. 1890, 1086
Painted in 1490, the year inscribed on both sides of the panel. At the Uffizi since 1773.

Albrecht Dürer
Adoration of the Magi
Oil on wood, 99x113.5
Inv. 1890, 1434
Monogrammed and dated 1504. At the Uffizi since 1793.

Hans Baldung Grien (?)
(Schwäbisch Gmünd 1484/5–Strassburg 1545)
copy after Albrecht Dürer
Adam and Eve

Oil on wood, 212x85
Inv. 1890, 8433, 8432
Painted after 1507, the year Dürer painted the originals. A the Uffizi since 1922.

Albrecht Dürer
The Apostle Philip
Tempera on wood, 45x38
Inv. 1890, 1089
Monogrammed and dated 1516. Arrived in Florence in 1620; date of entry unknown.

Hans Süss von Kulmbach
Stories from the Lives of Saints Pet and Paul
Oil on wood, various sizes fro 128.5x95.5 (Vocation of Peter to 132x96 (Martyrdom of Peter)
Inv. 1890, 1034, 1020, 1060, 1047, 1044, 1072, 1030, 1058
These panels were part of a polyptych with revolving door perhaps from a church in Cracow. Painted in 1514/6. A the Uffizi since 1843.

Albrecht Dürer
The Apostle James
Tempera on wood, 46x37
Inv. 1890, 1099
Monogrammed and dated 1516, like the Apostle Philip above. Arrived in Florence in 1620; date of entry unknown.

Jan Brueghel the Elder
(Brussels 1568–Antwerp 162
copy after Albrecht Dürer

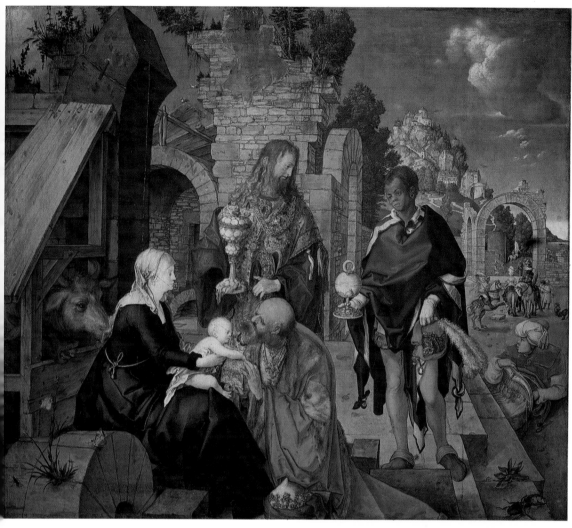

Albrecht Dürer: Adoration of the Magi

Hans Süss von Kulmbach: Crucifixion

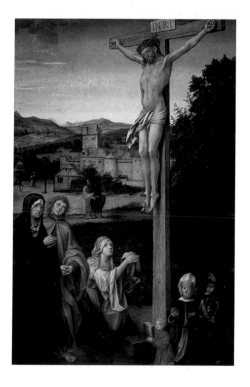

Calvary
Oil on wood, 62x42
Inv. 1890, 1083
Signed and dated 1604. At the
Uffizi since 1784.

Albrecht Dürer
Calvary
Pen and brush with highlights
in white lead on green-tinted
paper, 58x40
Inv. 1890, 8406
Monogrammed and dated
1505. Arrived in Florence in
1628; date of entry unknown.

Lukas Cranach the Elder
Adam and Eve
Oil on wood, 172x63
Inv. 1890, 1459, 1458
The Adam is monogrammed
and dated 1528. At the Uffizi
before 1704.

Above the door:

**German Artist of the 16th
Century (?)**
Open Book
Oil on wood, 70.2x65
Inv. 1890, 6191
Painted in 1500/25. At the
Uffizi since 1969.

Albrecht Dürer: The Artist's Father

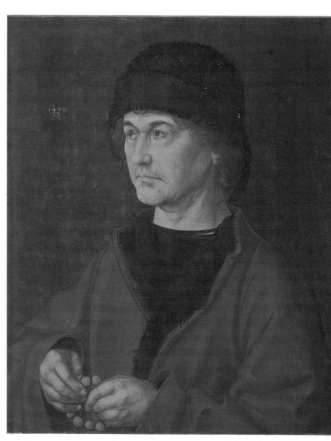

Lukas Cranach the Elder:
Martin Luther and his Wife

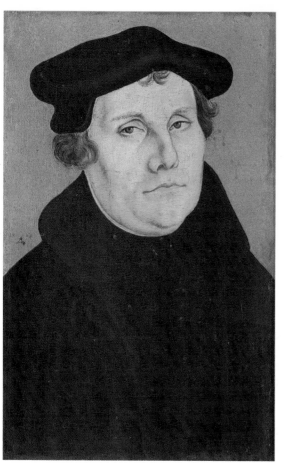

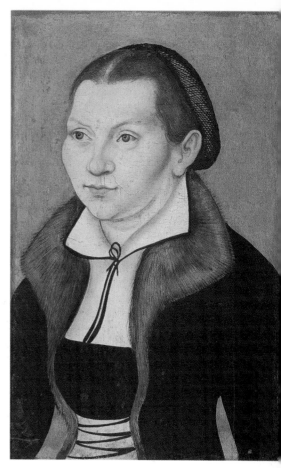

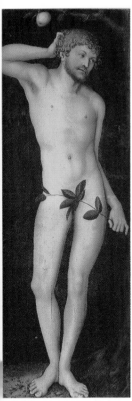

Jan Brueghel the Elder: Calvary
(copy after Albrecht Dürer)

Lukas Cranach the Elder:
Adam and Eve

ROOM 21
The Bellini and Giorgione Room

Like the two preceding rooms, this was once part of the Armoury of Grand Duke Ferdinando I. The ceiling was decorated by Ludovico Buti, one of the artists who painted the First Corridor under the direction of Allori. The grotesques, painted in 1588, are accompanied by figures of Indians from the New World, as well as exotic animals and tropical birds that show the interest the Medici had in Mexico and the Americas, an interest further demonstrated in the Mexican artisan work and objects in their collection which may well have been displayed in this very room. Among the paintings is a view of Florence showing the zone of Oltrarno and dated 1945, which is a replacement for a painting lost during the last war.

The room houses works by Giovanni Bellini, one of the major exponents of Venetian painting of the second half of the 15th century. Bellini's *Lamentation* is a solemn work with a moving spirituality that in its composition and the sculptural quality of the figures reminds one of Mantegna, the painter's brother-in-law, but also shows the influence of Piero della Francesca and Antonello da Messina, foreshadowing the work of Giorgione and the young Titian. Bellini is closest to Giorgione in the relationship he establishes between the realistic landscape in the background and the religious scene in the foreground, with all its symbolism, in the painting of the *Allegory*, which according to a recent interpretation by Carlo del Bravo is based on a text by Lorenzo Valla.

Among the other important paintings are the two attributed to Giorgione, *Moses Undergoes Trial by Fire* and the *Judgement of Solomon*, both painted with the artist's vivid sense of colour and depicting a landscape of great depth. There is also a *Saint Dominic* by the Ferrarese painter, Cosmè Tura, who depicts the emaciated figure with his usual polished, enamel-like technique.

Giorgione
(Castelfranco Veneto *c* 1477–Venice 1510)
Moses Undergoes Trial by Fire
Oil on wood, 89x72
Inv. 1890, 945
Painted around 1502/5. At the Uffizi since 1795.

Paolo Morando called Cavazzola, attr. to
(Verona *c* 1486–1522)
Warrior with Equerry
Oil on wood, 90x73
Inv. 1890, 911
Painted around 1518/22. At the Uffizi since 1821.

Giorgione
The Judgment of Solomon
Oil on wood, 89x72
Inv. 1890, 947
Painted in 1502/8. At the Uffizi since 1795.

Giovanni Bellini called Giambellino
(Venice 1425/30–1516)
Lamentation
Tempera on wood, 74x118
Inv. 1890, 943
Painted around 1500. At the Uffizi since 1798.

Giovanni Bellini
Allegory
Oil on wood, 73x119
Inv. 1890, 903
Painted sometime between 1487 and the first years of the new century. At the Uffizi since 1795.

Cosmè Tura
(Ferrara 1432–1495)
Saint Dominic
Tempera on wood, 51x32
Inv. 1890, 3273
Painted around 1475; probably part of the polyptych of San Luca in Borgo, in Ferrara. At the Uffizi since 1905.

Giovanni Bellini
Portrait of a Young Man
Oil on wood, 31x26
Inv. 1890, 1863
Painted around 1500. At the Uffizi since 1753.

Giovanni Battista Cima da Conegliano
(Conegliano Veneto *c* 1460–1517/8)
Madonna and Child
Tempera on wood, 66x57
Inv. 1890, 902
Painted around 1504. At the Uffizi since 1882.

Giovanni Mansueti
(Venice ? doc. 1485–1527)
Christ among the Doctors
Oil on canvas, 108x214
Inv. 1890, 523
Painted around 1500. At the Uffizi since 1852.

Bartolomeo Vivarini
(Murano doc. 1450–1499)
Saint Louis of Toulouse
Tempera on wood, 68x36
Inv. 1890, 3346
Painted around 1465. At the Uffizi since 1906.

Lorenzo Costa
(Ferrara *c* 1460–1535)
Portrait of Giovanni Bentivoglio
Tempera on wood, 55x49
Inv. 1890, 8384
Signed; painted in the 1490s. At the Uffizi since 1919.

Vittore Carpaccio
(Venice doc. 1475–1526)
Soldiers and Men in Oriental Clothes
Oil on wood, 68x42
Inv. 1890, 901
Painted between 1493 and 1500. At the Uffizi since 1883.

Giovanni Bellini: Allegory

Giovanni Bellini: Lamentation

Giovanni Bellini's *Allegory*, one of the best known works of the early Renaissance, is emblematic of all the achievements of this artist. Although the Christian symbolism is difficult to interpret, the landscape in the background is extraordinary and the placing of the figures in the foreground shows a remarkable mastery of spatial construction. The sacred figures look totally human and are in perfect unison with the everyday domestic environment.

101

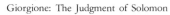

Giorgione: The Judgment of Solomon

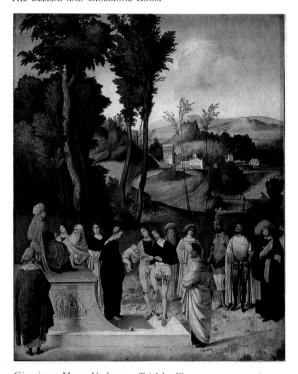

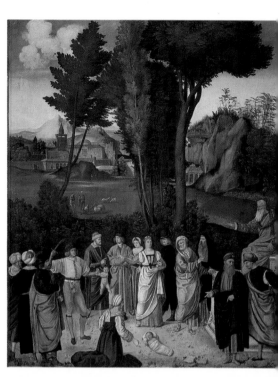

Giorgione: Moses Undergoes Trial by Fire

Giorgione: Moses Undergoes Trial by Fire, detail

Cavazzola: Warrior with Equerry

Room 22
Flemish and German Painting

The ceiling, like those of the neighbouring rooms, was decorated by Ludovico Buti in 1588, seven years after the decoration of the First Corridor on which he worked together with other artists from Allori's workshop. The grotesques and battle scenes refer to the original function of this small room which at one time housed arms from the collection of the Grand Duke. Some of the paintings were lost during the last war.

The room now offers a carefully selected anthology of works by major Flemish and German painters, active between the end of the 15th and the early decades of the 16th century.

Particularly noteworthy are the tiny *Deposition* by Gerard David, a painting much loved for its artistic and spiritual values by Eleonora of Toledo, who brought it with her when she came from Naples as a bride to Cosimo I in 1539; the two portraits by Joos van Clève and Bernaert van Orley, with their wealth of realistic detail heightened by the luminous use of colour; and the phlegmatic *Portrait of Sir Richard Southwell*, a masterpiece by Holbein who was much appreciated by the English aristocracy and had been nominated official court painter by Henry VIII. Here Holbein gives us a minutely detailed and realistic depiction of silken robes and flesh tones, as well as a perceptive portrait of the English gentleman, characterized by a breadth of composition that clearly shows how the painter benefited from his experience and observations during the time spent in Lombardy and the Veneto. One should also mention the diptych of *Saint Florian* by Albrecht Altdorfer, typical of his imaginative style, with a dazzling use of colour that lights up the wild, dreamlike landscape.

Master of Hoogstraeten
(Hoogstraeten, active *c* 1490–1530)
Madonna and Child with Saints
Oil on canvas, 84x70
Inv. 1890, 1019
Painted shortly after 1500. At the Uffizi since 1802.

Gerard David
(Oudewater *c* 1460–Bruges 1523)
Adoration of the Magi
Tempera on canvas, 95x80
Inv. 1890, 1029
Painted around 1490. At the Uffizi since 1845.

Master of the Virgo inter Virgines
(Delft, active 1470–*c* 1500)
Crucifixion
Oil on wood, 57x47
Inv. 1890, 1237
Painted at the end of the 15th century. Date of entry unknown.

Hans Memling, attr. to
(Seligenstadt *c* 1435–Bruges 1494)
"Mater Dolorosa"
Oil on wood, 55x33

Inv. 1890, 1084
Painted in the 1480s. At the Uffizi since 1774.

Bernaert van Orley
(Brussels *c* 1488–1541)
Portrait of a Man and his Wife
Oil on wood, 32x29, 37x29
Inv. 1890, 1140, 1161
Painted around 1521/5. At the Uffizi since 1773 and 1769 respectively.

Gerard David
Deposition
Oil on wood, 20x14
Inv. 1890, 1152
Painted between 1510 and 1520; connected to the painting of the same subject in the Frick Collection, New York. Originally the property of Eleonora di Toledo; at the Uffizi, in the Tribune, in 1589.

Joos van Clève
(Antwerp *c* 1485–1540/1)
Portrait of a Man and his Wife
Oil on wood, 57x42
Inv. 1890, 1643-4
Painted around 1520. At the Uffizi since 1753.

Hans Holbein the Younger
(Augsburg 1497/8–London 1543)
Sir Richard Southwell
Oil on wood, 47.5x38
Inv. 1890, 1087
Dated 1536, when the artist was already in England. At the Uffizi before 1638.

Hans Holbein the Younger
Self-portrait
Coloured pastels on paper, 32x26
Inv. 1890, 1630
A late work, painted around 1540/3. At the Uffizi since 1681.

Albrecht Altdorfer
(Regensburg? *c* 1480–1538)
Martyrdom of Saint Florian
Oil on wood, 76.4x67.2
Inv. Dep. 4
Painted between 1516 and 1525 for a church in Linz. At the Uffizi since 1914.

Albrecht Altdorfer
Saint Florian Taking Leave of the Monastery
Oil on wood, 81.4x67
Inv. Dep. 5

Painted together with the Martyrdom (see above). At the Uffizi since 1914.

Hans Holbein the Younger
(school of)
Portrait of a Man, thought to be Thomas More
Oil on wood, 42x36
Inv. 1890, 1120
Painted in the 1530s. At the Uffizi since 1773.

Georg Pencz
(Nuremberg *c* 1500–Leipzig 1550)
Portrait of a Young Man
Oil on wood, 91x70
Inv. 1890, 1891
Monogrammed and dated 1544. At the Uffizi since 1773.

Lucas van Leyden
(Leyden 1489–1533)
The Mocking of Christ
Oil on wood, 130x85
Inv. 1890, 1460
Painted in the early 16th century. At the Uffizi since 1795.

lbrecht Altdorfer: Martyrdom of Saint Florian

Master of Hoogstraeten:
Madonna and Child
with Saints

Master of the Virgo inter Virgines: Crucifixion

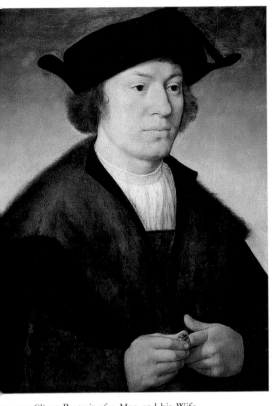

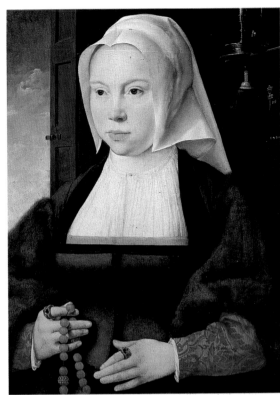

os van Clève: Portrait of a Man and his Wife

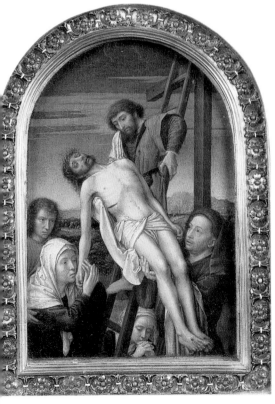

érard David: Deposition

Gérard David: Adam and Eve

ROOM 23
The Correggio Room

Decorated, like the two preceding rooms, by Ludovico Buti in 1588, the ceiling of this small room, as befits its original use as an Armoury, is painted with scenes connected to military arts, including a forge for making weapons in the centre, artisan workshops for the making of spears and lances, models of fortifications, cannons, the manufacture of gunpowder and the construction of a fortress.

Named for the great Emilian painter, this room contains three paintings fundamental for the study of Correggio's work; beginning with the small and exquisite *Madonna and Child in Glory*, with its echoes of Leonardo and Giorgione, to the more accomplished *Rest on the Flight into Egypt*, which shows how Correggio developed further, thanks to his contacts with works by Andrea del Sarto and Beccafumi, finally reaching his full maturity with the *Adoration of the Child* painted after he had finished the magnificent cycles of frescoes for the Camera della Badessa di San Paolo and the dome of San Giovanni Evangelista at Parma.

Alongside works by the Milanese followers of Leonardo, such as Luini, Boltraffio and De Predis, since 1984 this room also houses works by Andrea Mantegna, the greatest artist of Northern Italy active in the second half of the 15th century. The *Triptych* and the *Portrait of Cardinal Carlo de' Medici* belong to the period of Mantegna's fullest achievements and maturity; the minute *Madonna and Child* was probably painted slightly later. All three paintings show the brilliant use of colour and the strong sculptural qualities that so influenced painters from Milan, Ferrara and Venice.

Showing close contact with this artistic style are the portraits of *Guidubaldo da Montefeltro Duke of Urbino* and his wife *Elisabetta Gonzaga*, now attributed to Raphael by the majority of scholars and probably dating from his youth when he was still under influence of Venetian portraitists and Leonardo.

Antonio Allegri called Correggio
(Reggio Emilia 1489–1534)
Adoration of the Child
Oil on canvas, 81x77
Inv. 1890, 1453
Painted in 1524/6. Sent as a gift in 1617 from Francesco I of Modena to Cosimo II de' Medici and placed in the Tribune.

Correggio
Rest during the Flight into Egypt
Oil on canvas, 123.5x106.5
Inv. 1890, 1455
Painted around 1515/7 for the Munari chapel in the church of San Francesco at Correggio. Exchanged with Andrea del Sarto's Sacrifice of Isaac in 1649, and placed in the Tribune in the same year.

Correggio
Madonna and Child in Glory
Oil on wood, 20x16.3
Inv. 1890, 1329
Painted around 1510/5. At the Uffizi since 1798.

Raffaello Sanzio called Raphael, attr. to
(Urbino 1483–Rome 1520)
Portrait of Elisabetta Gonzaga
Tempera on wood, 52.5x37.3
Inv. 1890, 1441
Painted in 1502/3. Arrived in Florence in 1631, together with the rest of Vittoria della Rovere's inheritance, and was placed in the Tribune.

Raphael
Portrait of Guidubaldo da Montefeltro
Tempera on wood, 70.5x49.9
Inv. 1890, 8538
Painted between 1506 and 1508, when the sitter died. Arrived in Florence in 1631, together with the rest of Vittoria della Rovere's inheritance, and was placed in the Tribune.

Vincenzo Foppa
(Brescia 1427/30–1515/6)
Madonna and Child with an Angel
Tempera on wood, 41x32.5
Inv. 1890, 9492
Painted in 1479/80. At the Uffizi since 1975.

Boccaccio Boccaccino
(Ferrara 1466 ?–Cremona 1524/5)
Gipsy Girl
Tempera on wood, 24x19
Inv. 1890, 8539
Painted in 1516/8. At the Uffizi since 1925.

Giovanni Antonio Boltraffio
(Milan 1467–1516)
Narcissus
Tempera on wood, 19x31
Inv. 1890, 2184
Painted shortly after 1500. At the Uffizi since 1894.

Giovanni Antonio Bazzi called Sodoma
(Vercelli 1477–Siena 1549)
Christ at the Column
Tempera on wood, 85x60
Inv. 1890, 738
Painted between 1510 and 1540. At the Uffizi, in the Tribune, in 1589.

Giovanni Ambrogio de' Predis
(Milan *c* 1455–after 1508)
Portrait of a Man
Tempera on wood, 60x45

Inv. 1890, 1494
Painted around 1500. At the Uffizi since 1861.

Alessandro Araldi
(Parma *c* 1460–1528/9)
Portrait of Barbara Pallavicino (?)
Tempera on wood, 46.5x35
Inv. 1890, 8383
Painted in the 1510s. At the Uffizi since 1919.

Andrea Mantegna
(Isola di Carturo 1431–Mantua 1506)
Madonna and Child
Tempera on wood, 29x21.5
Inv. 1890, 1348
Painted around 1466; perhaps is the painting mentioned by Vasari as being in Francesco de Medici's collection. Date of entry unknown.

Andrea Mantegna
Epiphany, Circumcision and Ascension
Tempera on wood, 86x161.5 (overall, including frame)
Inv. 1890, 910
Not originally conceived as a triptych, the three panels were

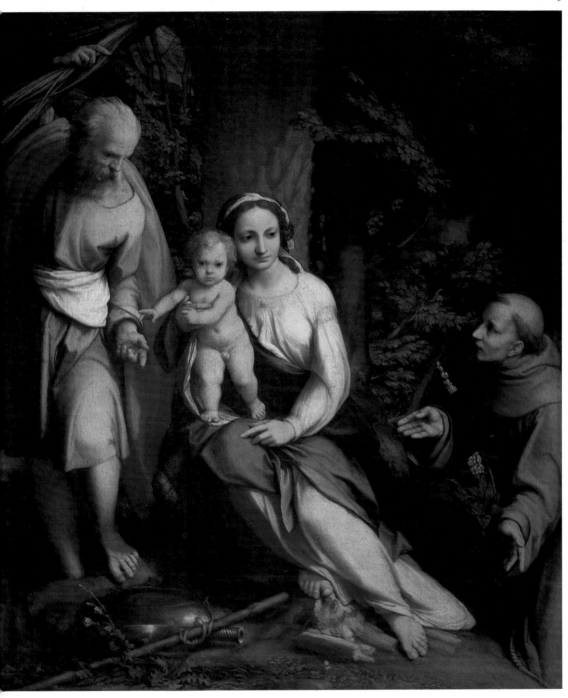

Correggio: Rest on the Flight into Egypt

...inted between 1463 and
...470. From the Medici
...ollections in the Casino di San
...arco; already in the Uffizi by
...632.

...ndrea Mantegna
...ardinal Carlo de' Medici
...empera on wood, 40.5x29.5
...v. 1890, 8540
...inted between 1450 and
...466. From the Medici

collections; date of entry
unknown.

**Giovanni Pedrini or Gian
Pietro Rizzi, called
Giampietrino**
(?–after 1540)
Saint Catherine of Alexandria
Tempera on wood, 64x50
Inv. 1890, 8544
Painted in the 1520s. At the
Uffizi since 1925.

Bernardino Luini
(Luino *c* 1460–doc. until 1532)
Herodias
Tempera on wood, 51x58
Inv. 1890, 1454
Painted in 1527/31. At the
Uffizi since 1793.

Bernardino de' Conti
(Pavia 1450–? *c* 1525)
Portrait of a Man
Tempera on wood, 42x32

Inv. 1890, 1883
Painted around 1500. At the
Uffizi since 1753.

Francesco Maineri
(Parma 1489–1506)
Christ Carrying the Cross
Oil on wood, 42x50
Inv. 1890, 3348
A late work. At the Uffizi since
1906.

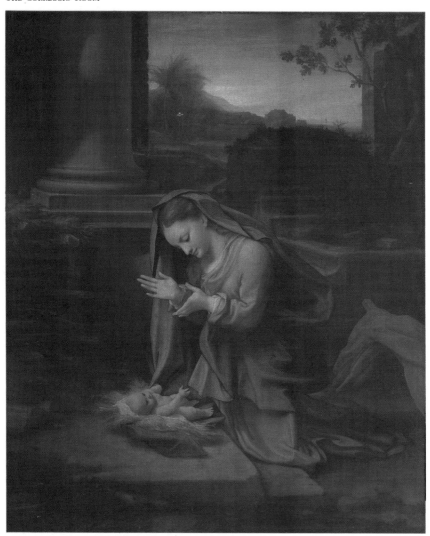

▷
Raphael:
Elisabetta Gonzaga

▷▷
Raphael:
Guidubaldo da Montefeltro

Correggio: Adoration of the Child

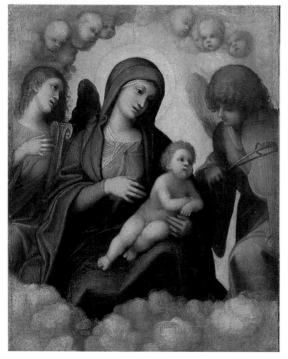

▷
Bernardino Luini: Herod

Correggio: Madonna and Child in Glory

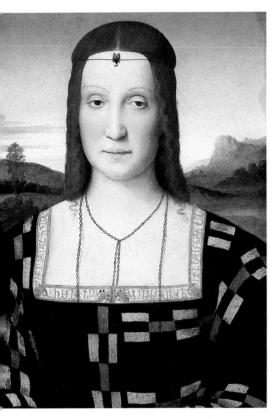 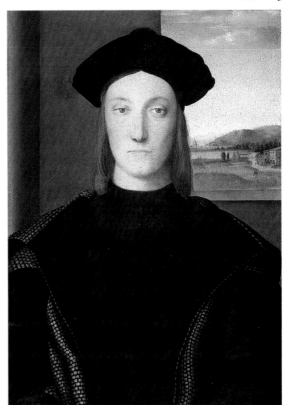

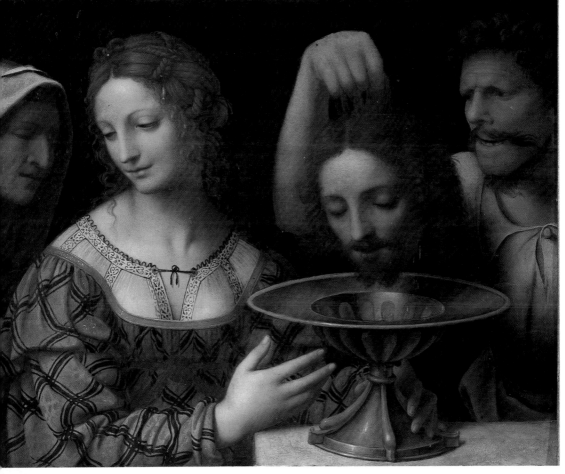

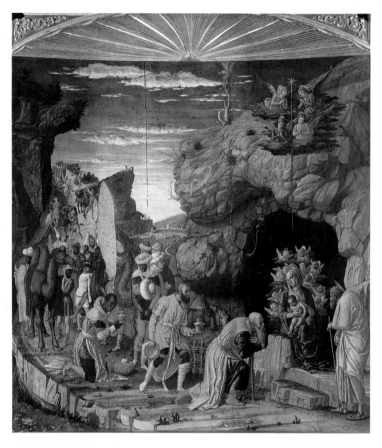

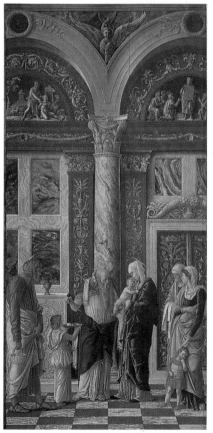

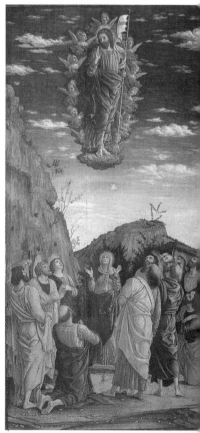

Mantegna: Triptych showing
Epiphany, Circumcision
and Ascension

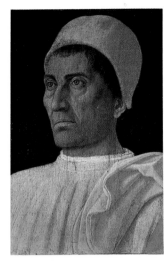

Mantegna: Cardinal Carlo de' Medici

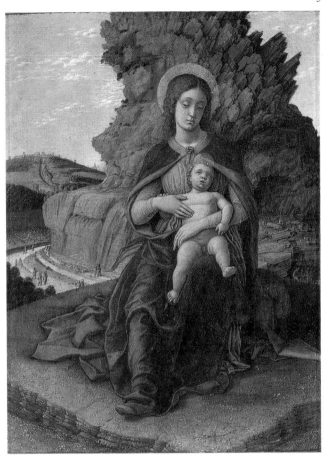

Mantegna: Madonna and Child

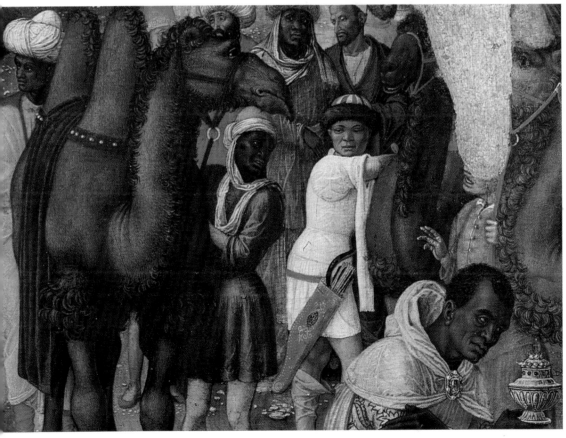

Mantegna: Triptych, detail

113

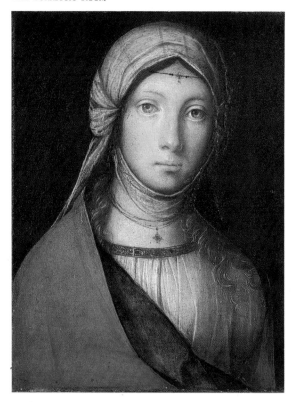

Boccaccio Boccaccino: Gipsy Girl

Francesco Maineri: Christ Carrying the Cross

Giovanni Antonio Boltraffio: Narcissus

ROOM 24
The Room of Miniatures

Once called "The Room of the Idols" because it contained antique bronzes, Mexican objects, miniatures and goldsmithery, or the "Room of Madame" since Christine of Lorraine, Grand Duchess of Tuscany, kept her jewels here, this small room was laid out rather like the Tribune. Later it was used to house the fabulous collection of precious stones, carnelians and engraved gems begun by the Medici during the 15th century.

When Peter Leopold of Lorraine ordered the Gallery to be re-organized by Zanobi del Rosso in 1781, this room was made into an oval shape and decorated by the painter Filippo Lucci, who frescoed the ceiling with an allegory of "Fame" wearing a laurel crown and carrying a vase filled with gems and precious stones.

When the Museo degli Argenti was created in 1928, the glyptic collection was transferred to Palazzo Pitti and all the miniatures from the Grandducal collection were assembled here.

The Medici interest in miniatures and paintings of small dimensions began in 1584 with Cosimo I's patronage of the perceptive, cultivated miniaturist, Giulio Clovio, one of whose pupils was the famous architect, Bernardo Buontalenti. During the 18th century Daniel Froeschl, Valerio Marucelli and Giovan Battista Stefaneschi were all employed at the Medici Court. Among the works of these artists exhibited on the walls of this room or shown in the cabinets are the *Crucifixion with Mary Magdalen* by Clovio, dated 1553, the *Madonna and Child with Saint John and an Angel* by Buontalenti, the *Crucifixion*, from a design by Michelangelo, initialed and dated 1600 by Froeschl, the copy on parchment by Marucelli of Raphael's *Canigiani Madonna* which was once in the Medici Collection and is now in Munich, and finally, a copy in miniature by Stefaneschi of Titian's *Adoration of the Shepherds*, today at the Pitti, a precious record as the painting has been for the most part destroyed.

ROOM 25
Michelangelo and the Florentine Painters

In the space now occupied by rooms 25 to 33, Ferdinando I in 1588 placed workshops for minor arts and the "Fonderia" where perfumes, poisons and antidotes were distilled. During the second half of the 18th century the first two rooms (25 and 26) housed a collection of medals and gems and, at the end of the century, paintings by 15th and 16th century Venetian masters were added. In the 1920s, with Giovanni Poggi's reorganization, the first room displayed paintings by Titian and members of his school that were replaced, thirty years later, by works by Raphael, Michelangelo and other Florentine artists.

In this room that bears his name, the undisputed centre of attention is Michelangelo's tondo (still in its original frame) painted for the Doni family of Florence: the only panel painting by the artist, who except for the frescoes in Rome, dedicated most of his time to sculpture. Scholars have always praised the revolutionary composition of the painting, centered on the twisted figure of the Madonna who turns toward Saint Joseph to receive the Child; now a recent restoration has brought back the brilliance of the original colouring which calls for a radical reappraisal of Michelangelo as a painter, as well as the importance and extent of his influence on Pontormo and the Florentine Mannerists.

Moving in another direction, toward a religious art of a truly devotional nature according to the teachings of Savonarola, are the works of Fra Bartolomeo and his disciple and collaborator, Mariotto Albertinelli, whose *Visitation* (1503), with obvious stylistic elements taken from Fra Bartolomeo, displayed here.

Solemn and spacious, *The Virgin Appears Saint Bernard* by Fra Bartolomeo has a late 15th-century sense of colour, blended with a classical composition reminiscent of Leonardo and Perugino, together with an almost medieval iconography of the holy and miraculous vision of the saint.

In a completely different style, a precocious outburst of Mannerism, is Rosso Fiorentino's *Moses Defends the Daughters of Jethro*, where the heightened tension of the powerful Michelangelesque nudes recalls the figures from the lost cartoon for *The Battle of Cascina*. Here the bodies are reduced to masses of colour under a dazzling light and the faces appear distorted, sometimes even monstrous.

Alonso Berruguete
(Paredes de Nava 1488–Toledo 1561)
Madonna and Child
Tempera on wood, 89x64
Inv. 1890, 5852
Attributed to Berruguete by Berti and Becherucci and dated at around 1517, towards the end of the artist's stay in Italy. At the Uffizi before 1825.

Francesco Granacci
(Florence 1477–1543)
Joseph Presents his Father and his Brothers to the Pharaoh
Tempera on wood, 95x224
Inv. 1890, 2152
Painted around 1515, together with works by Andrea del Sarto, Pontormo and

Bachiacca, for Pier Francesco Borgherini's bedroom. At the Uffizi, in the Tribune, in 1589.

Alonso Berruguete
Salome with the Baptist's Head
Tempera on wood, 87.5x71
Inv. 1890, 5374
According to Longhi, painted in 1512/6, during the artist's stay in Italy. At the Uffizi since 1795.

Francesco Ubertini called Bachiacca
(Florence 1494–1557)
Christ before Caiaphas
Tempera on wood, 50.5x41
Inv. 1890, 8407
Painted in 1535/40. At the Uffizi since 1919.

Giovan Battista di Jacopo called Rosso Fiorentino
(Florence 1495–Fontainebleau 1540)
Moses Defends the Daughters of Jethro
Oil on canvas, 160x117
Inv. 1890, 2151
It is probably the painting that Vasari mentions as having been painted around 1523 for Giovanni Bandini. At the Uffizi since 1632.

Michelangelo Buonarroti
(Caprese near Florence 1475–Rome 1564)
Holy Family
Tempera on wood, diam. 120
Inv. 1890, 1456
Painted in 1506/8 for the merchant Agnolo Doni and his wife Maddalena Strozzi. The frame is original and was designed by Michelangelo. At the Uffizi, in the Tribune, in 1635.

Giuliano Bugiardini
(Florence 1476–1555)
Portrait of a Woman known as "The Nun"
Tempera on wood, 65x48
Inv. 1890, 8380
Painted between 1500 and 1510. At the Uffizi since 1919.

Lorenzo di Credi, attr. to
(Florence 1459?–1537)
Portrait of a Man
Tempera on wood, 51x37
Inv. 1890, 1482

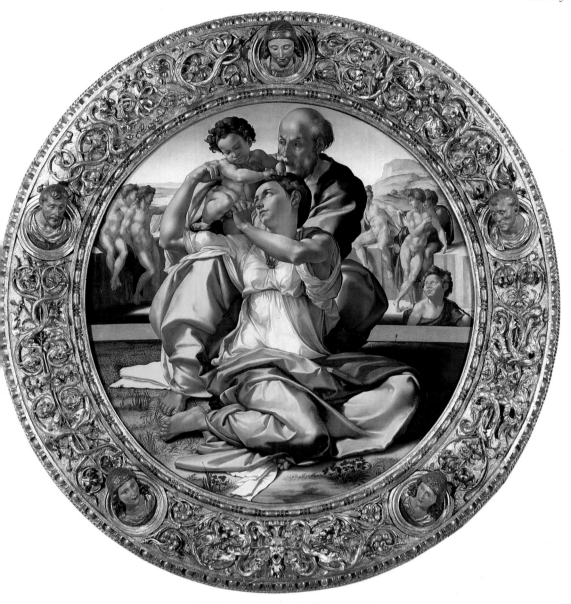

Michelangelo: Holy Family (Doni Tondo)

thought to be the portrait of Verrocchio or Perugino, this painting was in the past attributed to Raphael. Painted round 1500. At the Uffizi, in the Tribune, in 1704.

Fra Bartolomeo
(Savignano near Prato 1472–Florence 1517)
The Virgin Appears to Saint Bernard
Tempera on wood, 215x231
Inv. 1890, 8455
Commissioned on November 18, 1504 by Bernardo del Bianco for his chapel in the Badia Fiorentina; completed in 1507. At the Uffizi since 1945.

Mariotto Albertinelli
(Florence 1474–1515)
Annunciation, Nativity and Presentation in the Temple
Tempera on wood, 23x150
Inv. 1890, 1586
It is the predella of the Visitation painted in 1503 for the chapel of the Congregazione di San Martino in Florence, which later became the church of Santa Elisabetta. At the Uffizi since 1794.

Mariotto Albertinelli
Visitation
Tempera on wood, 232x146
Inv. 1890, 1587
See previous entry. At the Uffizi since 1786.

The recent cleaning (1985) of the painting and frame of the *Doni Tondo* – one of the fundamental works in the formation of artists active in the first half of the 16th century – has offered us the opportunity to reconsider some of the theories proposed by scholars in the past. Among other things we are now able to identify the Hellenistic models that inspired Michelangelo for the poses of his figures; and among the classical sculptures the most important was undoubtedly the *Laocoon*, which was discovered in January 1506, so that we can now date the painting between 1506 and 1508.

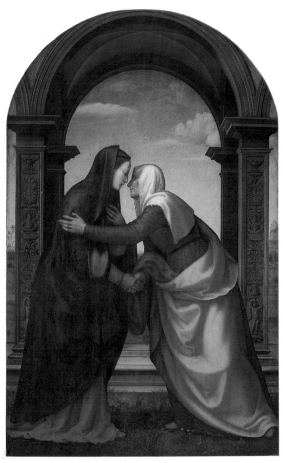

Mariotto Albertinelli: Visitation

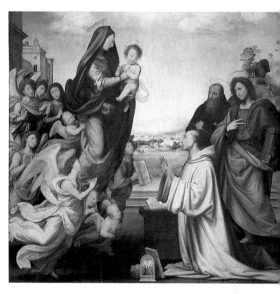

Fra Bartolomeo: The Virgin Appears to Saint Bernard

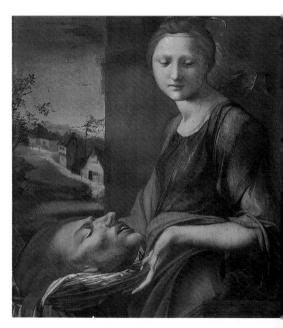

Alonso Berruguete: Salome with the Baptist's Head

Francesco Granacci: Joseph Presents his
Father and Brothers to the Pharaoh

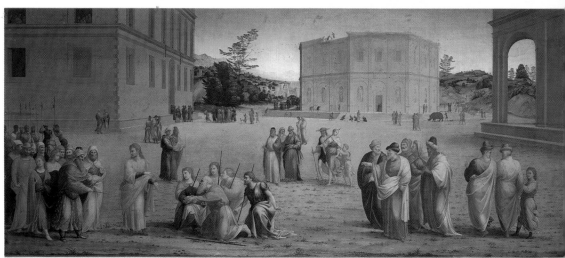

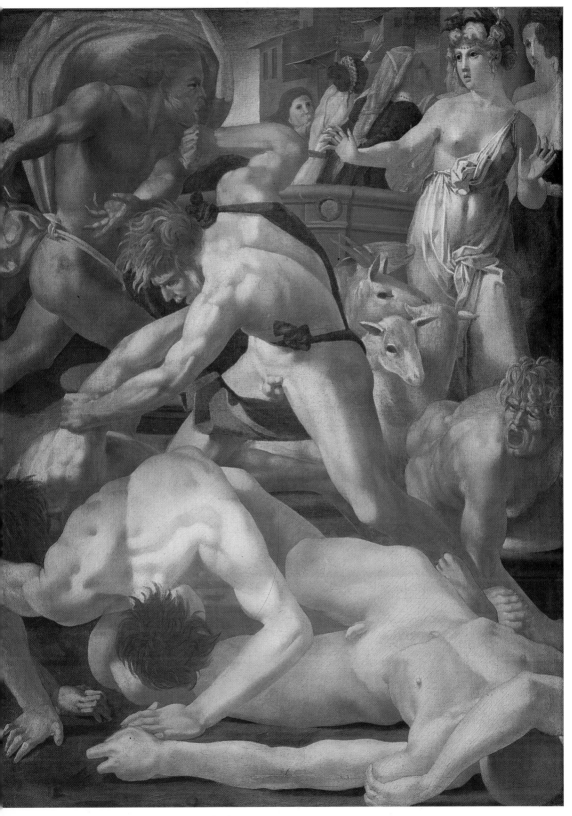

osso Fiorentino: Moses Defends the Daughters of Jethro

ROOM 26
The Raphael and Andrea del Sarto Room

This room, which was re-arranged after the end of the last war, houses the majority of the paintings of the Uffizi's Raphael collection, with the exception of the two portraits in the Correggio Room. It is a concise but splendid anthology of famous works which trace the artist's development from his training with Perugino, through the impact of his contact with the Florentine artistic tradition, to his assimilation of the classical atmosphere of Rome. From the *Portrait of an Unknown Man*, identified by some scholars as Francesco Maria della Rovere, painted at the beginning of the 16th century, one moves to the *Madonna of the Goldfinch*, painted for the Florentine Lorenzo Nasi and clearly influenced by the work of Leonardo and Michelangelo, and finally to the *Self-portrait* of 1506, the *Portrait of Julius II* (in part painted by assistants) and *Leo X with his Cardinals*, mature works that show the influence of the Flemish and Venetian portraitists.
Next to the works of Raphael are those of Andrea del Sarto, the painter who, after the

departure of the three great masters of the Renaissance, remained in Florence as a repository of the great tradition and created a new artistic vision which blended the religious classicism of Fra Bartolomeo with the titanic vision of Michelangelo, the "sfumato" of Leonardo and Raphael's early style.
The room houses one of Andrea's master pieces, the famous *Madonna of the Harpies*. A recent restoration has allowed a deeper more profound study of the work and its use of both colour and space. Also in this room are Andrea's *Saint James* and part of his Vallombrosa altarpiece, both late works painted on the eve of the siege of Florence (1529).
Directly opposed to Andrea's serenity and celestial vision is the feverish, visionary world of the introspective Pontormo, to whom the next room is dedicated and who is represented here by the tormented figure of *Saint Anthony Abbot* and the frenzied scene of the *Martyrdom of Saint Maurice and the Theban Legion*, which shows a careful study of Northern, especially German, engravings.

Andrea d'Agnolo called Andrea del Sarto
(Florence 1486–1530)
Saint James
Oil on canvas, 159x86
Inv. 1890, 1583
Painted in 1528/9 as a banner for the Compagnia di San Jacopo del Nicchio in Florence. At the Uffizi since 1795.

Andrea del Sarto
Saints Michael, Giovanni Gualberto, John the Baptist, Bernardo degli Uberti and Stories from their Lives
Tempera on wood, 184x172 (overall)
Inv. 1890, 8395
Part of the altarpiece of the church of Romitorio delle Celle at Vallombrosa; painted in 1528 according to the date below Saint Michael. At the Uffizi since 1919.

Jaopo Carrucci called Pontormo
(Pontorme near Empoli 1494–Florence 1556)
Saint Antony Abbot
Oil on canvas, 78x66
Inv. 1890, 8379

Painted around 1518/9. At the Uffizi since 1919.

Jacopo Pontormo
Martyrdom of Saint Maurice and the Theban Legion
Tempera on wood, 46x45
Inv. 1890, 1525
According to Vasari, painted probably in 1529/30 for Carlo Neroni as a copy of the painting of the same subject in the Palatine Gallery. At the Uffizi since 1704.

Raffaello Sanzio called Raphael
(Urbino 1483–Rome 1520)
Portrait of a Man, thought to be Francesco Maria della Rovere
Tempera on wood, 48x35.5
Inv. 1890, 8760
Painted probably in 1503/4, it is thought to be the portrait of the Montefeltro's successor as ruler of Urbino. At the Uffizi since 1928.

Raphael
Self-portrait
Tempera on wood, 47.5x33
Inv. 1890, 1706

Recent technical tests have brought to light the drawing underneath, confirming that it is indeed an authentic self-portrait, painted around 1506. From the collection of Cardinal Leopoldo de' Medici; at the Uffizi since 1682.

Raphael
Madonna of the Goldfinch
Tempera on wood, 107x77
Inv. 1890, 1447
Painted in 1505/6 for Lorenzo di Bartolomeo Nasi, on the occasion of his wedding to Sandra di Matteo Canigiani. In 1547 it was damaged by the collapse of the building it was in. From the collection of Cardinal Giovan Carlo de' Medici; at the Uffizi since 1666.

Raphael
Pope Leo X with Cardinals Giulio de' Medici and Luigi de' Rossi
Tempera on wood, 155.5x119.5
Inv. 1890, 40
Painted before September 1518, when Raphael left for Florence where he was to

represent the pope at the wedding of Lorenzo de' Medici with Maddalena de la Tour d'Auvergne. At the Uffizi, in the Tribune, in 1589.

Raphael and assistants
Pope Julius II
Tempera on wood, 108.5x80
Inv. 1890, 1450
Painted around 1512; connected to the other autograph version in the National Gallery, London. At the Uffizi since 1704.

Pier Francesco di Jacopo Foschi
(Florence 1502–1567)
Portrait of a Man
Tempera on wood, 65x50
Inv. 1890, 1483
Previously attributed to Pontormo; painted in the 1430s. At the Uffizi since 1773.

Jacopo Pontormo
Portrait of a Woman with Spindles
Tempera on wood, 76x54
Inv. 1890, 1480
Painted in 1514/7. At the Uffizi since 1773.

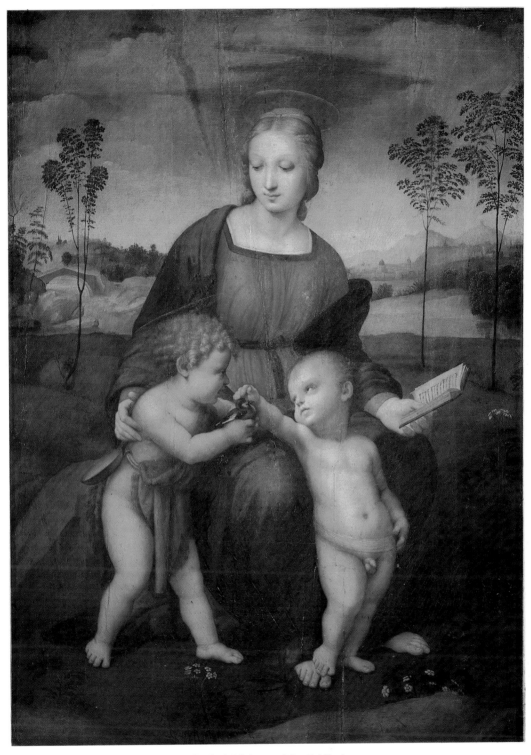

Raphael: Madonna of the Goldfinch

Andrea del Sarto
Madonna of the Harpies
Tempera on wood, 207x178
Inv. 1890, 1577
Signed and dated 1517. Begun
on May 14, 1515, the date of
the contract signed with the
Poor Clares of the convent of

San Francesco de' Macci, who
had commissioned the painting.
At the Uffizi, in the Tribune, in
1785.

**Francesco Ubertini called
Bachiacca**
(Florence 1494–1557)

Deposition
Tempera on wood, 93x71
Inv. 1890, 511
Probably from the convent of
Santa Maria degli Angeli.
Painted in 1517/8. At the
Uffizi since 1867.

**Domenico Ubaldini called
Puligo**
(Florence 1492–1527)
Portrait of Piero Carnesecchi
Tempera on wood, 59.5x39.5
Inv. 1890, 1489
Probably painted in 1527. At
the Uffizi since 1797.

121

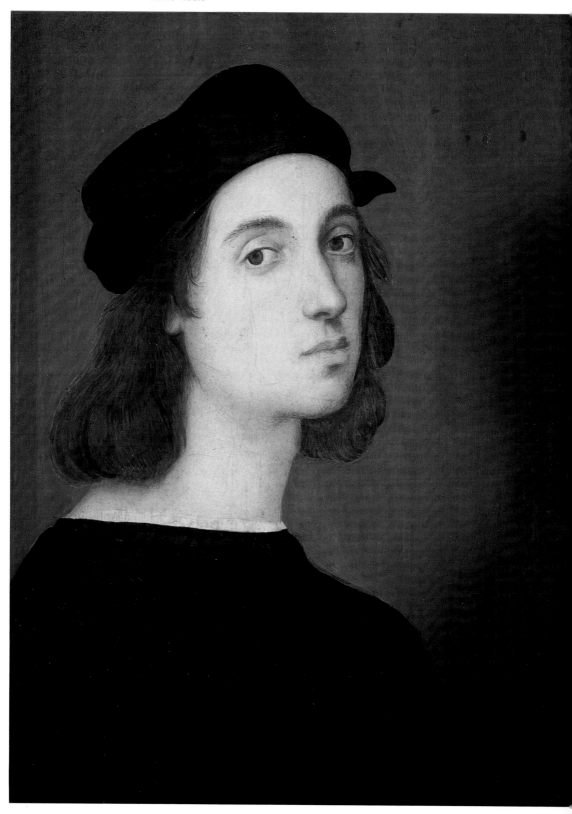

Raphael: Self-portrait

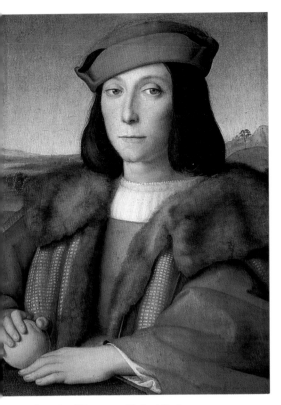

aphael: Portrait of Francesco Maria della Rovere

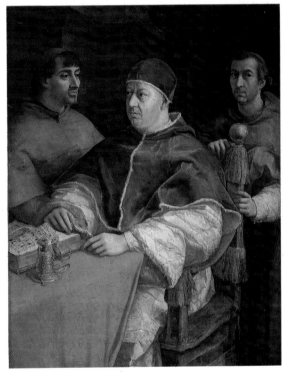

Raphael: Portrait of Leo X with the Cardinals

aphael: Portrait of Julius II

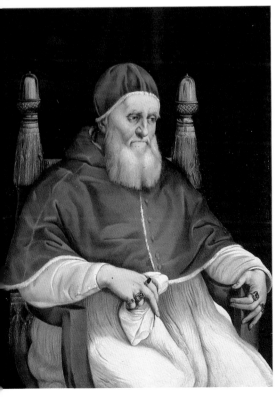

Recent studies (1984) have confirmed the authenticity of Raphael's *Self-portrait*. The Gallery also possesses the *Portrait of a Man*, which was painted just before Raphael moved to Florence and shows strong Umbrian and Northern influences; the *Madonna of the Goldfinch*, the artist's first experience in this type of composition; the *Portrait of Julius II*, painted to a large extent by assistants on cartoons by Raphael; and the triple portrait of *Leo X with the cardinals*, a solemn and classical composition that reveals Venetian influence in particular in the vast range of bright colours.

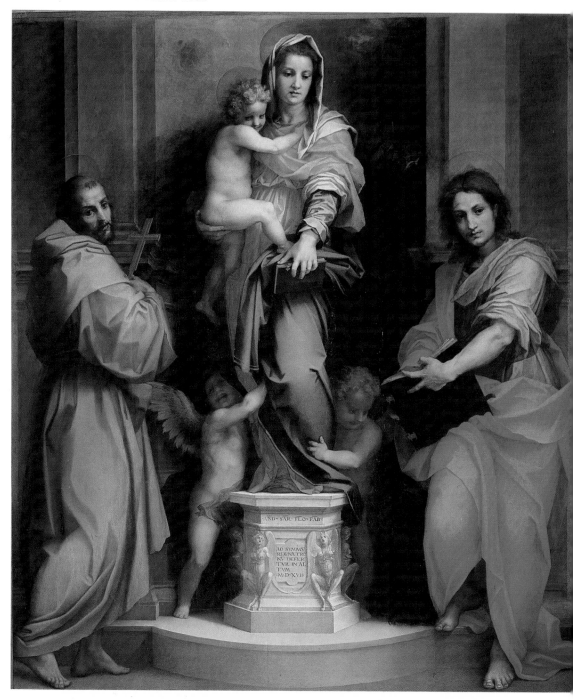

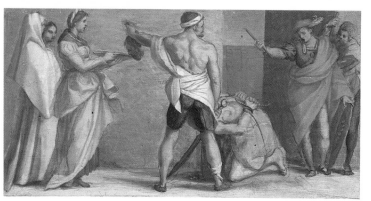

ndrea del Sarto: Madonna of the Harpies

ntormo: Saint Antony Abbot

ndrea del Sarto: Beheading of John the Baptist and
o angels, from the predella of the Vallombrosa Altarpiece

Room 27
The Pontormo and Rosso Fiorentino Room

As a direct development of the works exhibited in the two preceding ones, this room houses works by the two famous pupils of Andrea del Sarto. These disciples, however, developed according to very different artistic lines with the firm intention of breaking away from the classicism of their master.

In the case of Jacopo Pontormo, the blend of Michelangelo's "terribilità" as observed in the frescoes of the Sistine Chapel on the one hand, and the intense study of Dürer's engravings on the other, led to the unconventional style of the *Supper at Emmaus* from the monastery of Galluzzo. This painting creates an atmosphere that seems suspended, as if by magic, between the brilliant clothes of the diners, the stupendous realistic touches of the objects on the table and the expressive, almost bewitched, faces of the Carthusian monks turned towards the spectator.

Together with other paintings by Pontormo it was only natural to place the *Portrait of a Young Girl* by the young Rosso Fiorentino. Also by Rosso is a *Madonna and Child with*

Saints (1518), which so disturbed the dono when he saw a preparatory sketch, as Vasa tells us, because the "cruel and desperate a pearance" of the figures transformed "a those saints into devils." It was not the fir time the artist had provoked such a reactic to his work. His anti-conformist approac sharp and visionary, based on a fiery, surre use of colour applied to a sketchy desig found its most spectacular application, thre years later, in the Volterra *Deposition*.

It is interesting to compare such a restles bizarre style to the paintings of Pontorm pupil, Bronzino, which are also in this roon The *Holy Family with Young Saint John*, painte around 1540, shows how the fervour ar tensions of Pontormo could be smooth over, controlled and used in the official art the Court. This was a sophisticated, pleasir art, much admired by the Court and the Flo entine bourgeoisie for the perfection of i draughtsmanship, the smooth finish of i surface and the supreme harmony of i overall composition.

Jacopo Carrucci called Pontormo
(Pontorme near Empoli 1494–Florence 1556)
Madonna and Child with Saints
Tempera on wood, 73x61
Inv. 1890, 1538
Probably painted in 1520/5. In the collection of the Grand Dukes in 1666; date of entry unknown.

Domenico di Giacomo di Pace called Beccafumi
(Valdibibiena near Siena *c* 1486–Siena 1551)
Holy Family with the Young Saint John
Tempera on wood, diam. 84
Inv. 1890, 780
Painted around 1518/20. At the Uffizi since 1795.

Francesco Ubertini called Bachiacca
(Florence 1494–1557)
Stories from the Life of Saint Acasius
Tempera on wood, 37.5x256
Inv. 1890, 877
Originally the predella for the altarpiece showing the Martyrdom of Saint Acasius by Giovannantonio Sogliani, commissioned in 1521 by

Alfonsina Orsini for the church of San Salvatore at Camaldoli and today in San Lorenzo. At the Uffizi since 1861.

Giovan Battista di Jacopo called Rosso Fiorentino, attr.
(Florence 1495–Fontainebleau 1540)
Portrait of a Young Girl
Tempera on wood, 45x33
Inv. 1890, 3245
Painted in 1514/5. Date of entry unknown.

Agnolo Bronzino
(Florence 1503–1572)
Portrait of a Lady
Tempera on wood, 121x95
Inv. 1890, 793
A late work, painted probably in 1559 (the date on the painting) with the assistance of Alessandro Allori. At the Uffizi since 1675.

Giorgio Vasari
(Arezzo 1511–Florence 1574)
Adoration of the Shepherds
Tempera on wood, 90x67
Inv. 1890, 9449
Another version of the painting in the Galleria Borghese, painted in 1546 for Cardinal Salviati. It was probably

presented as a gift by the artist to Pierantonio Bandini in 1553. At the Uffizi since 1965.

Jacopo Pontormo, attr. to
Portrait of Maria Salviati
Tempera on wood, 87x71
Inv. 1890, 3565
Probably painted before 1543 when the sitter died. Maria Salviati was the wife of Giovanni dalle Bande Nere and the mother of Cosimo I de' Medici. At the Uffizi since 1911.

Jacopino del Conte
(Florence 1510–1598)
Madonna and Child with Saint John
Tempera on wood, 126x94
Inv. 1890, 6009
Painted before 1550. Formerly in Sant'Ambrogio; at the Uffizi since 1881.

Jacopo Pontormo
Portrait of a Musician
Tempera on wood, 88x67
Inv. 1890, 743
Painted around 1518. Formerly identified as the musician Francesco dell'Ajolle. At the Uffizi since 1836.

Rosso Fiorentino
Madonna and Child with Saints
Tempera on wood, 112x141
Inv. 1890, 3190
Commissioned on January 30 1518 by the hospital of Santa Maria Nuova for the church Ognissanti. At the Uffizi sinc 1900.

Jacopo Pontormo
Birth of Saint John
Tempera on wood, diam. 59
Inv. 1890, 1532
Probably painted in 1526, on the occasion of the birth of Aldighieri, first child of Girolamo della Casa and Elisabetta Tornaquinci, whos coats-of-arms appear on the reverse. At the Uffizi since 1704.

Agnolo Bronzino
Lamentation
Tempera on wood, 115x100
Inv. 1890, 8545
Painted in 1546/8. Formerly the church of Santa Trinita; a the Uffizi since 1925.

Jacopo Pontormo
Supper at Emmaus
Oil on canvas, 230x173
Inv. 1890, 8740

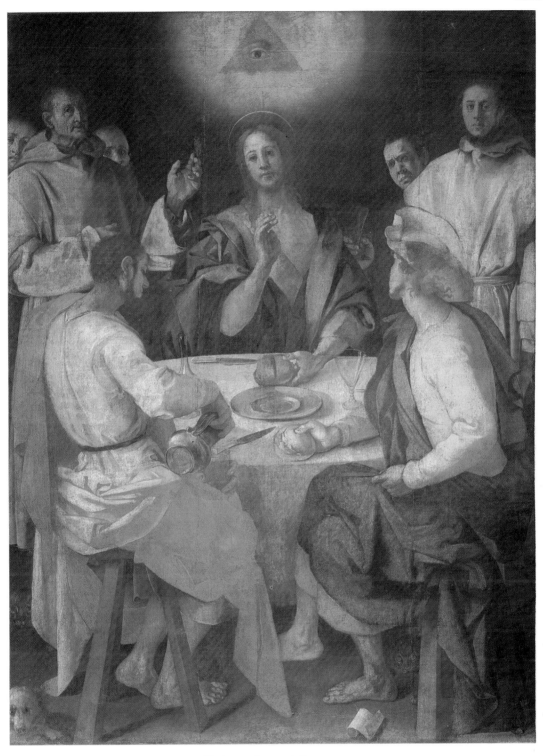

Pontormo: Supper at Emmaus

ated 1525 (on the scroll on e ground). Painted together th other works for the monks San Lorenzo at Galluzzo near orence. At the Uffizi since 48.

gnolo Bronzino

Holy Family with the Young Saint John
Tempera on wood, 117x93
Inv. 1890, 8377
Painted around 1540 for the Panciatichi family, whose portraits Bronzino also painted at about the same time (now in

the Tribune). The Panciatichi coat-of-arms appears on the banner on the tower in the top lefthand corner. At the Uffizi since 1919.

Francesco di Cristofano called Franciabigio

(Florence 1484–1525)
Portrait of a Young Man
Tempera on wood, 60x47
Inv. 1890, 8381
Monogrammed and dated 1541. At the Uffizi since 1919.

127

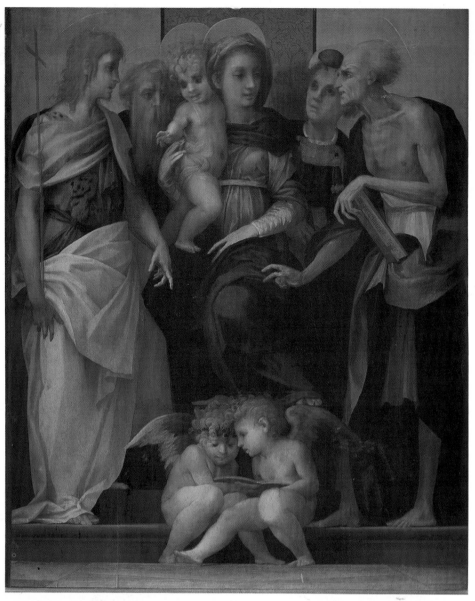

Rosso Fiorentino: Madonna and Child with Saints

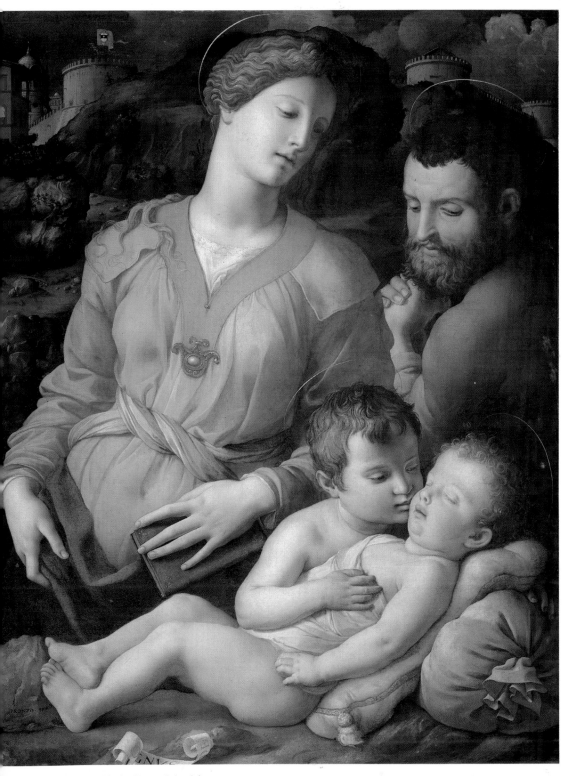

Bronzino: Holy Family with the Young Saint John

Pontormo: Birth of John the Baptist

◁

Beccafumi: Holy Family with the Young Saint John

ROOM 28
The Titian Room

This room (and the following ones until Room 32) appeared on the Gallery floor plan as early as the 16th century, but they were designated for different purposes. They were used as service rooms, rooms for the director and the staff, as well as libraries or storerooms. Only in this century were they turned into exhibition rooms and, from 1926 on, 16th-century paintings (primarily from the Veneto) have been shown here in an order very similar to the present one. They are now also joined by way of the "Corridor of the Cinquecento" to the Veronese Room, established much earlier.

This is the first room dedicated to the great Venetian painting of the Renaissance: here are masterpieces that differ distinctly from the Tuscan works in the preceding rooms. Instead of cool colours, subtle intellectual exercises interested primarily in design, here one finds new, warmer colours, a living and vibrant interpretation of classical forms, a play of light over the rich colours; in short, a different and distinctive way of "fare pittura." Titian was surely the protagonist of this

new manner, as is confirmed in the *Flor* painted in the second decade of the centur pale and golden, she seems to have escape the melancholy of Giorgione's wome thanks to a concrete and living sense of m ture womanhood. Next to it is the celebrate *Venus of Urbino* (added to the Medici Colle tion in 1631, an inheritance from the Del Rovere family of Urbino), a painting symbo lic of Titian's poetic vision and gifted style c expression. Far more studied, and worke with a heavy impasto of colour derived fro an attention to Mannerism, is the late wor *Venus and Cupid*.

In this room are three important examples c Titian's mastery in portraiture; supreme i this field, he was much sought after by rule and by his famous contemporaries.

Here one finds also the work of another e ponent of Venetian painting: Palma il Ve chio, who trained under Titian and Gio gione but managed to evolve his own seren poetic style, based on large landscape con positions well suited to his richly colourfu figures, as in the *Holy Family with Saints*.

Tiziano Vecellio called Titian
(Pieve di Cadore *c* 1488–Venice 1576)
Bishop Ludovico Beccadelli
Oil on canvas, 117.5x97
Inv. 1890, 1457
Signed and dated 1552. Bought by Cardinal Leopoldo de' Medici in 1653; at the Uffizi since 1704.

Titian
Venus and Cupid
Oil on canvas, 139.5x195.5
Inv. 1890, 1431
Presented as a gift to Cosimo II de' Medici in 1619 by Paolo Giordano Orsini; at the Uffizi since 1635.

Francesco Beccaruzzi
(Conegliano *c* 1492–Treviso before 1563)
Portrait of a Man
Oil on canvas, 108x92
Inv. 1890, 908
Painted around 1550. From the

inheritance of Cardinal Leopoldo de' Medici; at the Uffizi since 1794.

Jacopo Negretti called Palma il Vecchio
(Serina near Bergamo *c* 1480–Venice 1528)
Holy Family with the Young Saint John and Mary Magdalen
Oil on wood, 87x117
Inv. 1890, 950
Acquired in 1793 thanks to an exchange with the Imperial Galleries in Vienna.

Palma il Vecchio
Resurrection of Lazarus
Oil on wood, 94x110
Inv. 1890, 3256
Signed along the border of the sarcophagus lid. Purchased in 1916.

Paolo Pino
(active in Venice in the mid-16th century)
Portrait of Doctor Coignati

Oil on canvas, 89x74
Inv. 1890, 968
Signed and dated 1534. At the Uffizi since 1817.

Sebastiano Florigerio
(Conegliano *c* 1500–1543)
Portrait of Raffaele Grassi
Oil on canvas, 127x103
Inv. 1890, 894
Purchased by Cardinal Leopoldo de' Medici before 1675; at the Uffizi since 1794.

Titian
Francesco Maria della Rovere
Oil on canvas, 114x103
Inv. 1890, 926
Painted in 1536/8. Arrived in Florence in 1631, together with the rest of Vittoria della Rovere's inheritance; at the Uffizi since 1795.

Titian
Eleonora Gonzaga della Rovere
Oil on canvas, 114x103
Inv. 1890, 919

Painted in 1536/8. Arrived in Florence in 1631, together wi the rest of Vittoria della Rovere's inheritance; at the Uffizi since 1796.

Palma il Vecchio
Judith
Oil on wood, 90x71
Inv. 1890, 939
A late work, painted around 1525/8. Arrived in Florence i 1631 with the della Rovere inheritance; at the Uffizi since 1798.

Titian
Portrait of a Knight of Malta
Oil on canvas, 80x64
Inv. 1890, 942
In the collection of Cardinal Leopoldo de' Medici in 1654; the Uffizi since 1798.

Titian
Venus of Urbino
Oil on canvas, 119x165
Inv. 1890, 1437

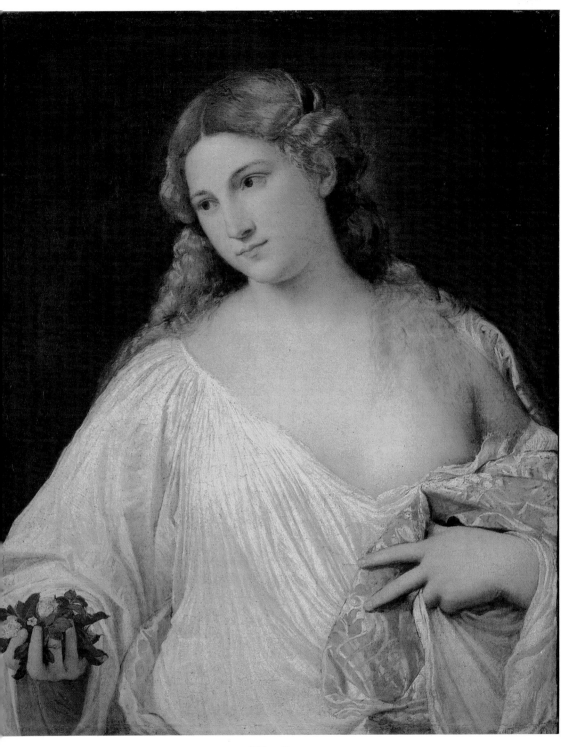

Titian: Flora

ommissioned in 1538 by
uidubaldo della Rovere.
rrived in Florence in 1631
th the della Rovere
heritance; at the Uffizi since
'36.

itian
ora
l on canvas, 79.7x63.5
v. 1890, 1462

Until 1641 in the collection of
Alfonso Lopez in Amsterdam;
at the Uffizi since 1793.

Titian
Portrait of Caterina Cornaro as
Saint Catherine of Alexandria
Oil on canvas, 102.5x72
Inv. 1890, 909
Dated 1542 (?). At the Uffizi, in
the Tribune, in 1777.

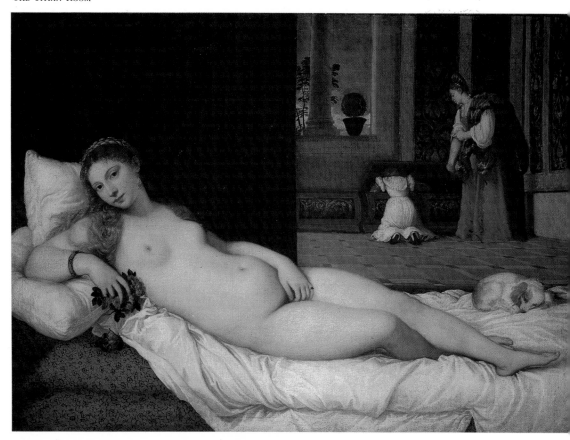

Titian: Venus of Urbino

Titian: Francesco Maria della Rovere

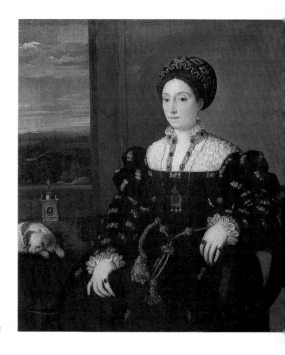

Titian: Eleonora Gonzaga della Rovere

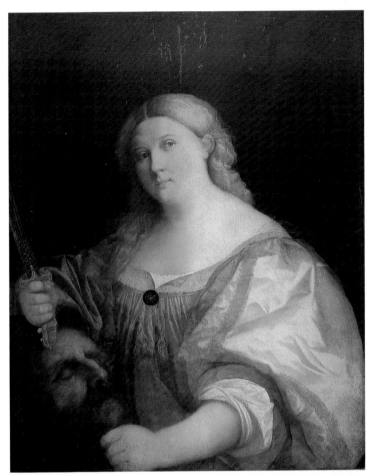

Palma il Vecchio: Judith

Palma il Vecchio: Holy Family with the Young
Saint John and Mary Magdalen

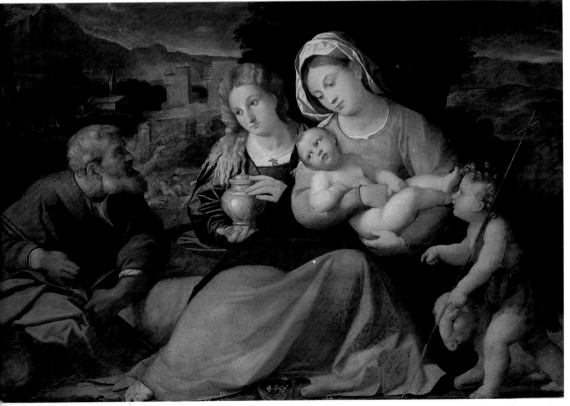

Room 29
The Parmigianino Room

In this room and in the two following ones the Gallery exhibits a wide range (though not a complete panorama) of paintings from Northern Italy, with special emphasis on the region of Emilia and the cities of Bologna, Parma and Ferrara. These active centres of 16th-century art are represented here by painters who, although expressing themselves in different styles, show the vitality as well as the variety of Emilian artistic development.

Leaving the Titian Room one notices first the most famous of the Emilian Mannerists, Parmigianino, with his undoubted masterpiece, the so-called *Madonna of the Long Neck*, a late work that sums up the extraordinar[y] gifts of the painter. The elongation of the f[i]gures is extremely evident, to the extent [of] almost creating abstract geometrical form[s]; the choice of colours and the exquisite detai[l] are remarkable and the disturbing expre[s]sions of the flawless faces of the group at th[e] left are like so many coloured cameos. Th[e] *Madonna and Child with Saints*, known as th[e] *Madonna di San Zaccaria*, is an early work wit[h] echoes of Correggio and Raphael, with cla[s]sical overtones in the threatening atmo[s]phere of the landscape, but which neverthe[less] remains a work filled with the strong[ly] individual style of the painter from Parma.

Francesco de' Rossi called Cecchino Salviati
(Florence 1510–Rome 1563)
Nativity
Oil on wood, 85x108
Inv. Palatina, 114
Of unknown provenance; at the Uffizi since around 1949.

Domenico di Giacomo di Pace called Beccafumi
(Valdibibiena near Siena *c* 1486–Siena 1551)
Escape of Clelia and the Roman Virgins
Oil on wood, 74x122
Inv. 1890, 6057
At the Uffizi at least since 1880.

Luca Cambiaso
(Moneglia 1527–Madrid 1585)
Madonna and Child
Oil on canvas, 74.3x59.5
Inv. 1890, 776
At the Uffizi in 1635; transferred to other galleries and returned to the Uffizi in 1972.

Pietro Bonaccorsi called Perin del Vaga
(Florence 1501–Rome 1547)
Tarquinius Superbus Founds the Temple of Jove on the Capitol
Fresco transferred to canvas, 132x150
Inv. 1890, 5907
Removed in 1830 from Palazzo Baldassini in Rome together

with the other fresco (see below, Inv. 1890, 5380).
Purchased in 1880.

Ippolito Scarsella called Scarsellino
(Ferrara *c* 1550–1620)
Judgment of Paris
Oil on copper, 51x73.5
Inv. 1890, 1382
From the Medici collections; at the Uffizi since 1796.

Benvenuto Tisi called Garofalo
(Ferrara 1481–1559)
Annunciation
Oil on wood, 55.2x76
Inv. 1890, 1365
At Palazzo Pitti in the early 18th century; at the Uffizi since 1773.

Francesco Mazzola called Parmigianino
(Parma 1504–Casalmaggiore 1540)
Madonna and Child with Angels, known as the "Madonna with the Long Neck"
Oil on wood, 219x135
Inv. Palatina 230
Painted in 1534/40 for the church of the Servites in Parma. Purchased by Ferdinando de' Medici in 1698; at the Uffizi since 1948.

Parmigianino
Portrait of a Man
Oil on wood, 88x68.5
Inv. 1890, 1623
Catalogued as a self-portrait in Cosimo III de' Medici's collection. At the Uffizi since 1682.

Parmigianino
Madonna and Child with Saints, known as "Madonna di San Zaccaria"
Oil on wood, 75.5x60
Inv. 1890, 1328
Painted for Count Giorgio Manzuoli in Bologna. At the Uffizi, in the Tribune, in 1605.

Lavinia Fontana
(Bologna 1552–Rome 1614)
Jesus Appears to Mary Magdalen
Oil on canvas, 80x65.5
Inv. 1890, 1383
Signed and dated 1581. From the estate of Don Antonio de' Medici da Capistrato; at the Uffizi since 1632.

Perin del Vaga
The Justice of Seleucus
Fresco transferred to canvas, 148x197
Removed in 1830 from Palazzo Baldassini in Rome together with the other fresco (see above, Inv. 1890, 5907).
Purchased in 1880.

Ludovico Mazzolino
(Ferrara *c* 1480–1528)
Adoration of the Shepherds
Oil on wood, 79.5x60.5
Inv. 1890, 1352
From Palazzo Pitti; at the Uffi[zi] since 1880.

Girolamo da Carpi
(Ferrara 1501–1556)
Jesus in the House of Mary and Martha
Oil on wood, 59.5x39.5
Inv. 1890, 1354
From Palazzo Pitti; at the Uffi[zi] since 1796.

Amico Aspertini
(Bologna 1474/5–1552)
Adoration of the Shepherds
Oil on wood, 44.5x34
Inv. 1890, 3803
Presented to the Uffizi by Bernard Berenson in 1914.

Ludovico Mazzolino
Slaughter of the Innocents
Oil on wood, 49x59
Inv. 1890, 1350
At the Uffizi since 1704.

Battista Franco called Semolei
(Venice 1498–1561)
Calvary
Oil on canvas, 115x118
Inv. 1890, 9490
Signed and dated 1552; purchased in 1975.

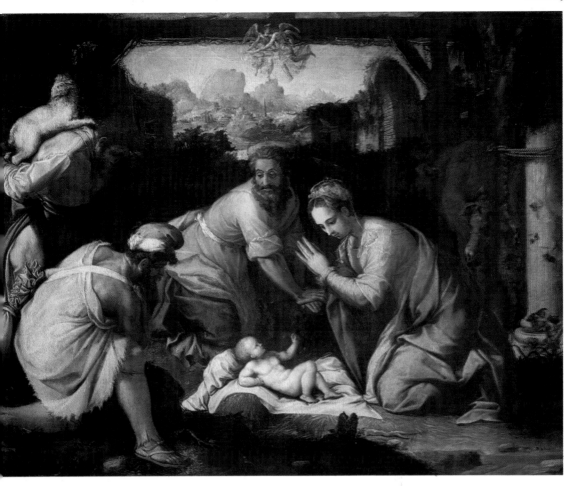

ecchino Salviati: Nativity

erin del Vaga: Tarquinius
uperbus Founds the Temple
f Jove on the Capitol

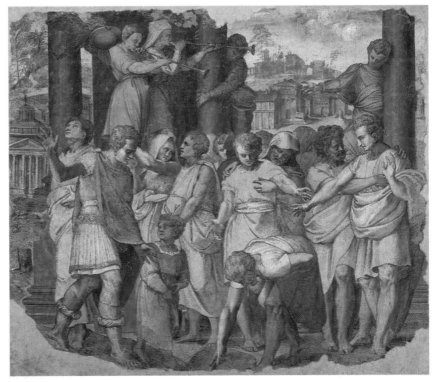

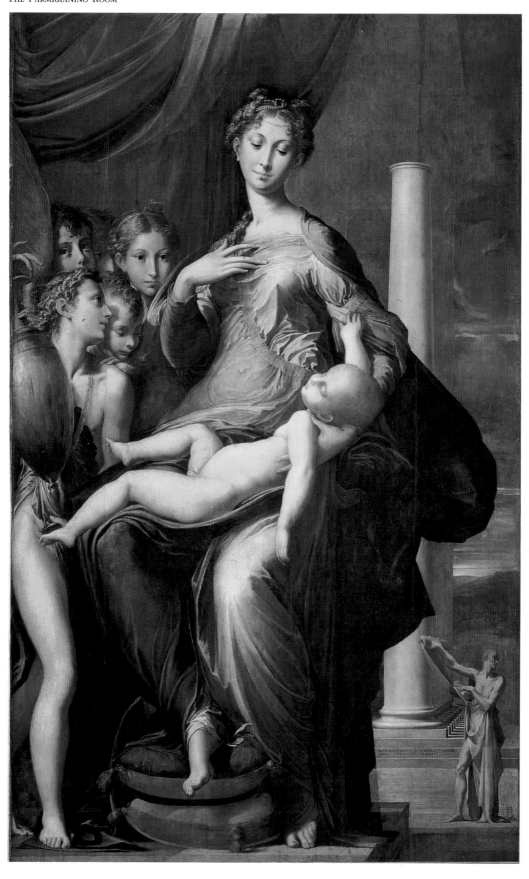

Parmigianino: Madonna with the Long Neck

ROOM 30
Emilian Painting

Ludovico Mazzolino was active in Ferrara where he painted in the unconventional and imaginative manner that was typical of this city. His compositions are crowded, teeming with figures, rich in detail, characteristics due, at least in part, to his acquaintance with the paintings of Northern Europe. The tumultuous scene showing the *Slaughter of the* *Innocents* or the over ornate *Madonna and Child with Saints* are excellent examples of Mazzolino's work.

In the same room there are also some small paintings by Dosso Dossi and by Garofalo as well as a beautiful portrait by Niccolò dell'Abate, one of the most elegant and sophisticated Emilian Mannerists.

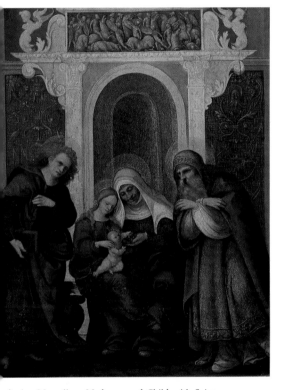

Ludovico Mazzolino: Madonna and Child with Saints

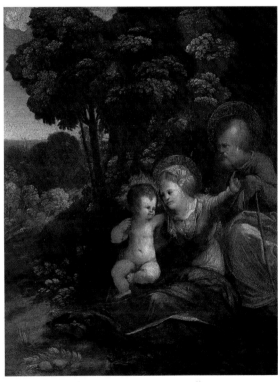

Dosso Dossi: Rest on the Flight into Egypt

Ludovico Mazzolino
(Ferrara *c* 1480–1528)
Madonna and Child with Saints
Oil on wood, 29.5x22.8
Inv. 1890, 1347
Probably purchased by
Ferdinando de' Medici. At the
Uffizi since 1773.

Niccolò Pisano
(Doc. 1484–1538)
Holy Family
Oil on wood, 61.8x49.7
Inv. 1890, 8543
Acquired by the Florentine
Galleries in 1911 from the

Intendenza di Finanza; at the
Uffizi since 1925.

Niccolò dell'Abate
(Modena *c* 1509–doc. France
1571)
Portrait of a Young Man
Oil on wood, 47x41
Inv. 1890, 1377
From Palazzo Pitti; at the Uffizi
since 1796.

**Emilian Artist of the 16th
Century**
The Vision of Saint Aldegonda
Tempera on wood, 21x34

Inv. 1890, 1357
Formerly (*c* 1705) in Palazzo
Pitti; at the Uffizi since 1773.

**Giovan Battista Luteri
called Dosso Dossi**
(Ferrara *c* 1489–1542)
Rest during the Flight into Egypt
Tempera on wood, 52x42.6
Inv. 1890, 8382
From Palazzo Pitti; at the Uffizi
since 1919.

**Benvenuto Tisi called
Garofalo**
(Ferrara 1481–1559)

Christ and the Tribute Money
Oil on wood, 20x22
Inv. 1890, 1353
First mentioned in the
inventory of Palazzo Pitti in the
period 1702/10; at the Uffizi
since 1753.

Ludovico Mazzolino
Circumcision
Oil on wood, 40x29
Inv. 1890, 1355
From Palazzo Pitti; at the Uffizi
since 1796.

ROOM 31
The Dosso Dossi Room

In some ways similar to Mazzolino, at least in his fanciful imagination, is Dosso Dossi. He showed a profound understanding of the works of Titian in his classical compositions, but changed the pure Venetian style to one that was both more sensual and more extravagant. The strong and brilliant colours, the expressions of the faces, at times exaggerated, the dramatic tension in the atmosphere — these are the means that Dosso uses to create an effect such as the one in the great painting known as *Witchcraft*, where the gestures and expressions of the figures are as self-explanatory as the meaning of the painting is mysterious.

Also in this room is Sebastiano del Piombo' splendid portrait of an unknown woman which used to be called the Fornarina. H use of colour is undoubtedly Venetian, eve though the influence of Roman art is also un mistakable. The portrait of a *Sick Ma* which is exhibited here as a companion piec to the portrait of the woman, has recent been attributed to Titian, for the overall qu lity is so extraordinary, sensitive and monu mental at the same time.

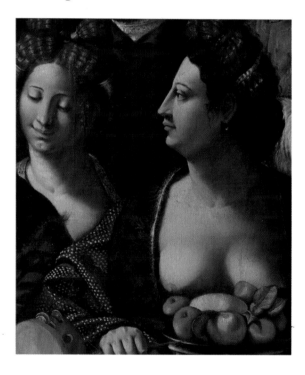

Dosso Dossi: Witchcraft, detail

Venetian Artist of the 16th Century
Old Man
Paper on wood, 57x40
Inv. 1890, 7103
Mentioned for the first time in the inventory of the Uffizi of 1890.

Tiziano Vecellio called Titian
(Pieve di Cadore *c* 1488–Venice 1576)
Portrait of a Man, "The Sick Man"
Oil on canvas, 81x60
Inv. 1890, 2183
Dated 1514. Formerly attributed to Leonardo and to Sebastiano del Piombo. From the collection of Cardinal Leopoldo de' Medici; at the Uffizi, in the Tribune, in 1704.

Giovan Battista Luteri called Dosso Dossi
(Ferrara *c* 1489–1542)
Witchcraft, or Allegory of Hercules
Oil on canvas, 143x144
Inv. Palatina 148
In the collection of Cardinal Leopoldo de' Medici from 1665; at the Uffizi since 1950.

Sebastiano Luciani called Sebastiano del Piombo
(Venice *c* 1485–Rome 1547)
Portrait of a Woman
Oil on wood, 68x55
Inv. 1890, 1443
Dated 1512. At the Uffizi, in the Tribune, in 1589.

Dosso Dossi
Portrait of a Warrior
Oil on canvas, 86x70
Inv. 1890, 889
At the Uffizi since 1798.

Dosso Dossi
The Virgin Appears to Saints John the Baptist and John the Evangelist
Oil on wood transferred to canvas, 153x114
Inv. Dep. 7
From the church of San Martino at Codigoro. At the Uffizi since 1913.

Lorenzo Lotto
(Venice *c* 1480–Loreto *c* 1556
Portrait of a Youth
Oil on wood, 28x22
Inv. 1890, 1481
Originally the property of the Cornaro family in Venice, fron whom Cardinal Leopoldo de' Medici purchased it in 1669. A the Uffizi since 1675.

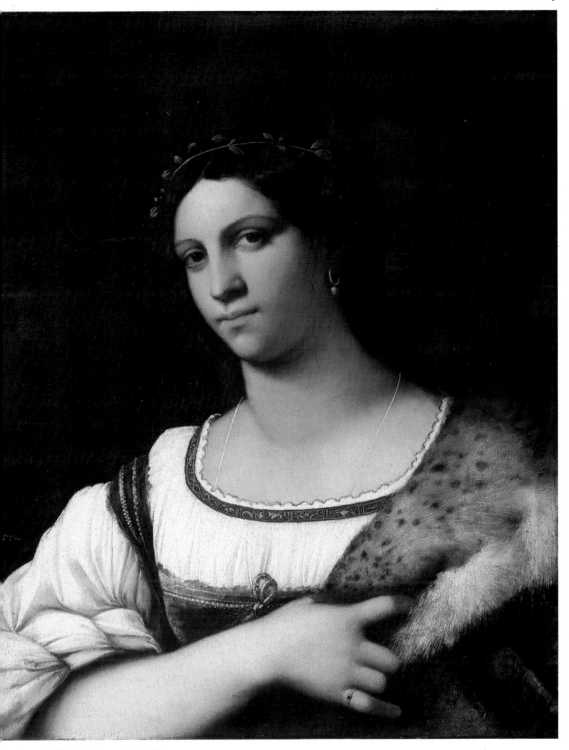

ebastiano del Piombo: Portrait of a Woman

Dosso Dossi: Witchcraft

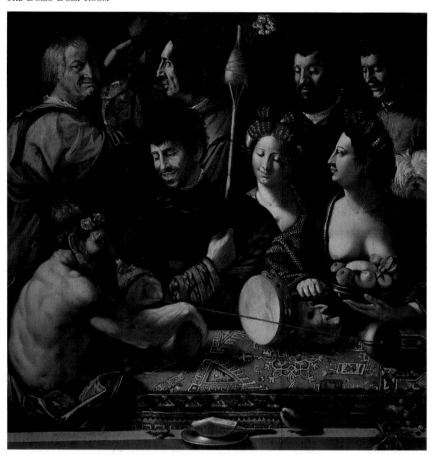

Dosso Dossi: The Virgin Appears to Saints John
the Baptist and John the Evangelist

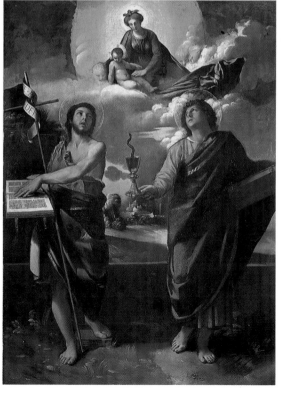

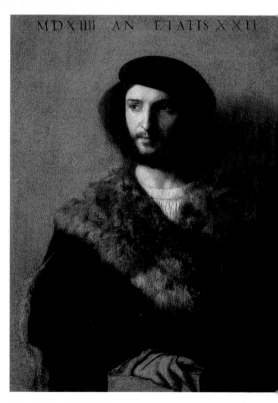

Titian: "The Sick Man"

ROOM 32
The Sebastiano del Piombo and Lorenzo Lotto Room

Here one continues with the Venetian painting of the 16th century, a period introduced in the previous room by the paintings of Sebastiano del Piombo. Evidence of Michelangelo's influence on Sebastiano while he was in Rome is provided by the large canvas showing *The Death of Adonis*, with its monumental composition and the statuesque nudes in the foreground. However, the use of "chiaroscuro" which attenuates the sculptural character of the figures, and the melancholy, twilight atmosphere of the background still preserve a great deal of the lessons learned from Giorgione. In fact, the memory of Venice is particularly evident in the lovely view of the Lagoon and the Ducal Palace.

Lorenzo Lotto, whose sensitive and perceptive *Portrait of a Young Man* is displayed in the Dossi room, is represented here by two important works showing a variety of different influences, as is the case with all the works of this indefatigable traveller, who was continuously on the move between the Marches, Rome and Lombardy. There is, however, an overall strain of Mannerism. *The Holy Family with Saints* is a typical example of his complex compositions, that use opposing movement and contrasting colours to achieve dramatic and emotional tension. The extreme accuracy of the details indicates also careful understanding of Northern painting.

The Gallery has recently acquired *Susannah and the Elders*, another complex work in which the dramatic and spectacular effects in the foreground, highlighted by dazzling colours, are balanced by the vast serene landscape in the background.

The numerous portraits by different Venetian painters of the first half of the 16th century all reveal the same source of inspiration: Titian.

Alessandro Oliverio
(active in the first half of the 16th century)
Portrait of a Man
Oil on canvas, 78x60
Inv. 1890, 1688
From the collection of Cosimo III de' Medici; at the Uffizi since 1691.

Venetian Artist of the 16th Century
Portrait of a Man
Oil on canvas, 47x39
Inv. 1890, 897
First mentioned in the inventory of the Uffizi in 1704.

Domenico Ricci called Brusasorci
(Verona 1492–1569)
Bathsheba Bathing
Oil on canvas, 91x98
Inv. 1890, 953
From the estate of Cardinal Leopoldo de' Medici (1675); at the Uffizi since 1796.

Domenico Campagnola
(Padua 1500–Venice 1581)

Portrait of a Man
Oil on canvas, 62x45.5
Inv. 1890, 895
In the collection of Ferdinando de' Medici before 1710; at the Uffizi since 1773.

Bernardino Licinio
(Pascante *c* 1490–*c* 1565)
Madonna and Child with Saint Francis
Oil on wood, 76x111
Inv. 1890, 892
In 1713 in the collection of Ferdinando de' Medici; at the Uffizi since 1769.

Lorenzo Lotto
(Venice *c* 1480–Loreto *c* 1556)
Susanna and the Elders
Oil on wood, 66x50
Inv. 1890, 9491
Signed and dated 1517.
Purchased in 1975 from the Contini Bonacossi Collection.

Venetian Artist of the 16th Century
Portrait of Teofilo Folengo (?)
Oil on wood, 83x79

Inv. 1890, 791
It appears in De Greyss's 1763 engraving of the Tribune.

Paris Bordon
(Treviso 1500–Venice 1571)
Portrait of a Knight
Oil on canvas, 115x90.5
Inv. 1890, 929
From the estate of Cardinal Leopoldo de' Medici (1675); at the Uffizi since 1795.

Sebastiano Luciani called Sebastiano del Piombo
(Venice *c* 1485–Rome 1547)
Death of Adonis
Oil on canvas, 189x285
Inv. 1890, 916
From the estate of Cardinal Leopoldo de' Medici (1675); at the Uffizi since 1798.

Paris Bordon
Portrait of a Man in Furs
Oil on canvas, 107x83
Inv. 1890, 907
From the estate of Cardinal Leopoldo de' Medici (1675); at the Uffizi since 1704.

Girolamo Muziano
(Acquafredda 1528/32–Rome 1592)
Portrait of a Man
Oil on canvas, 75x60
Inv. 1890, 891
From the Medici collections; at the Uffizi since 1798.

Emilian Artist of the 16th Century
Portrait of a Boy
Oil on wood, 58x44
Inv. 1890, 896
At the Uffizi, in the Tribune, in 1646.

Lorenzo Lotto
Holy Family with Saints Jerome, Ann and Joachim
Oil on canvas, 69x87.5
Inv. 1890, 893
Signed and dated 1534. In 1713 in the collection of Ferdinando de' Medici; at the Uffizi since 1798.

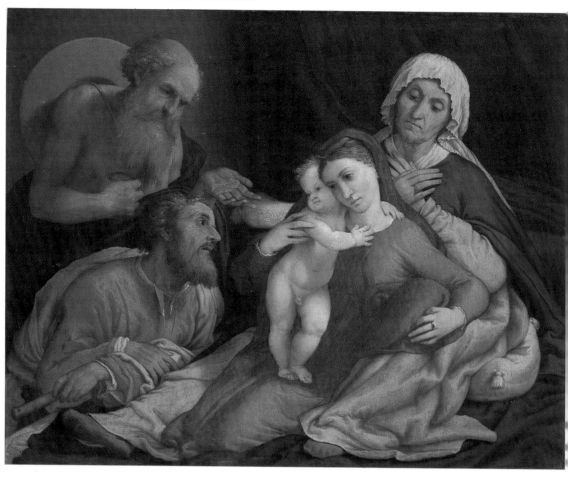

Lorenzo Lotto: Holy Family

Sebastiano del Piombo: Death of Ado

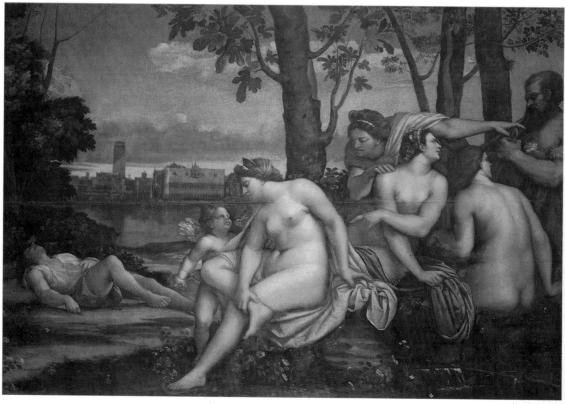

ROOM 33
The Cinquecento Corridor

In this room the display of Venetian painting is interrupted again: the works here are international, products of the craze that swept the European Courts in the 16th century for elegant and sophisticated works by Mannerist painters.

The French School is represented here by the excellent portraits of *Christine of Lorraine*, wife of the Tuscan Grand Duke Ferdinando I and of *François I*, King of France (attributed to François Clouet), both as precious as works of miniature in the extraordinary attention to details in the faces and clothing.

The Spaniard Luis de Morales reveals in his *Christ Carrying the Cross* a different cultural experience, resulting in a moving yet sinister Mannerism, devoid of elegance of form.

Particularly discerning in psychological insight are the portraits by Frans Pourbus and Christoph Amberger. Also fascinating, especially for its identification in the past with Torquato Tasso, is the *Portrait of a Man* of uncertain attribution (perhaps by Alessandro Allori); it is understandable that this melancholy, ethereal figure was in the 19th century thought to be a portrait of the unhappy poet.

The narrow passageway leading to Room 34 is filled with small, exquisite paintings, the products of Late Mannerism at the Medici Court. Giorgio Vasari, painter and architect of the Court par excellence, promoter and initiator of vast urbanistic and decorative projects, is represented here by the painting of *Vulcan's Forge*, a work typical of the learned artist's wide-ranging interests and talents. We must also mention the two small paintings on copper, late works by Bronzino, and the three splendid paintings by Jacopo Zucchi: *Age of Gold, Age of Silver* and *Age of Iron*. These, together with other small paintings by Alessandro Allori, are products of the artistic climate of the last quarter of the 16th century, which produced the final and splendid climax of Late Mannerism: the decoration of the Studiolo of Francesco I in Palazzo Vecchio. On the other hand, the two paintings by Empoli seem already part of that trend that led the artists at the end of the century to react against these forms and seek a new and simpler form of expression.

Francesco de' Rossi called Cecchino Salviati
(Florence 1510–Rome 1563)
Artemisia Mourning Mausolus
Oil on wood, 35x24.5
Inv. 1890, 1528
At the Uffizi since 1704.

Jacopo Ligozzi
(Verona 1547–Florence 1626)
Sacrifice of Isaac
Oil on wood, 51x37.5
Inv. 1890, 1337
Monogrammed on the reverse side. At the Uffizi since 1635.

Andrea Boscoli
(Florence c 1560–1606/7)
Saint Sebastian
Oil on wood, 45.5x26
Inv. 1890, 6204
First mentioned in the inventory of the Uffizi in 1890.

Martin van Valckenborch
(Louvain 1535–Frankfurt 1612)
Country Dance

Oil on wood, 48x35
Inv. 1890, 1249
From the Medici collections; at the Uffizi since 1798.

Alessandro Allori
(Florence 1535–1607)
Portrait of Bianca Cappello
Copper, 37x27
Inv. 1890, 1514
On the reverse: *Allegory of the Human Life*. At the Uffizi since 1948.

Jacopo Zucchi
(Florence 1541?–Rome or Florence 1589/90)
The Age of Gold
Oil on wood, 50x38.5
Inv. 1890, 1548
Together with two other panels (Inv. 1890, 1506 and 1509, see below) from the Villa Medici in Rome; brought to Florence in 1587 by Ferdinando I de' Medici. First mentioned in the inventory of the Uffizi in 1635.

Jacopo Zucchi
The Age of Silver
Oil on wood, 50x38.5
Inv. 1890, 1506
See previous entry.

Jacopo Zucchi
The Age of Iron
Oil on wood, 50x39
Inv. 1890, 1509
See above.

Alessandro Allori
Hercules and the Muses
Copper, 39x29
Inv. 1890, 1544
At the Uffizi, in the Tribune, in 1589.

Italian Artist of the 16th Century
Fortune
Oil on wood, 46x27
Inv. 1890, 8023
In 1649 in the Medici collection in Villa La Petraia; at the Uffizi since 1925.

Giorgio Vasari
(Arezzo 1511–Florence 1574)
Vulcan's Forge
Oil on copper, 38x28
Inv. 1890, 1558
At the Uffizi since 1589.

Orazio Samacchini
(Bologna 1532–1577)
Joseph and Potiphar's Wife
Oil on wood, 34x29
Inv. 1890, 1515
In the 1640 inventory of Palazzo Pitti; at the Uffizi since 1770.

Francesco Morandini called Poppi
(Poppi 1544–Florence 1597)
The Three Graces
Oil on copper, 30x25
Inv. 1890, 1471
In the 1798 inventory of Palazzo Pitti; at the Uffizi since 1948.

Orazio Samacchini
Susanna Bathing

Andrea Boscoli: Saint Sebastian

Alessandro Allori: Hercules and the Muses

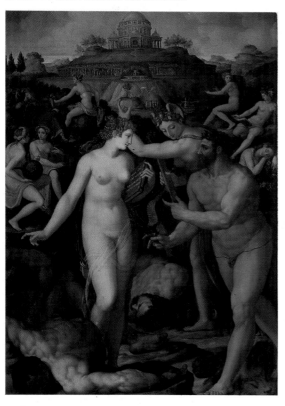

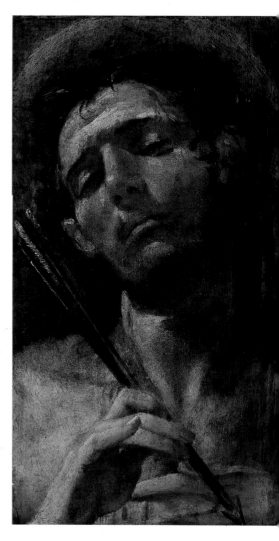

Oil on wood, 34.5x29
Inv. 1890, 1511
In the 1640 inventory of
Palazzo Pitti; at the Uffizi since
1770.

Alessandro Allori
Venus and Cupid
Oil on wood, 29x38
Inv. 1890, 1512
From the Medici collections; at
the Uffizi since 1796.

Agnolo Bronzino
(Florence 1503–1572)
Allegory of Happiness
Oil on copper, 40x30
Inv. 1890, 1543
Signed. First mentioned in the
inventory of the Uffizi in
1635/8.

Alessandro Allori
Sacrifice of Isaac
Oil on wood, 94x131
Inv. 1890, 1553
Signed and dated 1601. At the
Uffizi, in the Tribune, in 1589.

Agnolo Bronzino
Deposition
Oil on copper, 42x30
Inv. 1890, 1554
Signed. From Villa la Petraia; at
the Uffizi since 1796.

Alessandro Allori
Saint Peter Walking on the Water
Oil on copper, 47x40
Inv. 1890, 1549
Signed and dated 1596 (?).
From the Medici collections; at
the Uffizi since 1770.

**Flemish Artist of the 16th
Century**
Head of Medusa
Oil on wood, 49x74
Inv. 1890, 1479
From Palazzo Pitti; at the Uffizi
since 1753.

**Jacopo Chimenti called
Empoli**
(Florence 1551–1640)
Drunkenness of Noah
Oil on copper, 31x25
Inv. 1890, 1531

Purchased in 1779, together
with the companion piece
(*Sacrifice of Isaac*), from the
collection of Ignazio Hugford.

Empoli
Sacrifice of Isaac
Oil on copper, 31x25
Inv. 1890, 1463
See previous entry.

Alessandro Allori
Portrait of Ludovico Capponi (?)
Oil on wood, 45x36
Inv. 1890, 763
Purchased in 1867 from
Ippolito Rosini of Pisa.

**French Artist of the 16th
Century**
Potrait of Christine of Lorraine
Oil on wood, 39.5x32.5
Inv. 1890, 4338
In the 1558 inventory of
Palazzo Pitti; at the Uffizi since
1861.

**Italian Artist of the 16th
Century**

Man in Armour
Oil on wood, 71.5x58
Inv. 1890, 1504
At the Uffizi since 1881.

Christoph Amberger
(? c 1505–Augsburg 1561/2)
Portrait of Cornelius Gros
Oil on wood, 53.4x43
Inv. 1890, 1110
Dated 1544. At the Uffizi, in
the Tribune, in 1635.

Anthonis Mor van Dashor
(Utrecht 1517–Antwerp 157
Self-portrait
Oil on wood, 113x84
Inv. 1890, 1637
Signed and dated 1558.
Purchased by Cosimo III de'
Medici; at the Uffizi since 16

Frans Pourbus the Elder
(Bruges c 1542–1580)
Portrait of Viglius van Aytta
Oil on wood, 49x36
Inv. 1890, 1108
From the collection of Cardir
Leopoldo de' Medici; at the

onzino: Allegory
Happiness

opo Zucchi: The Age
Gold

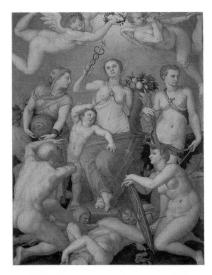
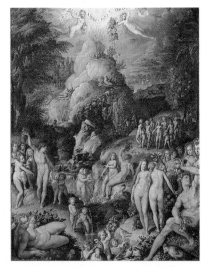

onzino: Deposition

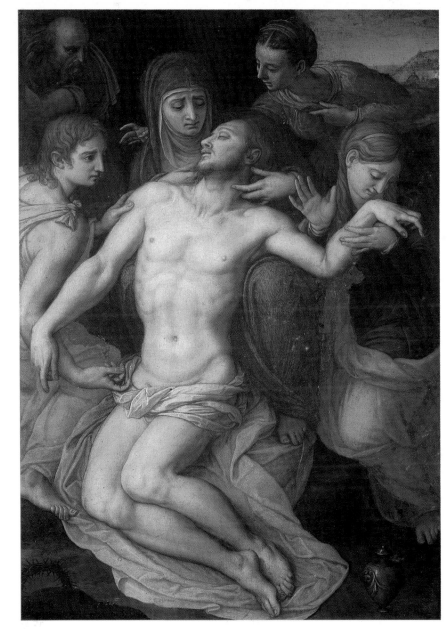

ffizi since 1675.

uis de Morales
3adajoz? *c* 1509–1586)
brist Carrying the Cross
il on wood, 59.5x56
iv. 1890, 3112
:om the De Noè Walker
illection; at the Uffizi since
398.

rançois Clouet
Tours *c* 1510–Paris 1572)
rançois I, King of France
oil on wood, 27.5x22.5
iv. 1890, 987
1 the Medici collections
robably before 1589; at the
ffizi since 1796.

an Perréal
c 1435–? 1530)
ortrait of a Lady
il on wood, 37x27
iv. Dep. 37
lentioned in the 1846
iventory of Palazzo Pitti; at
ie Uffizi since 1932.

Giorgio Vasari: Vulcan's Forge

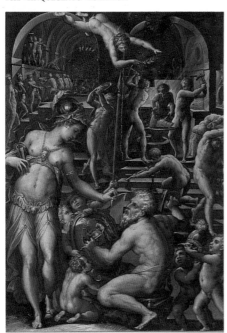

Empoli: Drunkenness of Noah

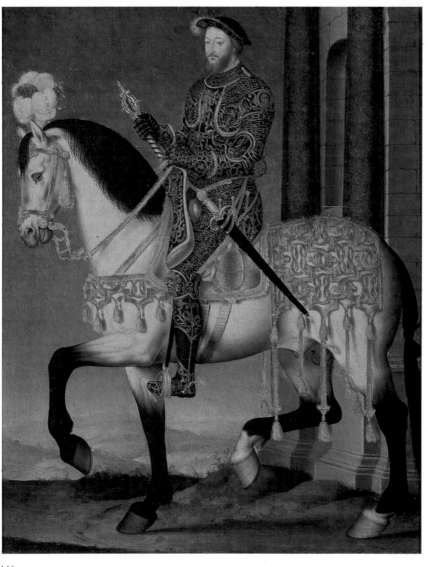

François Clouet: François I,
King of France

Cecchino Salviati: Artemisia

ean Perréal: Portrait of a Lady

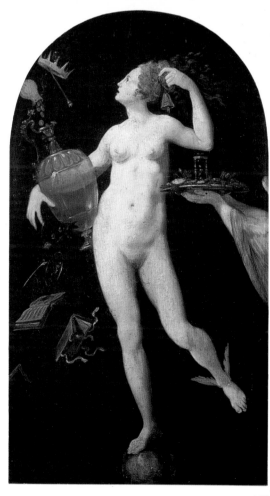

Christoph Amberger: Cornelius Gros

Italian Artist of the 16th Century: Fortune

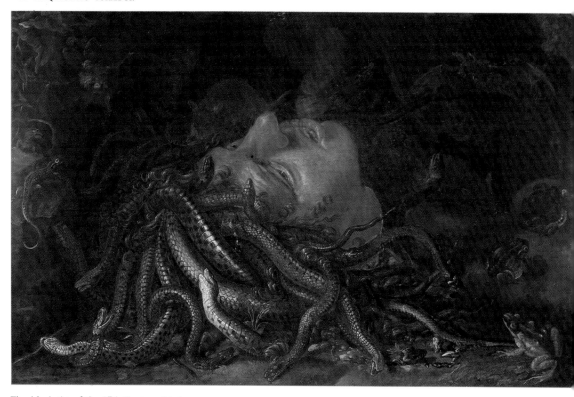

Flemish Artist of the 17th Century: Medusa

Alessandro Allori: Sacrifice of Isaac

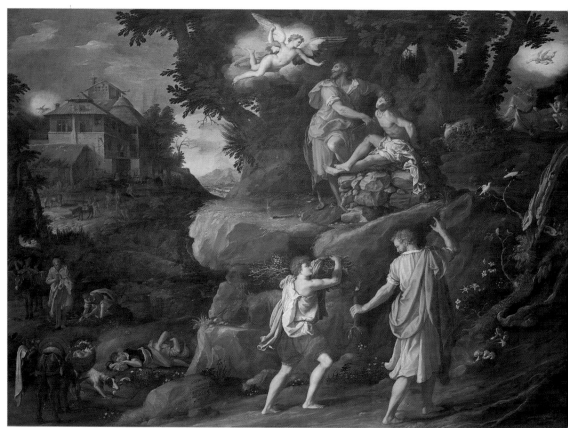

The Veronese Room

Around the middle of the 18th century this room was called the Porcelain Room; but by 1779 it was used as a 'second room of paintings,' containing some of the self-portraits which were also on display in the following room. After many other changes, the present arrangement was decided upon after the end of the last war. The exhibition of Lombard and Venetian painting, interrupted by the Cinquecento Corridor, is taken up once again and attention is centered upon two great painters: Veronese and Moroni.

In the work of Veronese, in a sense the last exponent of 16th-century Venetian painting, the shadows cast by the crisis in Mannerism are overcome by a return to the early works of Titian. The opulent forms, the light which enhances the magnificent colours, the vast spaces, all seem to exalt the triumphs and the grandeur of the Venetian Republic, apparently without any sense of interior drama. The *Holy Family with Saints* and the *Annuncia-tion* are supreme examples of Veronese's art: the blending of the bright colours, the play of light over the splendid fabrics, the dazzling light of the settings. *Esther and Ahasuerus* is similar in the spatial dimensions and theatrical effects to many of the painter's frescoes; here he portrays a solemn ceremony worthy of the glory of the Serenissima.

More subdued and intimate is the poetic vein that runs through the somber paintings of Moroni, the great portraitist: his sitters are austere and psychologically complex, portrayed according to the Lombard tradition with scrupulous realism, endowed only with human or moral attributes.

Also noteworthy is the only painting belonging to the Gallery by Giovanni Girolamo Savoldo, the *Transfiguration*, in which the Lombard tradition is beautifully blended with Venetian elements to create a solemn, morally meaningful work enriched by the splendid light effects.

Paolo Caliari called Veronese
(Verona 1528–Venice 1588)
Holy Family with Saints Barbara and John
Oil on canvas, 86x122
Inv. 1890, 1433
In 1648 in the Widmann collection in Venice; at the Uffizi since 1798.

Giovanni Girolamo Savoldo
(Brescia c 1480–Venice or Brescia 1548)
Transfiguration
Oil on wood, 139x126
Inv. 1890, 930
Originally in the Del Sera collection in Venice; at the Uffizi since 1798.

Giovanni Battista Moroni
(Albino 1529/30–Bergamo 1578)
Portrait of the Poet Giovanni Antonio Pantera
Oil on canvas, 81x63
Inv. 1890, 941

From the estate of Cardinal Leopoldo de' Medici (1675); at the Uffizi since 1795.

Paolo Veronese
Annunciation
Oil on canvas, 143x291
Inv. 1890, 899
In the Del Sera collection in Venice until 1654; at the Uffizi since 1798.

Paolo Veronese
Martyrdom of Saint Justina
Oil on canvas, 103x113
Inv. 1890, 946
At the Uffizi, in the Tribune, in 1704.

Giulio Campi
(Cremona 1502–c 1572)
Portrait of Galeazzo Campi
Oil on canvas, 78.5x62
Inv. 1890, 1628
At the Uffizi since 1683.

Giovanni Battista Moroni
Portrait of Pietro Secco Suardo

Oil on canvas, 183x104
Inv. 1890, 906
Signed and dated 1563. In 1713 in the collection of Ferdinando de' Medici; at the Uffizi since 1797.

Giovanni Battista Moroni
Portrait of a Man with a Book
Oil on canvas, 71x56
Inv. 1890, 933
Purchased by Cardinal Leopoldo de' Medici; at the Uffizi, in the Tribune, in 1704.

Jacopo Robusti called Tintoretto
(Venice 1518–1594)
Portrait of a Man
Oil on wood, 30x22
Inv. 1890, 1387
Dated 1546. At the Uffizi since 1798.

Giulio Campi
Portrait of a Musician
Oil on canvas, 74x58
Inv. 1890, 958

Originally in the Del Sera collection in Venice; at the Uffizi since 1800.

Paolo Veronese
Esther and Ahasuerus
Oil on canvas, 208x284
Inv. 1890, 912
From the Imperial Galleries in Vienna; at the Uffizi since 1793.

Giulio Campi
Portrait of a Man
Oil on canvas, 72.5x58
Inv. 1890, 1796
At the Uffizi since 1704.

Paolo Veronese
Saint Agatha Crowned by Angels
Oil on wood, 19x17
Inv. 1890, 1343
In 1713 in the collection of Ferdinando de' Medici; at the Uffizi since 1753.

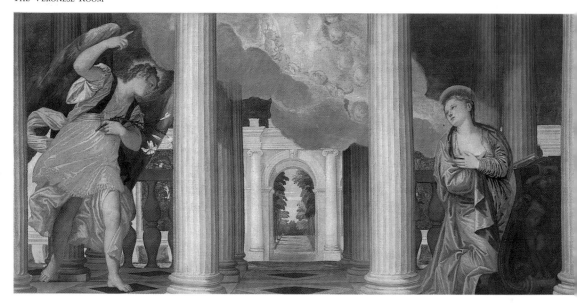

Veronese: Annunciation

Veronese: Esther and Ahasuerus

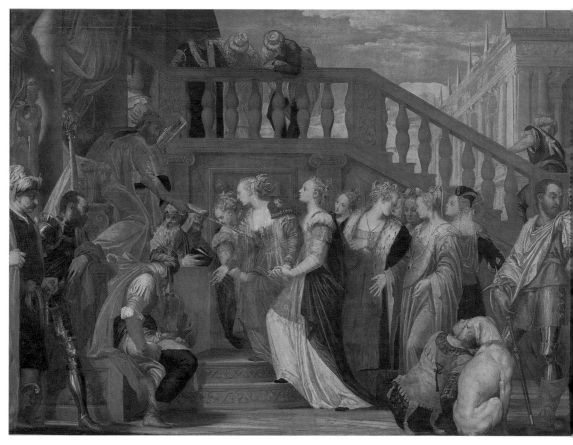

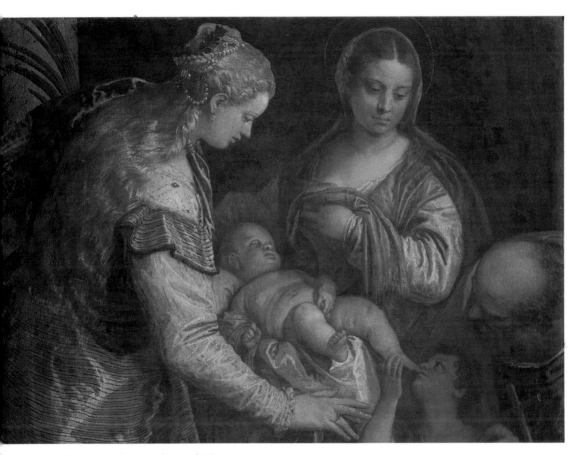

Veronese: Holy Family with Saints Barbara and John

Moroni: Portrait of the Poet
Giovanni Antonio Pantera

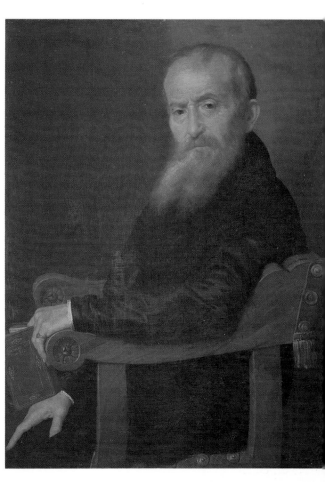

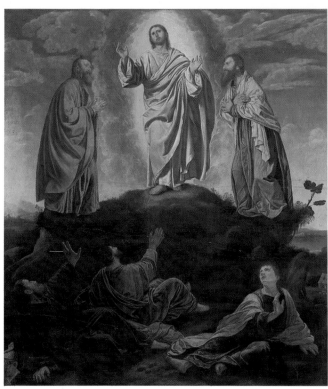

Savoldo: Transfiguration

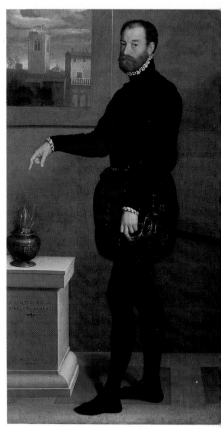

Moroni: Portrait of Pietro Secco Suardo

ROOM 35
The Tintoretto and Barocci Room

This room was laid out in 1681 in order to house the collection of self-portraits begun by Cardinal Leopoldo de' Medici: the room was created by Cosimo III as a tribute to his distinguished uncle. Originally there was an allegorical fresco by Pietro Dandini on the ceiling; on the wall facing the entrance, in a niche, was the large statue of the Cardinal, by Giovan Battista Foggini (today in the Vasari Corridor). So the room remained until the end of the 19th century when changes in the interior decoration were ordered.

Today's arrangement dates from the early 1950s: Jacopo Tintoretto and Jacopo Bassano, after Veronese, complete the anthology of 16th-century Venetian painting. The two artists worked in very different ways, achieving results that were also quite different from Veronese's art. Tintoretto seems to adopt, especially in the nervous speed of his work, the artistic restlessness of Mannerism, sometimes with rhetorical or theatrical effects, but always with great inventiveness and dramatic power.

Bassano is represented here by some autograph works as well as some painted by the vast school of his followers, realistic works with great wealth of detail. His figures, illuminated in the manner of Tintoretto, are sturdy and solidly placed in the vast stretches of the lyrical landscapes. Particularly noteworthy is the splendid painting of *Two Dogs*.

The other painter represented in this room is Federico Barocci from Urbino, whose fascinating work, rich in pictorial effects, is a link between Venetian Mannerism and the first signs of Baroque. The most impressive of his paintings is the celebrated *Madonna del Popolo*, but his beautiful and sensitive portraits are also interesting.

Recently some paintings of different schools have been added to the collection in this room, works that give an indication of the variety of Italian and foreign painting during the second half of the 16th century. Among these is the canvas of *Saints John the Evangelist and Francis* by El Greco.

In the centre of the room is the splendid table showing a view of the port of Livorno, inlaid in pietre dure, done between 1600 and 1604 by Cristofano Gaffuri from a design by Jacopo Ligozzi.

Venetian Artist of the 16th Century
Portrait of a Man
Oil on canvas, 95x76
Inv. 1890, 966
From the estate of Cardinal Leopoldo de' Medici (1675); at the Uffizi since 1798.

Jacopo da Ponte called Jacopo Bassano
(Bassano c 1517–1592)
Two Dogs
Oil on canvas, 85x126
In 1663 in the collection of Cardinal Carlo de' Medici; at the Uffizi, in the Tribune, in 1677.

Jacopo Bassano
Moses and the Burning Bush
Oil on canvas, 95x167
Inv. 1890, 913
From the estate of Cardinal Leopoldo de' Medici (1675); at the Uffizi since 1774.

Tiberio Tinelli
(Venice 1586–1638)
Portrait of the Poet Giulio Strozzi
Oil on canvas, 83x64
Inv. 1890, 962
In the Del Sera collection in Venice until 1672; at the Uffizi since 1795.

Tiziano Vecellio called Titian and assistants
(Pieve di Cadore c 1488–Venice 1576)
Saint Margaret
Oil on canvas, 116.5x98
Inv. 1890, 928
In the collection of Cardinal Leopoldo de' Medici before 1675; at the Uffizi since 1798.

Federico Barocci
(Urbino 1535–1612)
Portrait of Ippolito della Rovere
Oil on canvas, 106.5x88,5
Inv. 1890, 567
In 1652 in the collection of Vittoria della Rovere in Urbino; at the Uffizi since 1796.

Jacopo Robusti called Tintoretto
(Venice 1518–1594)
Leda and the Swan
Oil on canvas, 162x218
Inv. 1890, 3084
Originally in the collection of the Duke of Orléans in Paris; later in the De Noè Walker collection; at the Uffizi since 1893.

Federico Barocci, copy after
Saint Francis Receives the Stigmata
Oil on canvas, 126x98
Inv. 1890, 790
From Vienna; at the Uffizi since the late 18th century.

Andrea Meldolla called Schiavone
(Sibenik c 1500–Venice 1563)
Portrait of an Old Man
Oil on canvas, 95x76

Inv. 1890, 935
From the estate of Cardinal Leopoldo de' Medici (1675), where it was attributed to Tintoretto; at the Uffizi since 1798.

Jacopo Tintoretto
Portrait of Jacopo Sansovino
Oil on canvas, 70x65.5
Inv. 1890, 957
From the Medici collections; at the Uffizi, in the Tribune, in 1635.

Andrea Boscoli
(Florence c 1560–1606/7)
Wedding at Cana
Oil on canvas, 127.5x191
Inv. 1890, 8025
Signed at the foot of the chest. At the Uffizi since 1975.

Jacopo Bassano
Annunciation to the Shepherds
Oil on canvas, 40x96
Inv. 1890, 920

Jacopo Bassano: Two Dogs

From the estate of Cardinal Leopoldo de' Medici (1675); at the Uffizi since 1798.

Federico Barocci
"Madonna del Popolo"
Oil on wood, 359x252
Inv. 1890, 751
Signed and dated 1579. From the church of the Pieve in Arezzo; at the Uffizi since 1787.

Leandro da Ponte called Leandro Bassano
(Bassano 1557–Venice 1622)
Concert
Oil on canvas, 114x178
Inv. 1890, 915
At the Uffizi since 1704.

Jacopo Bassano
Judas and Tamar
Oil on canvas, 40x95
Inv. 1890, 927
Together with its companion piece, Annunciation to the Shepherds (Inv. 1890, 920, see above) from the collection of Cardinal Leopoldo de' Medici; at the Uffizi since 1798.

Domenikos Theotokopulos called El Greco
(Candia 1541–Toledo 1614)

Saints John the Evangelist and Francis
Oil on canvas, 110x86
Inv. 1890, 9493
Signed. In the 18th century at Boadilla del Monte in Spain; purchased in 1973.

Domenico Robusti called Tintoretto
(Venice 1560–1635)
Saint Augustine Heals the Cripples
Oil on canvas, 186x108
Inv. 1890, 914
From the estate of Cardinal Leopoldo de' Medici (1675); at the Uffizi since 1798.

Federico Barocci
Portrait of Francesco II della Rovere
Oil on canvas, 113x93
Inv. 1890, 1438
Arrived in Florence in 1631, with the inheritance of Vittoria della Rovere; at the Uffizi since about 1830.

Ludovico Cardi called Cigoli
(Cigoli 1559–Rome 1613)
Saint Francis Receives the Stigmata
Oil on wood, 247x171
Inv. 1890, 3496
Signed and dated 1596.

Originally in the monastery of Sant'Onofrio; at the Uffizi since 1928.

Federico Barocci
Christ and Mary Magdalen
Oil on canvas, 122x91
Inv. 1890, 798
At the Uffizi since 1798.

Jacopo Tintoretto
Portrait of a Venetian Admiral
Oil on canvas, 127x99
Inv. 1890, 921
From the estate of Cardinal Leopoldo de' Medici (1675); at the Uffizi since that same year.

Jacopo Tintoretto
Portrait of a Man with a Red Beard
Oil on canvas, 52.5x45.5
Inv. 1890, 924
In 1702 in the collection of Ferdinando de' Medici; at the Uffizi since 1798.

Federico Barocci
Portrait of a Girl
Oil on paper, 45x33
Inv. 1890, 765
From the collection "of small works" of Ferdinando de' Medici.

Joachim Beuckelaer
(Antwerp *c* 1535–*c* 1574)
Pilate Shows Jesus to the People
Oil on canvas, 110x140
Inv. 1890, 2215
Monogrammed and dated 1566. At the Uffizi since the late 19th century.

Jacopo Tintoretto
Christ and the Samaritan Woman at the Well
Oil on canvas, 116x93
Inv. 1890, 3497
With its companion piece, the Samaritan Woman (Inv. 1890, 3498, see below), it decorated the organ of the church of San Benedetto in Venice. Both at the Uffizi since 1910.

Jacopo Tintoretto
The Samaritan Woman
Oil on canvas, 116x93
Inv. 1890, 3498
See previous entry.

Jacopo Bassano
Portrait of an Artist
Oil on canvas, 110x88
Inv. 1890, 969
From the collection of Cosimo III de' Medici; at the Uffizi since 1685.

Jacopo Tintoretto: Portrait of a Venetian Admiral

omenico Tintoretto: Saint Augustine Heals the Cripples

Jacopo Tintoretto: Portrait of Jacopo Sansovino

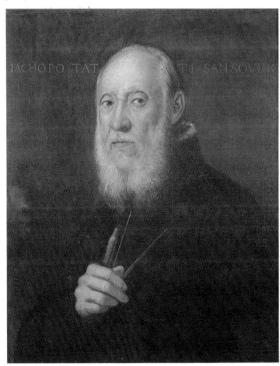

Federico Barocci: Portrait of Francesco Maria della Rovere

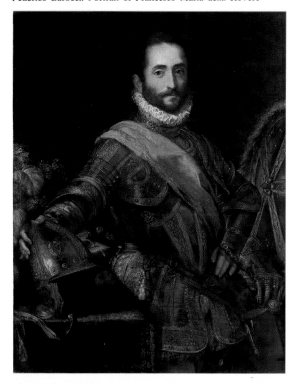

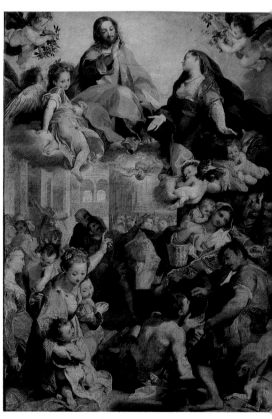

Federico Barocci: "Madonna del Popolo"

Cigoli: Saint Francis Receives the Stigmata

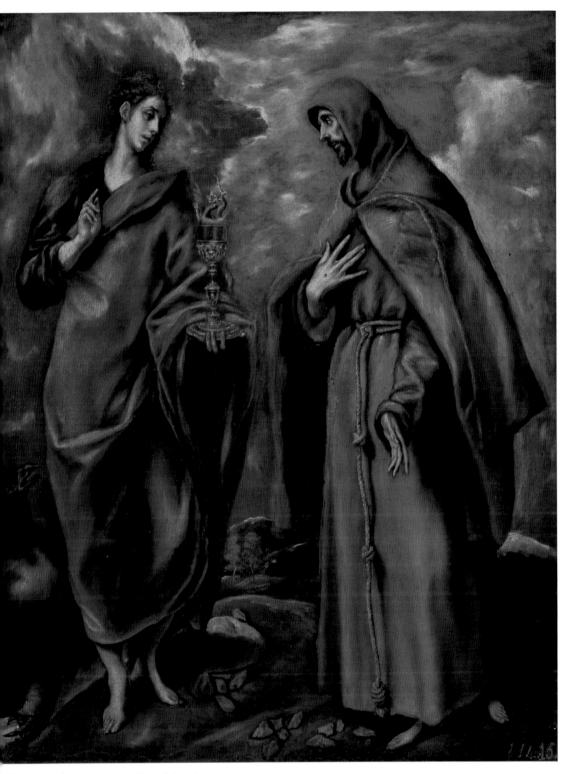

Greco: Saints John the Evangelist and Francis

ROOM 41
The Rubens Room

This room, indicated on the 18th-century plan of the Gallery as 'Room of the Medals,' was designated, towards the end of that century, by Grand Duke Peter Leopold to house a collection of classical statues, including the famous *Hermaphrodite* (now in Room 18). The present ordering dates from the end of the last war with a few later additions. Here one may admire works by Rubens, Van Dyck and some of their famous Flemish contemporaries and pupils. It is interesting to observe how the Medici Collection expanded during the 17th century to include European artists of the most important schools of contemporary painting, some of which, like Rubens and Van Dyck, had a notable influence on Italian art.

The Medici never commissioned a painting from Rubens, although the painter was in Florence on two different occasions, but they later bought two very important works: the two huge paintings of episodes from the life of Henry IV of France, commissioned by his wife Maria de' Medici as companion pieces to the series dedicated to the glorific tion of the queen herself.

Quite different in tone, more affectiona and intimate, but similar in the vitality of tl sitter and the sensual use of colour, is tl *Portrait of Isabella Brandt*, the painter's fir wife.

Among other works by Rubens's follower the most delightful are the lovely portraits l Antony Van Dyck, who was an elegant ar sophisticated innovator in this genre. Durir his travels throughout Italy he left mar wonderful examples of his work, such as, fe example, the fine portraits of the noble ar wealthy families in Genoa. At the Uffizi *Marguerite of Lorraine, Countess of Orléans*, rather pompous, official portrait as befits tl sitter's rank, but not devoid of psychologic insight and inventiveness of composition.

Also is this room, besides the famous po trait of Galileo, painted by Justus Suste mans, a favourite portraitist at the Medi Court, is a beautiful 17th-century table d signed by Giacinto Maria Marmi.

Sir Anthony van Dyck
(Antwerp 1599–London 1641)
Portrait of Jean de Montfort
Oil on canvas, 123x86
Inv. 1890, 1436
At the Uffizi, in the Tribune, in 1794.

Jan van den Hoecke
(Antwerp 1611–Brussels ? 1651)
Hercules between Vice and Virtue
Oil on canvas, 145.5x194
Inv. 1890, 1442
In Palazzo Pitti from 1713; at the Uffizi since 1753.

Peter Paul Rubens
(Siegen 1577–Antwerp 1640)
Bacchus astride a Barrel
Oil on canvas, 152x118
Inv. 1890, 796
In 1689 in the collection of Christina of Sweden in Rome; at the Uffizi since 1792 after an exchange with the Imperial Galleries in Vienna.

Sir Anthony van Dyck
Portrait of a Woman, thought to be
the mother of Sustermans
Oil on canvas, 81x63
Inv. 1890, 726
From 1705 in the collection of Ferdinando de' Medici; at the Uffizi since 1773.

Peter Paul Rubens
Henri IV at the Battle of Ivry
Oil on canvas, 367x693
Inv. 1890, 722
With its companion piece, Triumphal Entrance of Henri IV (Inv. 1890, 729, see below), purchased by Cosimo III de' Medici in 1686. At the Uffizi since 1773.

Justus Sustermans
(Antwerp 1597–Florence 1681)
Portrait of Galileo
Oil on canvas, 66x56
Inv. 1890, 745
Painted in 1636 and sent as a gift by Galileo to a friend in Paris. Later in the collection of Ferdinando II de' Medici; at the Uffizi since about 1678.

Sir Anthony van Dyck
Charles V on Horseback
Oil on canvas, 191x123
Inv. 1890, 1439
From 1713 in the collection of Ferdinando de' Medici; at the Uffizi since 1753.

School of Peter Paul Rubens
Philip IV of Spain on Horseback
Oil on canvas, 337x263
Inv. 1890, 792
Probably in the collection of Marquis Eliche in Madrid in 1651; at the Uffizi since 1753.

Sir Anthony van Dyck
Portrait of Marguerite of Lorraine,
Duchess of Orléans
Oil on canvas, 204x117
Inv. 1890, 777
First mentioned in the inventory of the Uffizi in 1753.

Peter Paul Rubens
Portrait of Isabella Brandt
Oil on wood, 86x62
Inv. 1890, 779
Sent as a gift in 1705 by the Elector of Düsseldorf to his

brother-in-law Ferdinando de Medici; at the Uffizi since 17

Peter Paul Rubens
Triumphal Entrance of Henri IV into Paris
Oil on canvas, 380x692
Inv. 1890, 729
See above, Henri IV at the Battle of Ivry, Inv. 1890, 722

Jakob Jordaens
(Antwerp 1593–1678)
Portrait of a Lady
Oil on canvas, 68x50
Inv. 1890, 3141
Purchased in 1902.

Jan van den Hoecke
Triumphal Entrance of Cardinal Prince Ferdinand of Spain into Antwerp
Oil on canvas, 405x328
Inv. 1890, 5404
Painted in 1635. From the beginning in the collection of Prince Ferdinand in Antwerp Purchased by the Uffizi in 17 from the British consul in Livorno, John Udny.

bens: Henri IV
he Battle of Ivry

van den Hoecke:
umphal Entrance of
dinal Prince Ferdinand
Spain into Antwerp

Rubens: Triumphal
Entrance of Henri IV
into Paris

Rubens: Portrait of
Isabella Brandt

Antony van Dyck: Portrait of Jean de Montfort

Jakob Jordaens: Portrait of a Lady

Justus Sustermans: Portrait of Galileo Galilei

Antony van Dyck: Charles V on Horseback

ROOM 42
The Room of Niobe

The sculptural group that gives the room its name shows the myth of Niobe, the proud and boastful mother whose children were killed as a punishment by Apollo and Diana in a lethal hail of arrows shot from their winged chariots. The largest statue, on the right side of the room, shows Niobe trying to protect her young daughter, while her other sons and daughters are struck down or desperately try to escape the arrows; the bearded figure at the left, the children's preceptor, is also part of the group. The sculptural group is probably a Roman copy of an Hellenistic original from the 3rd or 2nd century B.C., described by Pliny in the Temple of Apollo in Rome.

The first record of the discovery of nine statues in a Roman vineyard was in a letter from the sculptor Valerio Cioli to the secretary of Francesco I de' Medici in 1583. At the end of the century the Medici acquired the statues and Cardinal Ferdinando (later Grand Duke) kept them in Rome at the Villa Medici. Sent to Florence in 1775, the works were restored while a grand new room at the Uffizi was built especially for their display by architect Gaspare Maria Paoletti. In perfect Neo-Classical style, this room (the gem of this side of the Gallery, as the Tribune is of the other side) was decorated in white and gold stucco work by Grato Albertolli. The four large oval bas-reliefs with stories of Niobe were done by the sculptor Francesco Carradori, who was also responsible for the restoration of the marble group.

In this room is also the large marble vase, known as the Medici Vase, a Neo-Attic work whose elegant bas-relief shows the judgment of the Greek heroes as they condemn Ajax for his rape of Cassandra.

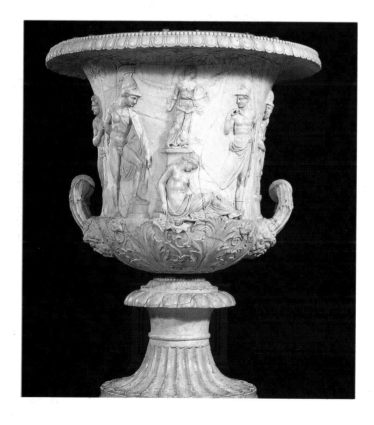

Medici Vase
(Neo-Attic art)

ROOM 43
The Caravaggio Room

In the 17th century, as we noted in the Rubens Room, the Grand Dukes and other members of the Medici family continued to search for new works and commissioned paintings of 'modern art' to enrich their collection and to keep up with the prevailing taste. Thanks to the zeal and the buying capacity of these patrons the Gallery has a broad and rich section of 17th-century art, which begins in this room and continues in the first section of the Vasari Corridor.

Well represented is Annibale Carracci, one of the masters of the Bolognese school. His youthful work, *Venus with a Satyr and Cupids*, although filled with Mannerist touches, goes directly to early 16th-century Venetian painting for its full bodied figures, warm and golden.

Very different is the evocation of *Bacchus* by Caravaggio: a portrait of a contemporary of the young painter's, dressed to vaguely resemble the pagan god. Caravaggio uses light as though it were a magnifying glass that shows reality for what it is: describing and unifying at the same level of importance the human figure, the still life, the vine leaves and the bottle. The very different cultural stimuli led these two painters to adopt very different styles and each became an undisputed head of a school of painting with a great many followers. Their works and those of their followers constitute a rich section of the Gallery. While the Caravaggio school is displayed in the Vasari Corridor, the Bolognese school is represented here, together with works by other 17th-century artists. Noteworthy is a fragment of a work by Gian Lorenzo Bernini, a rare example of a painting by the great architect and sculptor. Also in this room is the splendid 'veduta' of a Port with Villa Medici by Claude Lorrain, one of the most famous painters of this genre, then living and working in Rome. This painting unites, in an idealized landscape, the Roman residence of the Medici with a seascape alive with boats, pennants and flags: luminous and mellow, classical in its architecture, but inhabited by a colourful collection of figures.

Annibale Carracci
(Bologna 1560–Rome 1609)
Venus with a Satyr and Cupids
Oil on canvas, 112x142
Inv. 1890, 1452
In 1620 in the Bolognetti collection in Bologna; at the Uffizi since 1638.

Giovan Francesco Barbieri called Guercino
(Cento 1591–Bologna 1666)
Summer Diversions
Oil on copper, 34x46
Inv. 1890, 1379
In the inventory of Palazzo Pitti in the early 18th century. At the Uffizi since 1773.

Francesco Albani
(Bologna 1578–1660)
Dance of the Cupids
Oil on copper, 31.8x41.2
Inv. 1890, 1314
From Palazzo Pitti; at the Uffizi since 1779.

Simon Vouet
(Paris 1590–1649)
Annunciation
Oil on canvas, 120.5x86
Inv. 1890, 1013

Purchased in Paris in 1793 on behalf of the Grand Duke Ferdinand III of Tuscany for the Uffizi.

Giulio Carpioni
(Venice 1613–Vicenza 1679)
Neptune Pursuing Coronis
Oil on canvas, 67x50
Inv. 1890, 1404
In the early 18th century in the collection of Ferdinando de' Medici; at the Uffizi since 1773.

Mattia Preti
(Taverna 1613–Malta 1699)
Vanity
Oil on canvas, 93.5x65
Inv. 1890, 9283
Purchased for the Uffizi in 1951.

Michelangelo Merisi called Caravaggio
(Caravaggio or Milan 1570/1–Porto Ercole 1610)
Medusa
Oil on wood covered with canvas, diam. 55
Inv. 1890, 1351
Commissioned from the artist by Cardinal Francesco Maria

del Monte and presented as a gift to Ferdinando I de' Medici. In the Medici Armoury at the Uffizi since 1631.

Salvator Rosa
(Naples 1615–Rome 1673)
Landscape with Figures (Fear)
Oil on canvas, 48.5x38
Inv. 1890, 1423
In 1713 in Palazzo Pitti, in Ferdinando de' Medici's collection; at the Uffizi since about 1905.

Caravaggio
Bacchus
Oil on canvas, 95x85
Inv. 1890, 5312
Discovered in the storerooms by Marangoni in 1916; attributed to Caravaggio by Longhi.

Annibale Carracci
A Man with a Monkey
Oil on canvas, 68x58.3
Inv. 1890, 799
Probably in the collection of Cardinal Carlo de' Medici in 1666; at the Uffizi sometime between 1793 and 1810.

Claude Gellée called Lorrain
(Chamagne 1600–Rome 1682)
Harbour with Villa Medici
Oil on canvas, 102x133
Inv. 1890, 1096
Signed and dated 1637. From Palazzo Pitti; at the Uffizi since 1773.

Gian Lorenzo Bernini
(Naples 1598–1680)
Head of a Youth (Head of an Angel)
Oil on canvas, 63x62
Inv. 1890, 4882
Probably a fragment of a larger composition. At the Uffizi since 1957.

Caravaggio
Sacrifice of Isaac
Oil on canvas, 104x135
Inv. 1890, 4659
In 1672 in the Barberini collection in Rome. Presented to the Uffizi in 1917 by John Murray.

Annibale Carracci: Venus
with a Satyr and Cupids

Gian Lorenzo Bernini: Head of an Angel

Claude Lorrain: Harbour with Villa Medici

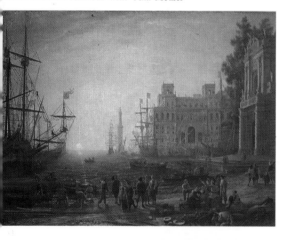

Guercino: Summer Diversions

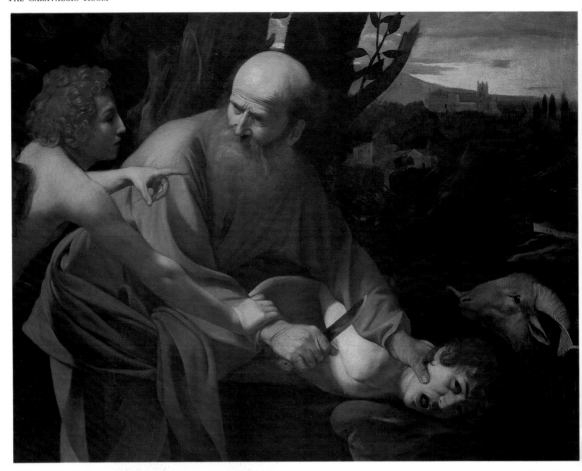

Caravaggio: Sacrifice of Isaac

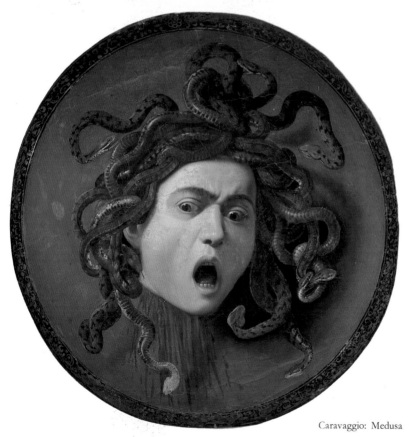

Caravaggio: Medusa

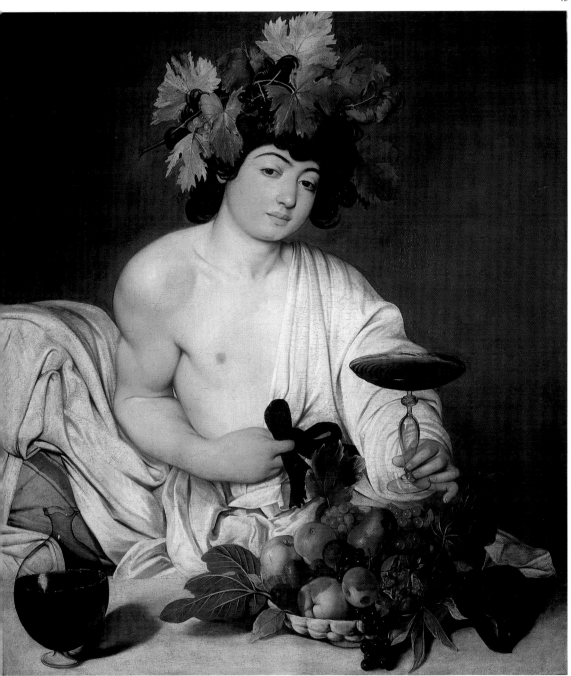

Caravaggio: Bacchus

In Caravaggio's painting classical myths and stories
from the Scriptures are portrayed with the strictest
realism: the head of the *Medusa*, simply a propitia-
tory symbol on ancient shields, here becomes the
violent representation of a severed head; the jolly
figure of Bacchus, god of wine, takes on the appear-
ance of a drunken young boy, dressed up and posed
by the artist; and in the scene of the *Sacrifice of Isaac*
the brutal realism seems almost to involve the angel.

ROOM 44
The Rembrandt Room

This room, which is dedicated to Northern European painting as well as to Rembrandt, attempts to reconstruct the appearance and atmosphere of a 'cabinet de peinture.' The paintings are placed so as to cover all available space on the walls and the frames are all identical.

The Uffizi collection of Dutch and Flemish masters specialized in scenes of everyday life, landscapes and still life shows the strong interest that the Medici, especially Cosimo II (a passionate collector), had in this style of painting.

An extremely important piece, earlier than all the others, is the famous view of the *Copper Mines* by Civetta (Henri Met de Bles), a large landscape enlivened by the figures in the foreground, assembled in realistic scenes of everyday life. Paul Bril and Herman van Swanevelt are represented by two luminous, Italianized landscapes; Frans van Mieris the Elder by some of his favourite subjects, picturesque scenes of colourful everyday life;

Gerrit Berckheyde by the splendid view of *The Groote Markt at Haarlem*; Rachel Ruysch and Jan van Huysum by two floral still lifes done in extraordinarily realistic detail. There is also one of Jakob van Ruysdael's typical Northern landscapes, in which nature is described with the utmost of realistic detail.

The dominant figure of Dutch 17th-century painting, austere and spiritual, is Rembrandt van Rijn; the Gallery possesses three self-portraits and a magnificent *Portrait of an Old Man*. These works show the artist's tendency to psychological investigation, so evident in the lucid introspection of the self-portraits. The alert, slightly melancholy optimism of the youth is portrayed with a bright, luminous quality; the older Rembrandt is sadly meditative, and even the shadows surrounding the tired and lined face seem to be threatening. Similar to this pained figure is the *Portrait of an Old Man*, also an exercise in psychological investigation, mellowed by a feeling of deep human understanding.

Herman van Swanevelt
(Woerden *c* 1600–Paris 1655)
Landscape
Oil on canvas, 52x66
Inv. 1890, 1310
In Palazzo Pitti from the early 18th century; at the Uffizi since 1753.

Jan Brueghel the Elder
(Brussels 1568–Antwerp 1625)
Landscape with a Ford
Oil on copper, 24x35
Inv. 1890, 1179
Signed and dated 1607. At the Uffizi since 1704.

Jakob van Ruysdael
(Haarlem 1628/9–Amsterdam? 1682)
Landscape with Shepherds and Peasants
Oil on canvas, 52x60
Inv. 1890, 1201
Signed. Purchased for the Uffizi in 1797.

Frans van Mieris the Elder
(Leiden 1635–1681)
Two Old Men at the Table
Oil on wood, 36x31.5
Inv. 1890, 1267
Signed. Probably sent as a gift by the Elector Johann Wilhelm to Ferdinando de' Medici in the early 18th century. At the Uffizi since 1825.

Jan van Huysum
(Amsterdam 1682–1749)
Vase of Flowers
Oil on glass, 63x50
Inv. 1890, 3095
From the De Noè Walker collection; at the Uffizi since 1893.

Gerrit Berckheyde
(Haarlem 1638–1698)
The Groote Markt in Haarlem
Oil on canvas, 54x64
Inv. 1890, 1219
Signed and dated 1693. From Poggio Imperiale; at the Uffizi since 1796.

Paul Bril
(Antwerp 1554–Rome 1626)
Landscape with Hunters
Oil on copper, 27x43
Inv. 1890, 1190
First mentioned in the inventory of the Uffizi in 1753.

Gabriel Metsu
(Leiden 1629–Amsterdam 1667)
A Lady and a Knight
Oil on wood, 56x50
Inv. 1890, 1296
In the collection of Ferdinando de' Medici from the early 18th century; at the Uffizi since 1779.

Cornelis Bega
(Haarlem 1631/2–1664)
Woman Playing a Lute
Oil on wood, 36x32
Inv. 1890, 1187
Companion piece to the *Man Playing a Lute* (Inv. 1890, 1182, not exhibited). First mentioned in the inventory of the Uffizi in 1704.

Rachel Ruysch
(Amsterdam 1664–1750)
Fruit and Insects
Oil on wood, 44x60
Inv. 1890, 1276
Signed and dated 1711. Companion piece to another still life (Inv. 1890, 1285, not exhibited). They were both sent by Elector Johann Wilhelm to Cosimo III de' Medici, probably in 1712. At the Uffizi since 1753.

Jan Steen
(Leiden 1626–1679)
The Luncheon
Oil on wood, 41x49.5
Inv. 1890, 1301
Signed in the top lefthand corner. In Palazzo Pitti from the early 18th century; at the Uffizi since 1753.

Johannes Lingelbach
(Frankfurt 1622–Amsterdam 1674)
Rest after the Hunt
Oil on canvas, applied to wood, 47.5x37
Inv. 1890, 1297
Signed in lower righthand corner. At the Uffizi since 1825.

Hendrick Pot
(Haarlem *c* 1585–Amsterdam 1657)
The Miser
Oil on wood, 36x32.7
Inv. 1890, 1284
Monogrammed in the lower lefthand corner. At the Uffizi since 1796.

Cornelis van Poelenburgh
(Utrecht 1586–1667)
Mercury and Batto
Oil on copper, 35.5x48
Inv. 1890, 1231
At the Uffizi since 1773.

Godfried Schalcken
(Made 1643–The Hague 1706)
Pygmalion
Oil on wood, 44x37
Inv. 1890, 1122
From Palazzo Pitti; at the Uffizi since 1784.

Rembrandt Harmenszoon van Rijn
(Leiden 1606–Amsterdam

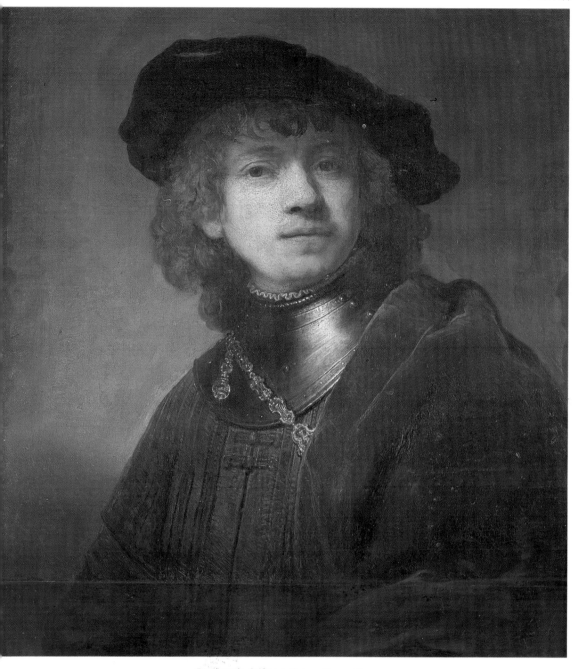

Rembrandt: Self-portrait as a Young Man

1669)
Self-portrait as an Old Man
Oil on canvas, 74x55
Inv. 1890, 1871
At the Uffizi since 1704.

Rembrandt Harmenszoon van Rijn
Portrait of an Old Man
Oil on canvas, 104x86
Inv. 1890, 8435
Signed and dated 1665. From the early 18th century in the collection of Ferdinando de' Medici; at the Uffizi since 1922.

Rembrandt Harmenszoon van Rijn
Self-portrait as a Young Man
Oil on wood, 62.5x54
Inv. 1890, 3890
Purchased in 1818 by Ferdinand III of Lorraine from the Gerini family; at the Uffizi since 1922.

Jan Miense Molenaer
(Haarlem *c* 1609–1668)
Peasants at the Tavern
Oil on wood, 69.5x115
Inv. 1890, 1278
From Palazzo Pitti; at the Uffizi

since 1770.

Frans van Mieris the Elder
The Painter's Family
Oil on wood, 52x40
Inv. 1890, 1305
Signed and dated 1675.
Commissioned by Cosimo III de' Medici; from the beginning in Palazzo Pitti; at the Uffizi since 1704.

Caspar Netscher
(Heidelberg 1639–The Hague 1684)
The Cook

Oil on canvas applied to wood, 30x22.7
Inv. 1890, 1288
Signed and dated 1664.
Purchased by Cosimo III de' Medici, probably in 1669; at the Uffizi since 1796.

Jacob Pynas
(Haarlem 1585–Delft after 1648)
Mercury and Herse
Oil on copper, 21x27.8
Inv. 1890, 1116
Mentioned in the 1761 inventory of the Villa di

169

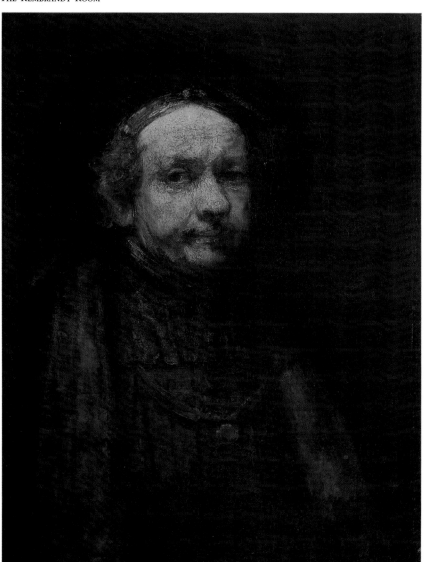

Rembrandt: Self-portrait
as an Old Man

▷

Cornelis van Poelenburg:
Mercury and Batto

▷

Rachel Ruysch:
Fruit and Insects

▽

Rembrandt: Portrait
of an Old Man

Castello; at the Uffizi since
1796.

Frans van Mieris the Elder
The Dutch Charlatan
Oil on wood, 48.6x37.7
Inv. 1890, 1174
Signed in the lower lefthand
corner. Brought to Florence in
1716 with the collection of
Anna Maria Lùisa de' Medici.
At the Uffizi since 1732.

Henri Met de Bles
(Bouvignes *c* 1480–Ferrara?
c 1550)
Copper Mines
Oil on wood, 83x114
Inv. 1890, 1051
At the Uffizi, in the Tribune, in
1603.

Hercules Pietersz Seghers
(Haarlem 1589/90–Amsterdam
c 1638)
Mountain Landscape

Oil on canvas applied to wood,
55x99
Inv. 1890, 1303
In 1656 in Rembrandt's
collection in Amsterdam. From
the collection of Maria Hadfield
Cosway; at the Uffizi since
1838.

Pieter Codde
(Amsterdam 1599–1678)
Concert
Oil on wood, 27x20.5
Inv. 1890, 8445
Monogrammed. Purchased by
the Florentine Galleries for the
Uffizi in 1920, and first
exhibited three years later.

Pieter Codde
Conversation
Oil on wood, 27x20.5
Inv. 1890, 8446
Purchased at the same time as
the *Concert* (Inv. 1890, 8445,
see above).

Frans van Mieris: The Dutch Charlatan

Gabriel Metsu: A Lady and a Knight

Jan Miense Molenaer: Peasants at the Tavern

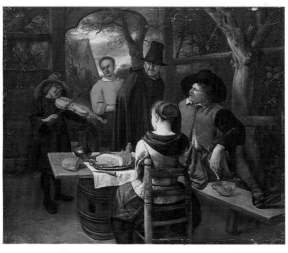

Jan Steen: The Luncheon

ROOM 45
Painting of the 18th Century

The last room in the Gallery, only recently opened, shows a wide range of 18th-century paintings, for the most part Italian and French. This collection continues into the Vasari Corridor. Recent acquisitions have been added to the older collections of the Medici and the Lorraine, filling in several gaps in the overall panorama of 18th-century European painting.

Susanna and the Elders, by the Venetian Giovan Battista Piazzetta, has been put back on display after a period in the Gallery's deposits; next to it are two small canvases by Giuseppe Maria Crespi, a Bolognese painter particularly admired by Ferdinando de' Medici and a favourite at the Tuscan Court. There are also other paintings of his, large ones with biblical or mythological themes or landscapes, but in these two works, *The Flea* and *The Artist's Family*, the mood is private, personal and witty, conveyed with brilliant technique and splendid flashes of light.

The major Venetian painters of 'vedute' are also well represented: Canaletto and Francesco Guardi. A marvellous theatrical effect is produced by Giovan Battista Tiepolo's allegorical scene painted with dazzling translucent colours; the Venetian school is further represented by Pietro Longhi and Rosalba Carriera.

Also among the French paintings are several indisputable masterpieces, such as the *Girl with the Shuttlecock and Racket* and the *Boy Playing Cards* by Jean Baptiste Siméon Chardin, both portrayed with affection, without any touches of stiff formality and with an almost Northern attention to detail; or the lovely *Portrait of Marie Adelaide of France*, by Liotard, a work remarkable for its purity of composition, freshness of colour and above all for its almost 19th-century naturalism.

Quite different is the ostentatious and mannered tone in the portraits of the daughters of Louis XV painted by Jean Marc Nattier, their empty grandeur softened somewhat by the mythological costumes in which they are dressed.

In a still different vein are the two magnificent paintings by Francisco Goya, recent acquisitions to the Gallery. The large *Portrait of the Countess of Chinchon* shows the great Spanish painter's art at its very highest level: the delicacy of the colour which highlights the transparency of the subject's dress and hair, combined with the impartial and often pitiless psychological analysis of the sitter.

Francisco Goya y Lucientes
(Fuendetodos 1746–Bordeaux 1828)
Maria Teresa de Vallabriga on Horseback
Oil on canvas, 82.5x61,7
Inv. 1890, 9485
Commissioned by Don Luis de Borbon, it was painted in 1783 at Boadilla del Monte.
Purchased from the Ruspoli family in 1974.

Francisco Goya y Lucientes
The Countess of Chinchon
Oil on canvas, 220x140
Inv. 1890, 9484
At Boadilla del Monte in the late 18th century. Purchased from the Ruspoli family in 1974.

Jean Baptiste Siméon Chardin
(Paris 1699–1779)
Girl with Racket and Shuttlecock
Oil on canvas, 82x66
Inv. 1890, 9274
Signed. Purchased for the Uffizi in 1951 with its companion piece (Inv. 1890, 9273, see below) from the Pallavicino di Rivalta Scrivia family.

Jean Baptiste Siméon Chardin
Boy Playing Cards
Oil on canvas, 82x66
Inv. 1890, 9273
See previous entry.

Giovanni Battista Tiepolo
(Venice 1696–Madrid 1770)
Erecting a Statue in Honour of an Emperor
Oil on canvas, 420x175
Inv. 1890, 3139
From the beginning in the Archbishop's Seminary in Udine; purchased for the Uffizi in 1900.

Rosalba Carriera
(Venice 1675–1757)
Flora
Pastel on paper, 47x32.5
Inv. 1890, 3099
At the Uffizi since 1890.

Giovanni Antonio Canal called Canaletto
(Venice 1697–1768)
Palazzo Ducale in Venice
Oil on canvas, 51x83
Inv. 1890, 1334
From Poggio Imperiale; at the Uffizi since 1796.

Alessandro Falca called Longhi
(Venice 1733–1813)
Portrait of a Lady
Oil on canvas, 100x80
Inv. 1890, 3573
Purchased for the Uffizi in 1911 from the Artelli collection in Trieste.

Canaletto
View of the Grand Canal
Oil on canvas, 45x73
Inv. 1890, 1318
At the Uffizi since 1798.

Francesco Guardi
(Venice 1712–1793)
Seascape with Arch
Oil on canvas, 30x53
Inv. 1890, 3358
Purchased for the Uffizi in 1906 with its companion piece (Inv. 1890, 3359, see below) from the collection of Luigi Grassi.

Francesco Guardi
Seascape with Bridges on a Canal

Chardin: Girl with Racket and Shuttlecock

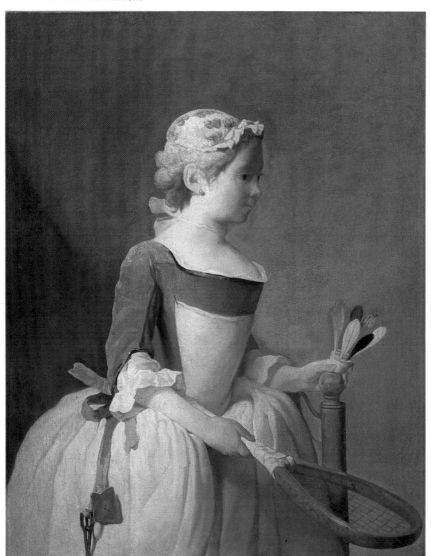

▽
Chardin: Boy Playing Cards

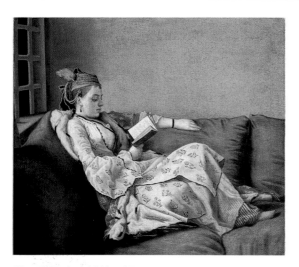

Liotard: Marie Adelaide of France

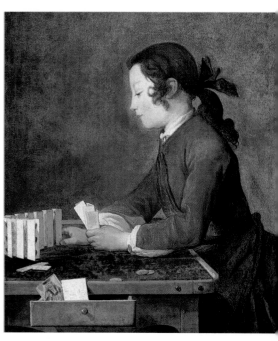

Goya: The Countess of Chinchon

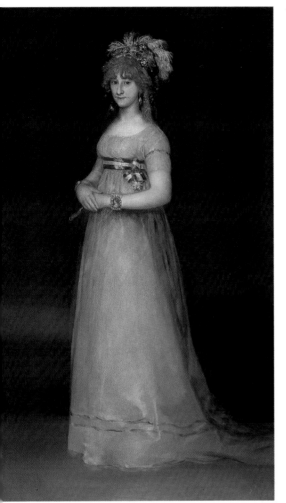

Goya: Maria Teresa de Vallabriga on Horseback

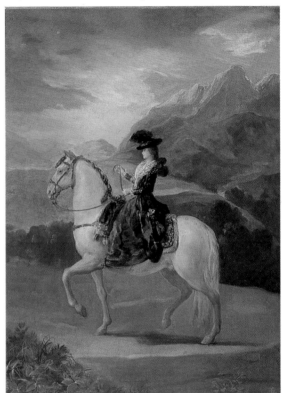

Oil on canvas, 30x53
Inv. 1890, 3359
See previous entry.

Pietro Falca called Longhi
(Venice 1702–1785)
The Confession
Oil on canvas, 61x49,5
Inv. 1890, 9275
Purchased for the Uffizi in 1951
from the Pallavicino collection.

Giovanni Battista Piazzetta
(Venice 1682–1754)
Susanna and the Elders
Oil on canvas, 100x135
Inv. 1890, 8419
In 1740 in the Bonomo
Algarotti collection; at the
Uffizi since 1920.

Giuseppe Maria Crespi
(Bologna 1665–1747)
The Flea

Oil on copper, 46.5x34
Inv. 1890, 1408
From Palazzo Pitti; at the Uffizi
since 1861.

Giuseppe Maria Crespi
The Artist's Family
Oil on copper, 28x24
Inv. 1890, 5382
In 1708 in the collection of
Ferdinando de' Medici; at the
Uffizi since 1753.

François Xavier Fabre
(Montpellier 1766–1837)
Portrait of Vittorio Alfieri
Oil on canvas, 93x73
Inv. 1890, 1000
Signed and dated 1793. From
the beginning in the d'Albany
collection; presented as a gift to
the Uffizi in 1824.

François Xavier Fabre
Portrait of the Countess d'Albany
Oil on canvas, 93x73
Inv. 1890, 1001
Signed and dated 1793. From
the beginning in the d'Albany
collection; presented as a gift to
the Uffizi in 1824, with its
companion piece (Inv. 1890,
1000, see above).

Jean Marc Nattier
(Paris 1685–1766)
Marie Adelaide of France as Diana
Oil on canvas, 95x128
Inv. Dep. 21
Signed and dated 1745. With its
companion piece (Inv. Dep. 23,
see below) sent to Madrid
around 1746. At the Uffizi
since 1922.

Jean Marc Nattier
Marie Zephirine of France

Oil on canvas, 70x82
Inv. Dep. 22
Sent to Palazzo Pitti in 1865
from Parma; at the Uffizi since
1922.

Jean Etienne Liotard
(Geneva 1702–1789)
Marie Adelaide of France
Oil on canvas, 50x56
Inv. Dep. 47
Dated 1753. Probably from
Parma; at the Uffizi since 1932.

Jean Marc Nattier
Henriette of France as Flora
Oil on canvas, 94.5x128.5
Inv. Dep. 23
Signed and dated in 1742. With
its companion piece (Inv. Dep.
21, see above) sent to Madrid
around 1746. At the Uffizi
since 1922.

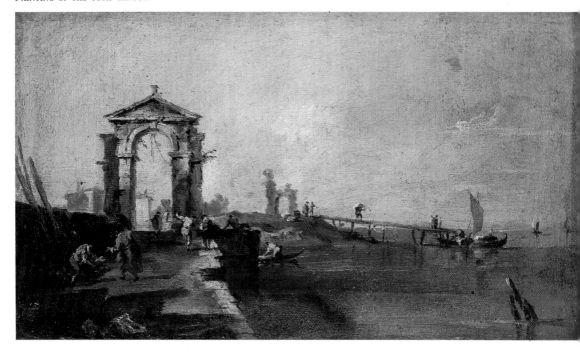

Francesco Guardi: Seascape
with Arch

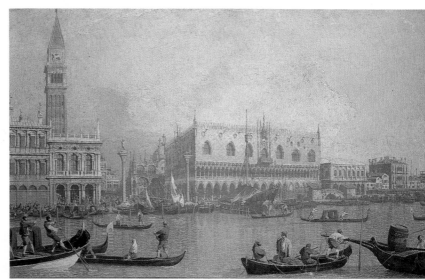

Canaletto: Palazzo Ducale
in Venice

Tiepolo: Erecting a Statue
in Honour of an Emperor

◁
Pietro Longhi: The Confession

◁◁
Piazzetta: Susannah and the Elders

The Vasari Corridor

Built in only five months in 1565 by the architect Giorgio Vasari, the Corridor was commissioned by Cosimo I to celebrate the wedding of his son and heir, Francesco, to Joan of Austria, daughter of the Emperor. The Corridor begins on the west side of the Gallery. Nearly a kilometre long, the passageway was built for the strictly private use of the ruling family. Crossing the Arno over the left side of Ponte Vecchio and passing behind the Oltrarno houses it reaches the Pitti Palace, which was then the Medici residence. Along the way are many windows which give splendid glimpses of the surrounding hills or city streets and bridges; an inside window looks into the church of Santa Felicita, at one time the rulers' private chapel.

Given to the state by Victor Emanuel II of Savoy when Florence was the capital of Italy, the Corridor became part of the Gallery. It subsequently underwent many changes and was often closed, sometimes for long periods due to the heavy damages incurred during the Second World War and then again during the flood of 1966.

Completely restored, it was re-opened to the public (only by reservation and for group tours) in 1972. Over seven hundred paintings are displayed here, a selection of the various sections of the museum's collection.

In the first part, from the Gallery to the Ponte Vecchio, there are paintings from the 17th and 18th centuries, a continuation of the display in the last three rooms in the Gallery. Noteworthy are important works by followers of Caravaggio (Manfredi, Gerrit van Honthorst) and by the Bolognese school (Reni, Albani, Guercino); followed by the Venetian school (Lys, Forabosco); the Roman school (Codazzi, Bamboccio); the Tuscan school (Dolci, Lippi) and the Neapolitan school (Cavallino, Caracciolo, Rosa).

Dating from late 17th and early 18th centuries there are the splendid large canvases by Crespi, works by Magnasco and finally, moving fully into the 18th century, the Venetians Bellotto and Carriera. There is also a wide-ranging selection of French painting (La Tour, La Hyre, Grimou, Boucher).

The section above the Ponte Vecchio is dedicated to the great collection of self-portraits (the most important in the world), begun by Cardinal Lepoldo de' Medici, whose statue by Foggini now stands at the end of this part of the Corridor (see Room 35). The self-portraits are arranged in chronological order, from the 16th century forward, and are also divided by schools. To mention only a few of the most famous names among the hundreds of paintings on display: Vasari, who must certainly take the place of honor, Andrea del Sarto, Baccio Bandinelli, Carlo Dolci, Veronese, Titian, Rosalba Carriera, Correggio, Barocci and then the Carracci, Reni, Guercino, Andrea Pozzo, Bernini, Salvator Rosa. . . to Pompeo Batoni.

The Italians are followed by German, Flemish and Dutch painters, among which Rubens, Rembrandt, Van Dyck; then the French and English (Vivien, Liotard, Reynolds, Constable, More).

The collection of self-portraits is briefly interrupted in the section near the church of Santa Felicita by a splendid collection of drawings, preparatory designs and sketches, a collection also begun by Cardinal Leopoldo. Then the self-portrait collection is resumed with paintings by both Italians and foreigners, from the 18th to the 20th centuries. Among the Italian section one finds the self-portraits of Canova, Fattori, Hayez, Previati, Boldini, Lega, Ciardi, Chini, Spadini and Checchi. Among the foreigners are David, Elizabeth Vigée-Lebrun, the pre-Raphaelites, Delacroix, Ingres, Corot, Sargent, Denis and Böcklin.

On the occasion of the 400th anniversary of the Uffizi, the Gallery was presented with over 200 self-portraits, donated by famous contemporary artists.

The last section of the Corridor, which finishes at the Boboli Gardens next to Buontalenti's Grotto, shows a selection of the "Iconographical Collection," a series of portraits of historical figures dating from the 16th century onward.

Gerrit van Honthorst:
Adoration of the Child

Bartolomeo Manfredi: Concert

Nicolas Renier:
The Fortune-teller

Guido Reni: David

Artemisia Gentileschi: Judith and Holophernes

◁
Francesco Rustici, called Rustichino:
Allegory of Painting and Architecture

Bernardo Strozzi: The Parable of the Wedding Guest

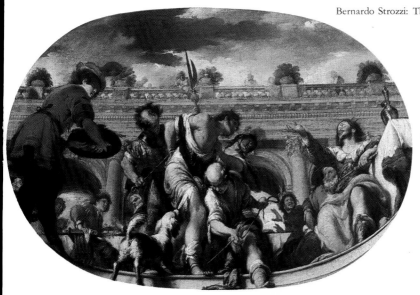

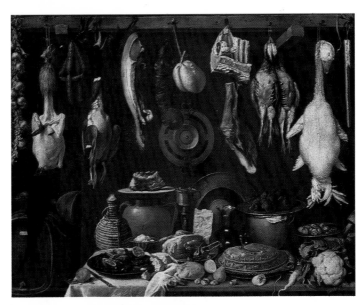

Rutilio Manetti: Massinissa and Sophonisbe

Empoli: Still Life

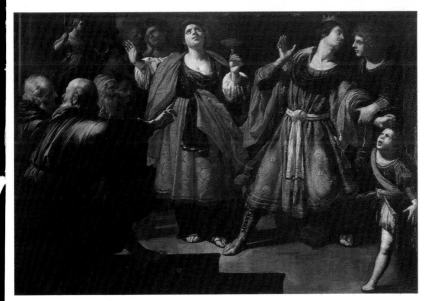

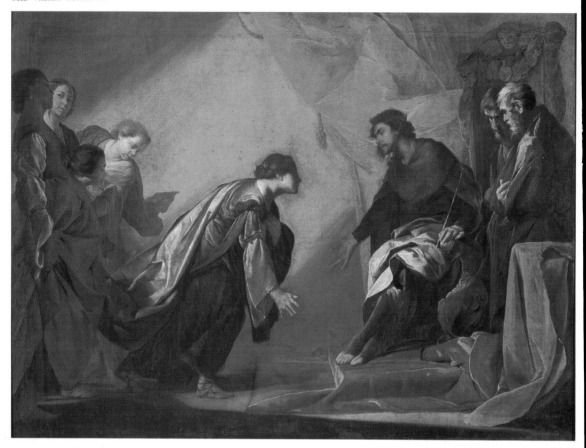

Bernardo Cavallino: Esther and Ahasuerus

Giovanni Battista Crespi, called Cerano:
Madonna in Glory

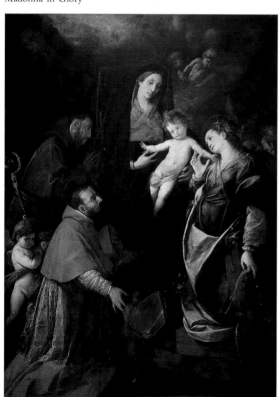

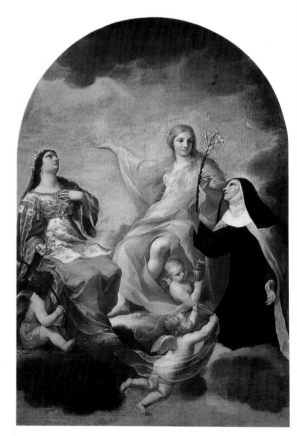

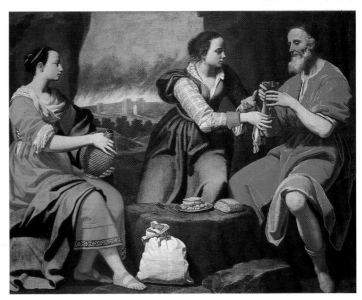

Lorenzo Lippi: Lot and his Daughters

Viviano Codazzi: Architectural Study
with two Arches

◁
Andrea Sacchi: The Three Magdalens

Francesco Albani: Rape of Europa

Rosalba Carriera: Enrichetta Anna Sofia of Modena

Giovanni Battista Gaulli, called Baciccio:
Cardinal Leopoldo de' Medici

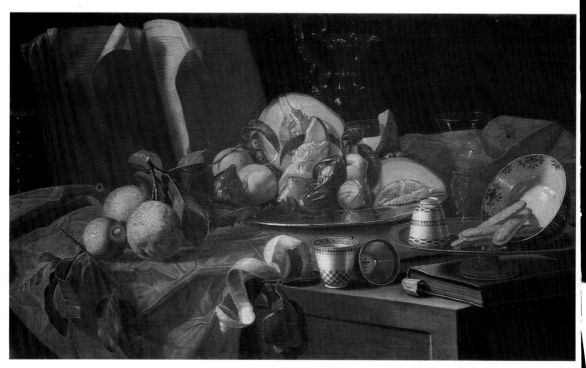

Cristoforo Munari: Still Life

Pompeo Batoni: Achilles and Chiron the Centaur

Domenico Beccafumi: Self-portrait

Alessandro Allori: Self-portrait

Diego Velazquez: Self-portrait

Peter Paul Rubens: Self-portrait

Johann Zoffany: Self-portrait

Elisabeth Vigée-Le Brun: Self-portrait

Jean-Auguste-Dominique Ingres: Self-portrait

Eugène Delacroix: Self-portrait

Maurice Denis: Self-portrait

Arnold Böcklin: Self-portrait

Marc Chagall: Self-portrait

Robert Nanteuil: Louis XIV, King of France
(from the Iconographical Collection)

Index of artists

(Numbers in bold face refer to illustrations)